To Mar
Enjoy
book —
Chris B

To Martin —
we hope this book will
be as meaningful to you
as it is to us!!
Mary Matalin

to Martin —
thanks for your service
to our nation!
best wishes —
Catherine Josep[h]

We Are a College at War

WE ARE A COLLEGE AT WAR

WOMEN WORKING FOR VICTORY IN WORLD WAR II

Mary Weaks-Baxter,
Christine Bruun, and
Catherine Forslund

Southern Illinois University Press
Carbondale and Edwardsville

13 12 11 10 4 3 2 1

Library of Congress Cataloging-in-Publication Data
Weaks-Baxter, Mary.
We are a college at war : women working for victory
in World War II / Mary Weaks-Baxter, Christine
Bruun, and Catherine Forslund.
 p. cm.
Includes bibliographical references and index.
ISBN-13: 978-0-8093-2992-2 (cloth : alk. paper)
ISBN-10: 0-8093-2992-1 (cloth : alk. paper)
ISBN-13: 978-0-8093-8591-1 (ebook)
ISBN-10: 0-8093-8591-0 (ebook)
1. Rockford College—History—20th century.
2. World War, 1939–1945—War work—Schools.
3. World War, 1939–1945—Women—Illinois.
4. Women college students—Illinois—History—
20th century. 5. Cheek, Mary Ashby. 6. Addams,
Jane, 1860–1935. I. Bruun, Christine, [date].
II. Forslund, Catherine, [date]. III. Title.
D810.E45R63 2010
940.53′77331082—dc22 2009049525

Dedicated to the women of the World War II Rockford College family

War calls for unity, sacrifice, determination, energy, and
loyalty.
> —Mary Ashby Cheek, president,
> Rockford College (1937–54)

We stand united in a belief in beauty, genius, and courage,
and that these expressed through truest womanhood
can yet transform the world.
> —Jane Addams in her 1881 graduation
> address at Rockford Female Seminary

Contents

Illustrations

Acknowledgments

This research project on American women and World War II has followed an evolving course. Like Mary Ashby Cheek, president of Rockford College from 1937 to 1954, Christine Bruun had lived in Danville, Kentucky, and had family connections to Centre College, so the earliest work grew out of these commonalities. However, the remarkable influence of President Cheek at Rockford College emerged as a story with its own momentum. Cheek's interest in internationalism and her belief in the women students at the college motivated Rockford women to expect that they could make a contribution in the public sphere. Our numerous interviews and conversations with alumnae who were students while she was president revealed to us not only her charisma but also the distinctive atmosphere and activities at the college during this period. In addition to the influence of President Cheek, alumnae told us of the inspiring dedication and meticulous scholarship of the faculty, who powerfully shaped their lives. These alumnae shared their letters (including correspondence with soldiers who were friends and fiancés), diaries, and photographs, all saved from these years.

The wealth of material that alumnae were passing along led us to recognize the intriguing story of the college's involvement in World War II and to cast the story more broadly. Alumnae told us of the excitement they experienced as they realized the active roles they could play. They became involved in international student organizations, the Red Cross, and all the women's branches of the military—the WAC (Women's Army Corps), WAVES (Women Accepted for Volunteer Emergency Service), SPAR (*Semper Paratus*—Always Ready)—as well as campus activities to support the war. An innovative example was the earn-and-learn program, one of the first of its kind, which allowed students to work in war-production factories while they were also attending classes. The women students clearly felt empowered to initiate change.

Our observations of what the women at Rockford College were doing during the war prompted us to look at the broader picture of what was occurring with other women college students in the country. Although women all over the United States were involved in the war effort, many college women were organizers and activists and appeared to be an under-researched population. This enlarged view helped us to place the microcosm of Rockford College in the fuller historical context of higher education around the war years. We also became more aware of the far-reaching influence of Jane Addams, who not only was an alumna of Rockford College but also helped shape the direction of the feminist movement well into the 1930s and beyond. Many of the alumnae who shared their memories and documents were living examples of how the ideals of Jane Addams and the effects of their college education led to the strategic roles and work they performed later in life. Ultimately, the project grew into a more refined understanding of how events that preceded and followed World War II dramatically affected the lives of women at Rockford College and elsewhere. The series of expanding ripples grew into a fuller and richer story than just that of Mary Ashby Cheek alone.

Many people have contributed their ongoing support to make this book possible. Their goodwill and helpful cooperation have made the whole process smoother. Foremost, we are grateful to the alumnae of Rockford College who were students during the war years. They have been exceedingly generous in sharing their time, recollections, memoirs, memorabilia, and a spirit of collaboration. Their friendliness and accommodating assistance had an engaging effect. They believed in the significant force of what they accomplished and very quickly convinced us to believe the same.

The library staff of Rockford College has been helpful at every juncture. Phil Hjemboe helped to make space in the library for us that could be dedicated specifically to this project, Kelly James ('95) worked with our student assistants on the best methods for preparing our archival material, and Audrey Wilson's assistance in interlibrary loan brought the work of numerous scholars to our aid. Particular thanks go to Mary Pryor, the college archivist, who has worked diligently to make all available documents accessible to us and who often assembled ordered sets of materials to make them more efficiently usable.

Other departments of the college have shown similar support. The Alumni and Development offices, especially Bern Sundstedt and Janice Holton, have been helpful in highlighting our work for alumni and encouraging them to participate in discussions that have been useful in our research. John McNamara of the Development Office secured funding to support our project, and Chuck Brown of College Relations helped us get the word out about our research efforts and our book publication. The Rockford College Information Technology

department, and in particular Bonnie Johnson, helped with technical advice, the purchase of scanning equipment, and development of the Web page for this project. Also, the Faculty Development Committee of the college has provided continued financial support of the project throughout its duration. President Robert Head and Dean Stephanie Quinn have shown constant interest in the project and backed the institutional support that we received.

Many people beyond the college campus supported our work. Several organizations gave us the opportunity to talk about our work with individuals in the community, including Midway Village Museum, the Rockford Network of Professional Women, and the Geneva History Center. James Sabathne ('93) was generous in commenting on an early version of our manuscript, and Marjorie Schafer completed a thorough, user-friendly index for us.

We are especially grateful to the executive editor of Southern Illinois University Press, Sylvia Frank Rodrigue. Without her encouragement, patience, and careful guidance, the book would not be where it is now. We also wish to thank the external reviewers whose astute comments and suggestions added clarity to the manuscript.

Finally, we have gained immeasurably from the steadfast efforts of our student research assistants. Heather Rapp ('06), Jeannie Harrison ('04), Samantha Guarino ('05), Kate Terry ('07), Nicole Lindsay ('08), and Amber Champion ('09) brought their skills and resourcefulness to help move the project along in the early stages. More recently, Jen Eller worked on the design of our companion Web site for the book, and Amber Kresol helped prepare our research materials for the college archives. We would like to extend a special thanks to Elizabeth Jenkins ('09) and Lucas Kramer ('09), who have worked tirelessly in their research efforts, bringing keen-minded insights and competence to the final phase of the project. They have given us immense help. We are deeply indebted to their dedicated efforts, and without Elizabeth and Luke, this book might well have been another year in coming.

The support of friends and families was crucial to our work on this project, which has ranged over more than a decade for some of us.

I (Christine Bruun) would like to express my gratitude to my late mother, Dr. Mary J. Vestermark, my role model and chief encourager. A colleague of Mary Ashby Cheek's, my mother showed enthusiasm for the project from its inception. My husband, David, has been a constant help, listening to drafts and offering thoughtful opinions along the way. He has always shown that what is important to me is also important to him, an appreciated gift. Two of my friends were especially helpful. Jeannie Gans enthusiastically supported the research on the feminist movement, and Ann Pennington of Danville, Kentucky, provided rich information about Mary Ashby Cheek from archival

sources in Kentucky. My thanks also go to Logan Cheek, nephew of Mary Ashby Cheek, who generously and graciously shared Cheek family documents and information with me.

My (Mary Weaks-Baxter) personal connections to the story we tell here are more recent ones, including an aunt by marriage, Carole Quitno Suhr, who graduated from Rockford College in 1956, and my mother-in-law, Doris Quitno Baxter, who took classes at the college. Both have been generous in telling me about their time on the Rockford campus. Although my nine-year-old son, Andrew, may not recognize his contributions to this project, his enthusiasm, good nature, and humor remind me again and again what's important in life. A Rockford native, my husband, Brent Baxter (MAT, '05), has shared with me numerous stories about the town during World War II. I thank him especially for the life that we have created and live together, one that sustains me and encourages me in all I do.

Growing up hearing about Rockford College made the college seem very familiar when I (Catherine Forslund) arrived in 2000. I learned almost immediately of Chris and Mary's work and was asked in 2005 to join them in the project. Guidance from my mother, Jacquelyn Silcroft Forslund, who graduated from Rockford College in 1946, and her recollections added much to my understanding of the college's spirit and thus enriched the text. The constant grounding provided by my husband, Roy Roncal, has made my contributions here possible and keeps me going. To him I owe more than I can say.

To all our other colleagues, family, and friends who also listened and encouraged us in this work, we offer our grateful appreciation. Any errors left herein are only ours.

Abbreviations

ASU American Student Union
AWOL absent without leave
AYC American Youth Congress
CBS Columbia Broadcasting System
CIA Central Intelligence Agency
EEOC Equal Employment Opportunity Commission
ERA Equal Rights Amendment
GI government issue—foot soldier
MP Military Police
OPA Office of Price Administration
POW prisoner of war
SPAR *Semper Paratus*–Always Ready
SS Schutzstaffel
UN United Nations
U.S. United States
USASOS United States Army Services of Supply
USO United Service Organizations
VE-Day Victory in Europe Day
VJ-Day Victory in Japan Day
V-Mail Victory Mail
WAAC Women's Army Auxiliary Corps
WAC Women's Army Corps
WAFS Women's Auxiliary Ferrying Squadron
WASP Women Airforce Service Pilots
WAVES Women Accepted for Volunteer Emergency Service
WPB War Production Board
WSSF World Student Service Fund

ABBREVIATIONS

YMCA Young Men's Christian Association

YWCA Young Women's Christian Association

Abbreviated Names of Rockford College Archival Collections

CGR Catherine Glossbrenner Rasmussen Scrapbook

ET Evelyn Turner Folder

JWR Julie White Rogers Folder

MAC Mary Ashby Cheek Folder

RCA Rockford College Archives

WPC World War II Project Collection

We Are a College at War

Introduction: The Jane Addams Legacy

Early in 1945, Corporal Joel Archer, who was serving with the U.S. Army in France, wrote a letter to an Illinois college student whom he had seen pictured in a Detroit newspaper photograph. Archer did not know the young woman but felt compelled to write to ask about her personal contributions to the war effort. His letter quickly drew the attention of students and faculty at the college the young woman attended, a small liberal arts institution named Rockford College situated on the Illinois-Wisconsin border, just a short train ride from Chicago. The college's newspaper quickly picked up the story and printed Archer's letter. "One of the fellows received some Detroit papers in one of which your picture was shown," Archer wrote. "You were one of a group of girls shown attending Rockford College; the picture provoked a bit of comment." Summing up his conversation with his fellow soldiers, Archer wrote about their various speculations and thoughts about young women on the home front:

> The gist of the discussion was how fortunate you are as a girl, to be going to school, and continuing your normal life with minor unpleasantness, in spite of the war. Of course, no one felt you should endure any undue hardships, but some men were wondering what you are contributing to the war effort and eventual victory. Your answer will interest me greatly, as it will settle a wager of a few francs on whether or not you are indifferent to the war. It would be of great interest to me to know what your personal contributions to the war effort have been, and will be in the future.[1]

Although no record of the student's response to the corporal's letter remains, *We Are a College at War: Women Working for Victory in World War II* answers

1

his question, at least in part, by exploring the ways that U.S. women carried forth a plan for victory through the example of one American women's college.

Examining the roles and experiences of the Rockford College women and community in the war effort not only emphasizes the importance of American women's contributions but also brings into question some of the standard historical assessments of feminist movements in the twentieth century. Much like similar women across the country, students, faculty, and staff at Rockford College actively supported relief efforts, voiced their political opinions, trained for war work, conserved resources, worked in factories, and prepared for the postwar world. Some even served overseas in the U.S. armed forces. The example of Rockford College during World War II twines together the stories of many individuals who were part of the often neglected chronicle of American women who participated in the war effort both at home and abroad. A women's college like many others of the time and the alma mater of 1931 Nobel Prize winner and social activist Jane Addams, Rockford College was also a community conflicted by political issues faced by American students and everyday citizens across the nation. Historians tend to agree, however, that American women during World War II engaged completely and willingly in the war effort because of their patriotism and their desire to come to the aid of American men—not because they saw themselves as part of a concerted women's movement. They were needed during the war to support the Allies, but they returned to the home (in many cases quite willingly) when war ended.

According to historian Daniel Horowitz in *Betty Friedan and the Making of* The Feminine Mystique*: The American Left, the Cold War, and Modern Feminism*, feminism was largely a dead issue for middle- and upper-class white women during the 1940s and 1950s, but a feminist movement was kept alive by those women who continued to work for gender issues related to the working classes and African Americans' civil rights. The war years were significant, however, in shaping the early lives of women like Betty Friedan, who was then enrolled at Smith College and studying under Dorothy Wolff Douglas, an activist for women's labor and a friend of Jane Addams. Horowitz explains that Douglas "helped shape [Friedan's] future and develop the ideas that proved so consequential to the reemergence of American feminism."[2] Although Horowitz points to the influence of women's education of the World War II years on the development of the feminist movement of the 1970s, he—like many other historians—fails to recognize a current of feminism that was more subtle and very much shaped by the difficulties and complications of war. In fact, Horowitz's assumption that feminism was dead for more privileged classes of women in America overlooks the role of a type of feminism that is perhaps unique in American history.

Although American middle- and upper-class women of the war years were not involved in feminist movements for suffrage or for the Equal Rights Amendment, their efforts can be framed in a context focused specifically on the political concept of "care" as a means of empowerment. In the essay collection *Revisioning the Political: Feminist Reconstructions of Traditional Concepts in Western Political Theory,* Joan C. Tronto argues in "Care as a Political Concept" that although "care" has not been historically considered part of political life, it is actually "a complex process that ultimately reflects the structures of power, economic order, the separation of public and private life, and our notions of autonomy and equality." Caring for and caregiving, according to Tronto, are a means of taking responsibility.[3] As citizens, young American women of the middle and upper classes saw the necessity of individual duty and sacrifice for the cause of freedom. Rockford College students recognized the vital role women could play in winning the war and the value of women becoming politically and socially active.

Not only was World War II the first war fought after American women received the right to vote, but more American women also contributed to the war effort than ever before or since. While large numbers of women received payment for their work during the war, even larger numbers worked as volunteers. If controlling money is a mark of gender freedom, so, too, was caregiving a way for women to assert their independence, reaffirm their significance in society, and align themselves in roles that could shape the outcome of the war. American women were clearly a driving force behind the men fighting at the front, whether they were of the lower or upper classes, and their roles were typically as caregivers: as relief workers, as factory workers making supplies and munitions, as nurses, as girlfriends back home who encouraged soldiers with care packages and letters. Although women's movements are typically identified as focusing on the individual and individual rights, the politics of care that came to the forefront during World War II signaled not only American women's patriotism but a women's movement that was rooted in the domestic, was much more relational, and was tied to the ideal of engaged citizenship.

Such active caregiving was deeply embedded in the history of Rockford College. Grounded in the college's history was a firm belief in the value of women's leadership and the importance of women's contributions to their communities. Founded as Rockford Female Seminary in 1847, Rockford College was the female counterpart to the all-male Beloit College, located just across the state line in Wisconsin. Modeled after Mount Holyoke College in Massachusetts, Rockford Female Seminary was founded by former New Englanders who wished to provide a Christian education for young women in what was then still a frontier region. Reverend Aratus Kent, the first president of the

Board of Trustees for Rockford Female Seminary, worked with a dedicated group of Presbyterian and Congregationalist leaders in the region to bring higher education to men at Beloit College and women at Rockford. Anna Peck Sill, the first principal of Rockford Female Seminary, had originally planned to become a missionary but ultimately came to believe that her true calling was to found a school in the Midwest to educate young women either to become missionaries or to marry men who would. In the scrapbook she started when she first opened Rockford Female Seminary, Sill placed a copy of the Mayflower Compact alongside a newspaper advertisement for the school.[4] Perhaps in doing so, Sill reminded herself and those who followed of the significant role her Puritan New England roots played in her life and the important compact that she believed she had with God in founding the seminary.

Nineteenth-century attitudes about women's education often challenged the work of women like Sill. In 1873, for example, Dr. Edward H. Clarke, a physician in Boston, published *Sex in Education*, which he wrote with the intent of frightening young women away from seeking degrees in higher education. Clarke reasoned that pursuing a degree would jeopardize both a woman's health and her femininity. Women should conform to the "law of periodicity," he and others argued. That is, they should remain in confinement and lie

First three buildings of Rockford Female Seminary. This image is from about 1880.
(Courtesy of Rockford College Archives.)

supine for at least three days during their menstrual period. Higher education, wrote Clarke, would interfere with the reproductive system and with "Nature's laws."[5] Like other women leaders of her time, Sill fought against opinions such as Clarke's, calling instead for a "systematic and thorough" education for women that should not be interrupted.[6]

Sill and her faculty worked to instill within their students the attitude that personal sacrifice was sometimes necessary for citizens of a democracy and that all members of society working together could make a positive difference. In 1861, during the American Civil War, the young women of Rockford Female Seminary busied themselves with war work as they knitted, baked, collected books, and packaged boxes for Union soldiers. One student named Serene Starin wrote home about a Christmas party in 1861, when soldiers who were visiting campus were presented with gifts of "tracts and little pocket Bibles" and "many bundles of tea, mustard, sage, and other necessities for the sick."[7] When the young women sent care packages to Illinois volunteers stationed in Missouri, the soldiers wrote the college to express their thanks for the mirrors and "housewives" (needlebooks or sewing kits) that were sent: "Ah, ladies, you have no idea of the scarcity of 'housewives' in Mo." The men exclaimed that the socks the young women had sent "made glad the 'souls'" of the men who received them, the books were a "source of a great amount of pleasure and profit," and the cake was "excellent." The letter closed with gracious words of appreciation:

> Such tokens as we have received at your hands, enable us when almost discouraged at the prospect before us—almost sorry that we ever "enlisted"—to resolve to press on in the sacred cause in which we are engaged, knowing that our friends still care for us, and are interested in our success.[8]

Although women's contributions to the war effort during the Civil War still remained firmly in the domestic realm, the soldiers' letter recognized just one of the ways in which American women like the Rockford students were involved in that war.

In the late 1870s, when Jane Addams (1860–1935) began her studies, the curriculum and the general atmosphere on the campus clearly reflected the strong nineteenth-century ties between religion and the budding movement for women's rights. The daughter of one of the college's trustees, Addams was raised in a family that valued its Quaker roots, and because Quakers did not include baptism as part of their ritual, Addams was not baptized. At Rockford, Addams found herself the focus of chapel prayers as the converted prayed for students like Jane who had not yet been baptized. Despite her discomfort with such pressures, Addams found at Rockford a place that her biographer nephew, James Weber Linn, called "a hotbed of suffrage" in his 1935 biography

of his aunt. When she graduated, according to Linn, Addams was "a convinced suffragist," and "the chief influence upon Jane was Rockford Seminary itself."[9]

Addams's accomplishments as a student also suggest the evolving opportunities for collegiate women. Increasingly, women were taken seriously in intercollegiate activities—even those that involved men. According to Addams's account in *Twenty Years at Hull-House*, her participation in the Interstate Oratorical Contest held at Illinois College resulted in her placing fifth behind William Jennings Bryan, who placed first. When she returned to campus, her friends made it clear to her that they believed her loss had "dealt the cause of woman's advancement a staggering blow."[10] Women studying at most seminaries in the nineteenth century were expected to complete advanced work, but they graduated with a certificate rather than a degree. Students could pursue a college degree if they chose a more rigorous academic program. As further evidence of Addams's belief in women's role in society, she was the first one to earn a bachelor's degree: after leaving Rockford with a seminary certificate in 1881, Addams was invited back in 1882 to receive the first bachelor's degree conferred by the college as a way to mark her high academic achievements as a student. At her 1881 graduation ceremony, Addams spoke as president of the graduating class, explaining:

> We have expressed to each other higher and nobler things than we have probably ever said to anyone else, and these years of young life being past, better perhaps than we shall see again. We stand united today in a belief in beauty, genius and courage, and that these expressed through truest womanhood can yet transform the world.[11]

In her analysis of Jane Addams's current relevancy for public affairs, Patricia Shields clearly shows the interrelatedness of Addams's ideas. Empathetic understanding of others, democracy, social feminism, and education were all of one fabric for her. At the heart of Addams's work was her belief in the power of relationships. When individuals could talk directly with each other and see life and its burdens through each other's eyes, then social action was made personal and relevant. This "sympathetic understanding" was an underlying principle for Addams. A heartfelt empathy for others made a shared democracy a reasonable mechanism by which diverse groups could be included.[12] As Addams herself put it, "Human experience and resultant sympathy . . . are the foundations and guarantee of Democracy."[13] According to Addams, women, who understood empathic care in the home, were ideally suited to transfer these family roles to the larger social arena. The well-run household became the model for Addams's view of the well-run city, what historians call "civic or municipal housekeeping."[14] Addams's social feminism was built on these

principles, and democracy was the culture in which they were embedded. Finally, the higher education that was emerging as a possibility for women served to bring a growing awareness of social concerns and the many ways that scientific inquiry could be applied. Hull-House became a teeming, bustling environment for exploring ways to address social needs. There was openness to hypothetical reasoning, questioning, and testing and to action based on the facts that emerged in the process.

Hull-House, from its early days, met emerging needs on many fronts. Like a family caring for its members, Hull-House cared for its neighborhood residents. The kitchen provided nutritious meals and dietetic know-how. Its coffee house extended hospitality for social gatherings and warm interaction. The gymnasium offered space for dancing and other sought-after activities. Reading rooms and an art gallery were places of enjoyment and intellectual stimulation. These were only a few of the life-need services the settlement house provided. Women, the hearth tenders of the home, were the most qualified, in Addams's opinion, to oversee these services. Historian Jean Bethke Elshtain frames Addams's model as "a healing domesticity in which the strong, maternal image sustains and enables instead of smothering or constraining. ... The maternal model thrust women into a world of care, responsibility, and obligation."[15] Women were natural executors of civic housekeeping, which ideally brought mutual benefit to all members of society.

Women like Sill and Addams were strong role models for Rockford's World War II–era students. Addams's accomplishments at Hull-House and as president of the Women's International League for Peace and Freedom (which garnered her the Nobel Peace Prize) were testimony to the power of higher education in transforming the nature of women's contributions to American society. Another former Rockford College student, Julia Lathrop—who was a Rockford native—finished her degree at Vassar College, joined Addams at Hull-House in 1890, and throughout her career worked tirelessly for juvenile rights. As chief of the Children's Bureau at the U.S. Department of Labor in 1912, Lathrop helped pass the Sheppard-Towner Act of 1921, which provided the first government support for the health and welfare of mothers and children. After ten years in Washington, D.C., she returned to Rockford, where she spent the rest of her life actively engaged in the community, taking on such roles as president of the Illinois League of Women Voters. Both Addams and Lathrop represented a new generation of formally educated women stretching the boundaries of the women's sphere in American society, but not altogether breaking through those bounds. They were empowered by Rockford Female Seminary and other women's colleges to do more than their mothers' generation, and in so doing, they paved the way for the next generations.

To ensure that students recognized America's place within a global community and a woman's responsibilities to the world beyond her family, at various times freshmen entering the college were required to write papers on Jane Addams. There was little doubt of the belief in the potential import of women's roles in society that was part of the seminary's ideology, yet two of Rockford's first presidents (all of whom were female until the first male president was hired in 1919) resigned their posts solely because of their gender after becoming engaged to be married. Their future husbands, of course, did not resign their positions upon notice of their engagements. This was typical for women of the time; even if a female teacher married, she was expected to leave the position. Despite the college's tradition of educating young women to become professionals and leaders in their communities, there were still societal norms to be followed. The legacy of Addams's and others' activism pushed the limits of women's roles through the first half of the twentieth century.

The woman who served the college as president during World War II, Mary Ashby Cheek, came to Rockford College in large part because she believed women's education was not a luxury to be enjoyed in one's own private sphere but a means to sharpen thinking, to develop originality, to feel humanitarian concern, and to fuel constructive action. She encouraged students to be active contributors to the world community, and World War II provided ample opportunity for her students' contributions. With the same fervor of the women of Hull-House and the women who supported American relief efforts during World War I, Rockford College students during World War II grew food in Victory Gardens; gathered books in the Victory Book Campaign; helped local United Service Organizations (USO) provide meals, entertainment, and public lectures; built morale plus the tools of war; and kept the country running while men were away fighting the war. Indeed, women were "thrust into a world of care, responsibility, and obligation."[16]

The values and ideas expressed by Adams were clearly evident in the thinking of Mary Ashby Cheek. Although Addams was a staunch pacifist during World War I, and Cheek supported American involvement in World War II as a means to preserve democracy, both similarly envisioned an active role for women in the world. In an essay written when she was a student at Rockford Female Seminary, Addams praised qualities in women such as "endurance, stability, relationships, and care."[17] Later, in a 1942 chapel speech exhorting students to support the war—capturing the spirit of those qualities Addams believed were integral in supporting feminist efforts—Cheek called for Rockford College women to demonstrate "unity, sacrifice, determination, energy, and loyalty."[18] Both Addams and Cheek viewed these characteristics as important for women in a democracy. Addams and Cheek both championed a liberal

arts education. Cheek saw resourcefulness resulting from the fullness of the college's curriculum offered to the women students. Similarly, at Hull-House, history, the arts, and the sciences all had a place in the classes and activities. Both Addams and Cheek had faith in education that moved women into the world arena. Addams promoted community action on behalf of immigrants, disenfranchised classes, women, and children; Cheek pressed the importance of helping refugees, including students, and reshaping the postwar world for democracy. At the end of her life, in 1987, Cheek accepted the Jane Addams Medal awarded her by Rockford College with these words for alumni: "You are epitomized always by that most illustrious alumna. . . . She was already a world citizen in her thinking."[19]

Another connection between Addams and Cheek was their friendship with Catharine Waugh McCulloch, Addams's classmate at Rockford Female Seminary. Addams and McCulloch went on to organize an effective alliance

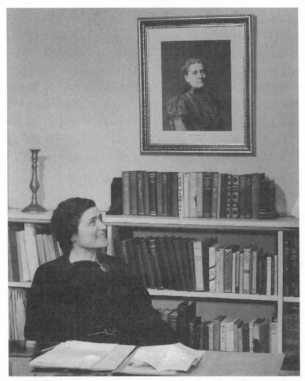

President Mary Ashby Cheek in her office looking at a portrait of Jane Addams, founder of Hull-House, who received the first bachelor's degree from Rockford College in 1882.
(Copyright *Rockford Register Star*; used with permission.)

for women's suffrage in Chicago. Subsequently, McCulloch, the first woman attorney in Chicago (even before she had the right to vote), became a close friend of Mary Ashby Cheek's and served on the Board of Trustees for Rockford College.

The close ties among women's colleges during the nineteenth and early twentieth centuries also directly linked Rockford College to national women leaders and involved Rockford in conversations about the nature of women's rights and responsibilities in American society. In fact, during the earliest years of the college, Anna Peck Sill became quite concerned because so many of her most promising students were transferring to Vassar College. The second principal of Rockford Female Seminary, Martha Hillard, was a Vassar graduate and taught at Vassar before she took the position at Rockford. In the twentieth century, Cheek was strongly influenced during her presidency by her friend and mentor Mary Woolley, who was president of Mount Holyoke from 1900 until 1937. In 1930, *Good Housekeeping* named Woolley and Addams as two of the greatest living women in America.[20] Like Addams, Woolley was a fervent advocate for empowering women in both national and international roles. "Miss Woolley's Way" paralleled the work of Jane Addams and provided an exemplar for Cheek.

The connections between Rockford College and Mount Holyoke were strong ones. The president who preceded Cheek at Rockford, Gordon Keith Chalmers, had been a faculty member at Mount Holyoke, and by the time Cheek assumed the presidency, the colleges were strongly intertwined. When Woolley visited Rockford College in 1938 to speak at a Charter Day service, she noted:

> It is not strange that I am pop-eyed about coming to Rockford. I do not know whether President Chalmers would like being called one of my boys but at least half of your previous administration was one of my girls, and those in my audience who have been at Mount Holyoke know how large a part of the previous administration at that college is now running yours![21]

Ultimately, Cheek came to Rockford College because of the strong recommendation of Woolley.

Primarily because of Cheek's leadership and Rockford's tradition of educating women to be active citizens, Rockford College women of the World War II era recognized their responsibility to the world at large. When Lieutenant Commander Mildred McAfee of the Navy WAVES (Women Accepted for Volunteer Emergency Service) gave the commencement address in 1943, she called students to nurture an ailing world back to health. "If women from a college like Rockford fail the world in its hour of need," McAfee urged, "there

is indeed little hope for its recovery into a life of vigorous health. It can't cure itself without help from skillful, reasonable men and women who care about the ultimate recovery to strength of this, their world."[22] Women on campus responded in myriad ways.

Before the war, Rockford College's student newspaper was called the *Purple Parrot*. Distributed on campus biweekly, the paper published news from the campus and the Rockford community as well as advertisements from local businesses. But in October 1943, the name of the paper was abruptly changed to the *Vanguard*. The editors of the paper explained their decision on the front page:

> Perhaps when the *Purple Parrot* first appeared it was meant to be a parrot. . . . We decided to say in the name of the paper what has been evident on each page of our student newspaper for more than a few years—we've got a mind of our own! The student newspaper is not a bird which blurts forth occasional snatches of words that happen to be picked up from a passer-by. It is actually an organized expression of imaginative and vital thought from ever developing minds.[23]

Their decision to change the name pointed to the growing spirit and determination of these women to ensure that their voices be heard, as well as to the increasing opportunities open to them. That same year, the *Vanguard* proclaimed, "We are a college at war." Stressing the significant role that students in colleges and universities played in the war effort and recognizing the sacrifices of America's soldiers, the editors of the paper argued that

> the success of our military forces today in our fight to preserve a democratic way of life allows us to exist as a democratic liberal arts college. It is the primary purpose of this paper, therefore, to contribute in our fullest capacity toward conscious understanding of how we, as a college community, can achieve our maximum effectiveness in prosecuting the war.[24]

These young women felt a responsibility not only to the men who were fighting overseas but also to women's roles in ensuring that democratic values prevailed.

In some ways, Rockford College women were unique. On the one hand, they were educated at a college that held fast to a tradition of civic responsibility and engagement, where in and out of the classroom, students were encouraged to recognize the important relationship between citizenship and democracy. Students took the college's Pledge to Victory that followed a four-point program—"Education for Freedom. Fitness for Freedom. Skills for Freedom. Funds for Freedom"—that was much like the "Four Freedoms" called for by President Franklin Roosevelt.[25] But these women were also representative of

many others across the United States who gave their utmost to hold steady the ideals and the realities of America and its way of life, as Lieutenant Commander McAfee encouraged them to do. By no means was Rockford College alone as a women's college bolstering the war effort. Mount Holyoke joined in fund-raising, in farming, and in providing space for an Industrial War Training Program. Students took courses in military technology and collected books and knitted articles to send overseas. Florida State College for Women sent many students into the armed forces. Texas State College for Women offered a wide range of applied science courses as well as those in the social sciences. The curriculum for women at these and other colleges was geared to meet expected needs during and after the war.

We Are a College at War tells the story of the many ways that young women at Rockford responded to that Pledge to Victory during World War II, mirroring the responses of unprecedented numbers of American women. The book focuses on letters, speeches, newspaper stories and ads, personal recollections, and photographs to reclaim a history rarely told. While highlighting the voices from the Rockford College community during the war, the book interweaves these selections with national historical context and analysis in order to show more generally the ways in which young American women were involved in the war effort. Likewise, because this narration presents events of the war era mainly from a female perspective, it offers an opportunity for closer study of how war events influenced developing women's history in the mid-twentieth century. The World War II years were the next boon for women's advancement in society after the granting of suffrage in 1920, and Rockford College women provide a window into that history in the making. Finally, a central theme throughout the book is the legacy of Jane Addams, who blazed a recognizable trail of intellectual history and social change in the twentieth century.

The chapters in this book show the evolution of woman's voice from one that was secured with the right to vote in 1920 and transformed into the women's movement of the 1970s. Historians typically view the 1950s as a setback for women, as a time of previous gains being lost. Tracing the evolution of a more subtle women's movement during World War II, *We Are a College at War* suggests that larger numbers of American women than have been previously recognized continued to work toward and be empowered through a form of Jane Addams's civic housekeeping principles. Because a "culture of care" remains distinctly connected to the home and the domestic realm, historians have often disregarded it as a means of securing liberation and independence, but dismissing this powerful tool for women also suggests a clear devaluation of women's abilities and talents. This is the story told through the lives of the Rockford College community before, during, and after World War II.

Primary materials like those collected here can at times create difficulties for researchers and readers, so our research methods need a note of explanation. When our project began in the mid-1990s, alumnae were approached for oral interviews and were asked to submit materials from their days at the college during the war. We interviewed alumnae via phone and in person, e-mailed questions, and gathered responses from a survey. Many of the women we contacted generously shared scrapbooks, diaries, letters, and photographs that have helped us to supplement materials already housed in the college archives, such as past issues of the college newspaper, alumnae publications, college catalogs, and various manuscript collections. Alumnae themselves were wondrous sources with often quite vivid remembrances, which came in many snatches of communication. Fortunate for us, each class during the war years also kept a scrapbook of clippings from the local newspapers, programs and fliers for events on campus, and more. The material assembled was very powerful with an important story to share. All of these primary materials are, of course, collected in the archives of the Rockford College library.

In many ways, we deal not only with history in *We Are a College at War* but also with women's perceptions of that history and of themselves. Our hope is that the many voices brought together in this book will speak for themselves while testifying to the strength and determination of young American women who fought World War II both on the home front and abroad.

1. War Looms

When Rockford College student Elane Summers Hellmuth planned an August 1940 horseback ride to Washington, D.C., to protest conscription, the Associated Press picked up the story. Just two months earlier, after the fall of France to Germany, the Burke-Wadsworth Bill was introduced into Congress, which proposed the first peacetime draft in U.S. history. It resulted in the intense national debate that inspired Summers to take her ride. Pictures of Summers handing out leaflets for the emergency peace mobilization committee were published in newspapers across the country.[1] The captions published with the photo explained that her attorney father had referred to her as a "pink," the epithet associated with post–World War I–era communist sympathizers, indicating the controversial nature of her actions. Dressed as Paul Revere, with a three-cornered hat, Summers came to be known as "Miss Pauline Revere" as she left Chicago carrying an anti-conscription scroll she planned to present to President Roosevelt. Advanced publicity indicated Summers would be riding a white steed with a placard hung around its neck that read "Mobilize for peace—defeat conscription." She planned to ride through the streets of towns along the way, passing out candy and suckers with labels that read "Don't be a sucker, lick conscription."[2] Summers represented a new generation of women who followed politics and were vocal about their beliefs. Although some of these women came from activist families, many, like Summers, were willing to cut themselves off from their families in order to take a stand.

In many ways, Summers exemplified not only the ideals of modern womanhood embodied in women's colleges like Rockford but also the continuing difficulties for a woman who took a public stand on an issue. Over fifty years after Summers's ride, fellow student Dorothy Delman ('42) described her with praise and admiration: "[She was beautiful, but] she was interested only in

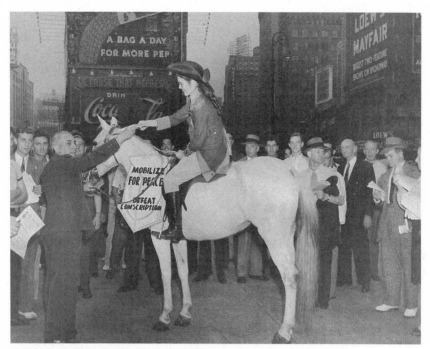

Elane Summers as Pauline Revere in Times Square, New York City.
(Courtesy of Associated Press/Wide World Photos.)

politics. . . . She . . . was very eloquent, a real leader. She had a brother who was two years older fighting in the Spanish civil war against Franco." According to Delman, Summers's ride was "the talk of the campus," but she was also criticized by a number of students for her seemingly unpatriotic activities.[3] Summers's horseback ride east also gained the attention of the national press. Newspaper reports traced her journey and indicated that she traveled primarily by bus. A wire story dated August 13 explained that when she arrived at Times Square in New York City, she received a "cool reception." One "tiny, black-haired woman" called out to Summers, "Hello Nazi. How much money are you getting from the Nazis?" Reportedly, a fight broke out in the crowd between two men who were quickly stopped by a policeman.[4]

Years later, in an interview for this book, Elane Summers Hellmuth confirmed that she reached Washington, D.C., where she presented scrolls to her congressmen.[5] Her activism, along with the emotions sparked by that activism, was indicative of the mood at Rockford College and across the country. Support of Summers's position was not universal at the college or among the general public, as the debate over conscription was dividing the nation. Protests took place in Washington, D.C., including women praying outside the White House

that the draft bill would not be passed or signed by President Roosevelt. The bill was eventually passed, after much debate and amendment, to require men aged twenty-one to thirty-five to register. When the first 18,000 men were inducted by December 1940, they mostly looked forward to a quick end to their one-year term of service. The proposed draft bill had aroused public attention, and college campuses around the country were not immune.

Summers's horseback ride also signaled a growing complication for young American women coming into womanhood during the war years. Since 1920, when U.S. women gained the right to vote, the Great Depression followed by a growing fear of war had increasingly moved American interest and involvement away from issues related to gender equality. Despite determined voices like that of Elane Summers's, the struggle of equality for American women was compromised by the war years and their aftermath. War meant that many American women worked in jobs traditionally assigned to men, and increasing numbers of women in American colleges and universities studied in traditionally masculine disciplines in the sciences and mathematics in preparation for war work. Yet despite these strides, according to historian Nancy Woloch, "the cause of women's rights, in particular, became peripheral. In World War II, women's pressure groups were pushed even farther toward the edge of public life, and after the war, the marginality increased."[6] According to most women's historians, during the twentieth century, women's equity issues, such as equal access to jobs and equal pay, were increasingly overshadowed and subverted by other concerns as economic issues came to the forefront during the Depression years and as supporting the war effort became both duty and necessity.

For young women like Summers who were coming of age during World War II, finding a voice in society and crafting an adult identity were largely shaped by war and its many complications. War certainly brought with it a broader, more worldly perspective for many young people. As Americans studied their world maps, following the lines of engagement and the boundaries of fallen states, and as Rockford College students sat in courses on the history of modern Europe, the economic history of Europe, international relations, and comparative government, young women could not help but be aware that what was happening overseas affected their lives in the United States. The media boom of the Depression years—despite the severely distressed economic situation—made war something that Americans could visualize and comprehend as never before through film newsreels at the movie theater, radio programs and news reports, and the onslaught of newsprint. Woloch argues, too, that as organized efforts for women's rights were sidetracked by issues of economics and war, the media increasingly gained control of the American woman's public image and voice.[7] Models of womanhood represented in the public media

were shaped with the ultimate goal of winning the war, and winning meant a focus not on individual gains but instead on saving the Western world, on formulating and taking part in a culture of care.

News from Abroad

For Mary Ashby Cheek, Rockford College's World War II president, international affairs played an important role in the liberal arts education of women. Cheek had pursued graduate work at the League of Nations in Geneva, Switzerland, and had also studied in England, Germany, and France. She believed that Rockford College women needed direct exposure to European scholars and students in order to fully understand wartime experiences. For this reason, she brought international speakers and student and faculty refugees to the college and encouraged student involvement with international organizations. Cheek brought the full breadth of international studies to bear so that students could grasp the political and social meanings of democracy.

Letters from other parts of the world helped Rockford College students understand how women were being affected by war in Europe and Asia. The student newspaper eagerly published letters that gave an insider's view of the war from the frontlines. One of these letters was sent by a twenty-one-year-old German woman to her American pen pal, Margaret Fillmore, whose sister attended Rockford College. Arneliese had recently married a Nazi officer, and her letter from Remscheid dated July 7, 1940, circulated through the campus in the October 25, 1940, issue of the *Purple Parrot*. In her letter, Arneliese illustrated attitudes of the German people and helped clarify what was at stake in the European war.

> I received your birthday greeting last month. I thank you very much. . . . I had waited writing hoping the war would be over. . . . You must certainly be happy with your freedom. We hope and believe most of all that our fuehrer, Adolph [*sic*] Hitler, will lead us quickly to a victorious peace. Now, since the French war has ended, and we have come to an agreement, we now go to the English, our chief enemy. . . . My husband is now fighting. He survived the French war and I hope that he will also return from England safely. The English visit us often at night with their airplanes and drop bombs from the height of 5,000 to 10,000 meters so that they don't know where they throw. They hit our civilians and houses instead of military objectives, also often hospitals and institutions. A week ago our fighters began bombarding England. We are proud of our air force.[8]

According to the news article, "the letter was censored but nothing was marked out." Arneliese believed that friendship between an American and a German

was certainly possible during a European war, which is how most in the United States saw the conflict in 1940.

Undoubtedly, the German government would have approved of Arneliese's report and views, particularly the optimism and overt patriotism reflected in her closing:

> It really isn't so terrible here. Except for an occasional air raid by the English, you wouldn't even notice that the war was going on. . . . Our fuehrer has suffered so much for us, and the whole business of the war has gone very well. I believe if you were to visit here, that you would not believe that we are at war. It is so peaceful and friendly in Germany. For me personally, everything is fine, except that I miss Gunther very much but he'll return soon. We will have conquered England in four weeks.[9]

Students who read the article heard the determination of one German citizen, which impressed upon them the seriousness of the situation in Europe. The prospect of a quick conquest of England would obviously have concerned students, especially those who had British acquaintances, but Arneliese's characterization of the peaceful nature of her life provided a stark contrast to the reports students received from other parts of Europe.

That same October issue of the newspaper announced an upcoming speech to the campus by Carl Joachim "C. J." Friedrich, a professor of political science at Harvard University who was originally from Heidelberg. In his lecture, he referred to a letter he had recently received from a friend in England that described the situation there shortly after Germany began the "London Blitz," bombing the city repeatedly for months. The letter was published in the *Purple Parrot* and gave students a view of the British side of the war. In addition, it provided the perennial female perspective from the home front.[10]

Living in Llandough, Penarth, England, Professor Friedrich's friend Peggy wrote on September 1, 1940, about the rapid pace at which the war had come to envelop the everyday lives of the people in her community. Peggy noted that although Great Britain had declared war on Germany a year previous, for the last several months, "except for the black-out and the sudden appearance of many men in uniform and women too, it was hard to realise there was a war."[11] But with France's surrender, the air raids became almost constant. Sirens announced the approach of bombers almost every night, and oftentimes raids occurred during the day as well. Without an air raid shelter at home, Peggy and her family slept downstairs as a precaution. While some similarities with Arneliese's life are evident here, the daily grind of air raids told readers of a very different experience overall.

The Germans are trying to break our morale by these raids for the bombs they drop fall on no military objectives and there have been some miraculous escapes. You can imagine for yourself whether our morale is broken when I quote [this example]. . . . We go down in our air raid shelters in the office—the men in one room, the women in the other, and one day, after an air raid, a circular was sent around saying that the noise coming from the women's room was more disconcerting to some of the older people than the fact that an air raid was in process.[12]

This sort of strength in the face of adversity inspired Rockford students just as the nation overall was inspired by British resilience during the Blitz.

War had become a way of life for young women like Peggy. She continued her letter by mentioning rationing and later discussing her sister's impending wedding:

We are rationed too—in butter, bacon, sugar, fats and tea. I miss my sugar most of all. However, please do not imagine we are starving or even hungry. Our rations are adequate and need only careful manipulation. My appetite has increased not decreased since the air raids and I have always been able to satisfy my hunger.[13]

Many who read this would have been reminded of family stories of World War I Victory Gardens and the nation's calls to sacrifice during that era. Peggy showed her frustration as well, stating, "But enough of this war—I am sick of it and I am sure you must be," and then moved quickly to describe the "long white dress of figured satin" that her sister was planning for her upcoming wedding to her fiancé serving in the Welsh Fusiliers.

At this early juncture, the division in America over the war was evident by Peggy's inquiry about American views of President Roosevelt. While Peggy noted that she was "greatly surprised to hear [Professor Friedrich's] opinion of Roosevelt," she indicated that "everyone thinks rather highly of him over here as a straight, sincere man, in fact, the embodiment of democracy, although we recognize the claims of Wendell Willkie too."[14] Asking Friedrich to "explain" why he thought Roosevelt "dictatorial enough to destroy the democracy of the U.S.A.," she questioned if Americans like Friedrich believed Roosevelt was "not enough of an isolationist" or if Roosevelt's "management of internal affairs" was the issue.[15] At the end of her letter, Peggy added a postscript story aimed at swaying the reader's view as to which nation, Britain or Germany, was the more civilized and deserving of U.S. support and sympathy:

By the way, I forgot this spicy piece of news. Over a thousand German planes have been brought down since air raids over this country began.

... These [German] pilots, only young boys about 18 years old, are terrified because they are told we, the British, will torture them when all we do is put them in an internment camp—a sort of town, guarded of course, where they cook and do everything for themselves. . . . One lot of our sailors put out to rescue a wounded German pilot and nearly had him in the boat, when another German pilot came down and machine-gunned them. . . . We don't mind them bombing us, because we bomb their military objectives, but we do not stoop so low as to machine-gun civilians like that. . . . We want to end this war quickly not waste ammunition.[16]

Peggy closed with the exclamation, "This is true C. J.—the world should know—think it over!"

Reading letters such as these, students glimpsed both sides of the war, augmenting the news in the local and national newspapers and on the radio. In Peggy's talk of bombings and shelters, they saw the strength of the British people and Peggy preparing for her sister's wedding with plenty of fabric for dresses, affirming absolute faith in the righteousness of the British cause—as Arneliese had in the German cause—and hoping to get her message to Americans. While studying such topics as U.S. entry into World War I, Rockford students were simultaneously exposed to a new war unfolding on the other side of the world. The sentiments presented in these letters illustrated the division among both Europeans and Americans, who were then considering their role in the developing international crisis. The whole world was spiraling toward war, in Europe and also in Asia with the rise of Japanese fascism matching that of Nazi Germany.

A former faculty member at the college helped to create for students a clearer understanding of the growing hostilities in Asia. In the late 1930s, Japan began to expand its influence, trying to create a "Greater East-Asia Co-Prosperity Sphere" on the model of British and other Western empires built in Asia during the previous century. An early objective of Japanese influence was China. Florence Janson Sherriff, a former professor at the college, moved to Shanghai, China, following her marriage in 1934. In August 1937, Sherriff was forced to leave the city when the U.S. State Department ordered all American women to evacuate. She wrote back to the college early in 1938, describing her return to Shanghai the previous November. Sherriff's letter was one of several printed in the *Alumna* magazine that gave the greater Rockford College community a perspective on the fighting taking place in China, including the capture of Shanghai by the end of 1937.[17] Describing the American women's return to Shanghai as reminding her "of rabbits scurrying for their holes no matter where they were," Sherriff noted as she opened her

letter that "it is a great joke between my husband and myself" that he brought them back to Shanghai just before the "last desperate finale," the final attempt to hold Nantso.[18]

The women arrived at Woosung on November 4 aboard the *President Doumer,* a French Mail Line ship.[19] Describing the two days they spent on the ship as "so peaceful . . . a bit of France itself," Sherriff explained that at Woosung they could hear distant bombing, and "the Japanese aeroplanes swooping above made us nervous." To make the three-hour trip upriver to the Bund, the women were transferred to a French destroyer that was flying a large Japanese flag "in courtesy to the Japanese who were celebrating the last emperor's birthday." Sherriff noted that "in response to our salute all the various and sundry Japanese water craft, gun-boats, destroyers, transport, hospital ships, etc., gave us a bugle call."[20] The rest of Sherriff's letter detailed the destruction that the women saw and their attempts to reclaim their lives in Shanghai.

> Woosung had been entirely destroyed. The road along the river was alive with Japanese trucks going back and forth from Shanghai. Many of the larger brick and stone buildings had been riddled with shells but were still standing. The famous Jukong wharf which the Chinese had built at tremendous cost . . . was riddled with holes but some had been patched up and it was occupied by the Japanese. One brave chimney belonging to the Chinese electric company had a hole through its middle but still proudly raised its height above the surrounding landscape. The University of Shanghai building seemed intact except for shell holes here and there. One cannot tell however to what extent looting has taken place and what is left of the library or the laboratory equipment. I have heard that the faculty homes have been quite thoroughly looted.[21]

Upon meeting her husband in Shanghai, Sherriff found her home intact, the servants waiting in the house, and the city sandbagged and garrisoned.

The following week, the fighting reached the section of the city where the Sherriffs lived, and Japanese troops were reported to be less than a mile from their home:

> The aeroplanes began to swoop around throwing bombs . . . and rattling the house until I thought the windows would fall out . . . and the shells began whizzing over our house from a long range zone over at Jessfield.[22] . . . It was awful for about an hour. Then it suddenly stopped and I felt that I had to get out of the house. . . . Now the fighting is a hundred miles away and the Japanese are steadily advancing to Nanking. Whether the fall of Nanking will mean the last, we cannot tell.[23]

Sherriff despaired that the Brussels Council failed to bring peace but recognized that "unless the powers back their words with force it would have no effect."[24] This was something that seemed lost to many national leaders, Englishman Neville Chamberlain chief among them. Yet, even with the Japanese occupation, Sherriff did not starve or suffer too terribly. She reported that "food is very high in price but it is obtainable. Cook said he thought he could get a turkey for Thanksgiving eve. And said sweet potatoes and pumpkin are about the cheapest you can buy. So things are not too bad." Although Sherriff could have sought refuge in Manila or Hong Kong after the Sino-Japanese War began in 1937, she decided instead to return to Shanghai, where she taught at St. John's University.[25]

This sort of firsthand information about early events in the war gave Rockford College students a compelling connection to the outside world, one that many Americans did not have. In large part, the emphasis on this global perspective was a reflection of the increasing interest of Americans in understanding the implications of this war on their own lives, but the fact that letters such as these were widely published on campus and in the alumnae bulletin points to the commitment of the college's administration to educate women for engagement beyond their homes. Augmenting what they learned through textbooks and classroom lectures and discussions, these connections made the role of the United States, and their role as citizens, much more significant when tied so closely to the war's events. The world was opening up for these young women because of the war that was brewing around them—whether they liked it or not.

The "Girl" Journalist

Although tremendous strides appeared to have been made with the granting of female suffrage in 1920, the years of economic depression in the United States served to push many American women back into traditional roles in the home. Jobs that were available were reserved for the heads of households, who were in most cases male. Despite this turn to more traditional roles, the 1930s saw a dramatic increase in female media figures who represented independence, strength, courage, and intelligence. According to Nancy Woloch, although the United States was suffering through the Depression, the media actually became more powerful and more prevalent in American society during the 1930s. In the midst of this "media blitz," moviemakers became increasingly more inventive in luring back moviegoers who had originally been turned away from theaters because of the economic crisis; more and more American households owned radios; and huge newspaper chains vied for readers. Large numbers of self-confident, more aggressive women were portrayed in the

media, according to Woloch: "the ambitious career girl, the gutsy entertainer, the sophisticated socialite, the blond seductress." But "leading the list" was "the worldly wise reporter."[26]

One popular example of this "worldly wise reporter" came under the headline "American College Girl Covers European War." A nationally published wire story reprinted in the March 21, 1940, issue of the *Purple Parrot* told of the exciting life of an American "girl" journalist.[27] This woman's glamorous life represented the sort of opportunity for women who increasingly sought the independence of the workplace and the allure and excitement of foreign travel. Here was an example of a woman contributing to the understanding of crucial events in Europe, matching male efforts stroke for stroke.

New York (CBS)—Wearing a trench coat, a red hat, a pair of Norwegian boots, and rejoicing because she can still get fingerwaves,[28] an American college girl, just a few years out of Vassar, is covering the most dramatic newsbeat in the world.

Roving European reporter for the Columbia Broadcasting System, Mary Marvin Breckinridge scored a real scoop recently when she drove eighty miles through a blinding Norway snowstorm (the trip took 25 hours) to broadcast a description of the burial of the German sailors killed in the *Altmark* incident.[29]

Breckinridge covered not only headline news but also human interest stories that examined the war's impact on civilians in several European countries. She traveled on skates in Holland near where "a German advance was expected" and was the only female journalist allowed to visit German prisoner of war (POW) camps to interview captured British pilots and seamen.[30]

Following a tour of Britain as a photographer, Breckinridge was invited by Edward R. Murrow, then Columbia Broadcasting's European chief of staff, to give a talk to CBS listeners; after that, she was appointed a "roving reporter" or reporter without portfolio in Europe for CBS. In a story that held particular interest for American college women, she wrote about her visit to a school for fiancées of Hitler's Elite Guards or SS (Schutzstaffel) men while she was broadcasting from Berlin.[31] According to Breckinridge, the women at the school were taught "how to read the newspapers, and [were instilled with] a certain viewpoint. . . . [Every night] the brides . . . fill their hot water bottles and climb up to their dormitories [with] neat, white, iron beds, and beside each one is the photograph of the fiancé, in helmet, cap with visor, or overseas cap."[32] The idea of this use of women's more traditional social roles for supporting the war effort was not unique to Germany, but rarely was it shown in such stark terms.

Breckinridge was a powerful inspiration to college women of the war era, exemplifying new possibilities for their own lives. Here was a young woman who traveled far from home, pursued adventure, and made a living doing it. Alongside the American young man going out into the world to find his way, especially as a soldier, new roles in American womanhood were being created by women like Breckinridge. Here was a model that women in the United States and abroad could emulate and in so doing make important contributions to the world around them. Not long after "American College Girl Covers European War" appeared, another story was published in the college newspaper under the byline "The Girl Reporter," illustrating that at least one student was so inspired by Breckinridge that she adopted the moniker. As the nation debated going to war, the idea that women could do no more than wait at home and worry about their menfolk was eroding.

National and Local Student Activism

The spirit of wartime questioning and dialogue at Rockford College followed the long tradition of Jane Addams, whose debating efforts brought Rockford Female Seminary into the Illinois Oratorical Association as a respected member. Addams's social feminism was based on the premise that educated women, steeped in a culture of caring and of understanding social needs, would lay hold of the social claim and take action in the public forum. By speaking out and organizing, college women were demonstrating the validity of Addams's ideas and ideals. A woman student from Swarthmore College in Pennsylvania summed up the formative influence of taking a stand: "The family dinner table saw heated debates between us which strengthened both my Democratic and interventionist allegiance and my ability to defend my views."[33] By expressing their convictions about the war, students at Rockford and elsewhere were finding a voice that fit their respective beliefs. War-related activities were creating a public identity for college women.

Frieda Harris Engel ('40) was at the forefront of discussions on campus concerning the *St. Louis*, a ship carrying 937 German Jews that headed to Cuba in 1937 seeking refuge from the Nazis. The *St. Louis* was ultimately turned away from both Cuban and American shores and headed back to Europe, where the passengers were taken in by England, France, and Belgium. As war spread rapidly through Europe in the following years, many of the *St. Louis's* passengers were sent to concentration camps, and over half of them perished in captivity. Years later, Engel explained how she became active in political issues as a student. She arrived at the college a day early so she would not travel on Rosh Hashanah and was greeted and taken care of by three seniors:

They took me back to their room. . . . One said, "What are we all doing here when we should be in Spain?"[34] I had known about this and my sympathies were already with the loyalists who were fighting against Franco. . . . That made for a very interesting beginning to Rockford. I found that others shared my beginning understanding for social conditions in this world, some of the injustices that abounded, and certainly what some of the coming Fascism would mean in Europe.[35]

Concern for the fate of the *St. Louis* led Engel and others to act. The students decided to propose that the college send a telegram to President Roosevelt, asking him to allow the passengers of the *St. Louis* to seek asylum in the United States. They made their proposal at the regular compulsory chapel for all students on campus:

> We had expected probably, foolishly, that there would be a quick agreement, but there wasn't, and you could hear some murmur of dissent. Mary Ashby Cheek, our president, immediately rose and saved that situation, suggested that instead of having a vote at that point that, actually, we think about it and talk about it and consider what a thoughtful response should be, and suggested that we all meet again on Saturday. . . . People argued and talked about this issue everywhere, and, on Saturday, a full turnout—the chapel was filled [and the telegram passed].[36]

After the telegram was approved, it was sent, but the boat still returned to Germany, in part because of immigration quotas. The discussions on campus point to the fact that even before Pearl Harbor, the students—like many Americans—were attentive to European problems and showed a strong desire to get involved on some level. Despite the fate of the *St. Louis* passengers, the still valuable and powerful message learned by Engel and her compatriots was learning not to give up and "that indeed the forces of decency and good will win out."[37]

In the months leading up to the outbreak of war in Europe, American students and faculty believed they could help change what was happening in the world around them. When President Roosevelt sent multiple pleas to German chancellor Adolf Hitler calling for peace in the spring and late summer of 1939, Rockford College students and faculty at a September weekly chapel convocation voted unanimously to send Roosevelt a telegram. According to a report from the local Rockford newspaper, the students and faculty commended Roosevelt for taking such a "positive action in making America a force for peace today."[38]

On other campuses across the country, sentiments grew just as high as at Rockford. As early as 1937, over a thousand students and faculty members from Vassar College reportedly participated in a peace demonstration that was part of a nationwide movement.[39] While students carried posters with slogans such as "Careers Not Conscription," "Sanity Not Slaughter," and "Scholarships Not Battleships," the teachers' union placard proclaimed, "Workers of the World, Unite for Peace."[40] In December 1939, a group of undergraduates at Princeton University formed the American Independence League, which was "dedicated to the purpose of revealing, strengthening and expressing the determination of the American people to keep out of the European war." The league claimed one-third of the Princeton student body as members and noted that a second chapter was being formed at Harvard. At the University of Pittsburgh, the Loyal Order of the Sons of Leavenworth had recently formed, with the slogan "If America goes to war, we go to Leavenworth."[41] American student activists were strongly against the United States being pulled, or pushed, into another deadly European war.

Although some Rockford students in the American Student Union (ASU) sympathized with the Republican forces opposing Franco in the Spanish civil war in the late 1930s, they and many others at the college allied themselves with student peace organizations. Pacifism was a strong part of Jane Addams's legacy, and a number of Rockford College students viewed her ideals as a model during the prewar years. Daniel Levine, in *Jane Addams and the Liberal Tradition*, explains that Addams, who headed the Women's Peace Party, viewed war as contrary to the role best suited to women: "Women were the natural protectors of human beings. . . . Women literally bore and brought up humanity. They would not sit by and see it torn apart by high explosives."[42] Quite consistent with Addams, the students heeded the dire warnings of the American Youth Congress (AYC) and were fearful of harm to those they held dear.

By February 1940, an article in the Rockford College newspaper carried a warning to students across the country from the National Assembly of the AYC that "some, under the banners of false moral issues, attempt to present the slaughter of youth as a holy crusade." History should teach lessons, members of the congress claimed:

> We have learned our lesson. Today the millions of young people of the United States of America are ashamed that there are Americans who coin the tainted money of death. . . . Here and now we solemnly renew our sacred pledge to the youth of the world; we swear that we will not rest until the slaughter of our generation is stopped.

Looking back at World War I, the AYC warned, "Once before our country

poured materials, money, credits and wasted ideals into a holy crusade; our fathers' generation was decimated."[43]

Many Rockford College students would have seen a wire story printed in the college newspaper explaining that at Columbia University, 88 percent of the school's 1,500 students opposed American participation in the war. At Radcliffe, only 3 percent of students favored U.S. entry into the war. At the University of Chicago, students placed two hundred white crosses along the sidewalks with a sign on each cross that read, "Will your name be here?" New York University students paraded in Washington Square with a coffin and a placard that stated "Youth 1940—Died 1941."[44] American students were outspoken in their desire for the nation to steer clear of another war.

Emotions also ran high on the Rockford College campus. In February 1940, one student, Mary Barron ('43), wrote in the college newspaper urging students and faculty to consider the implications of American involvement, expressing her views about the war with particularly strong feelings:

> Neither is it an instance as to whether we think Russia wrong and Germany wrong; it is not even a case as to whether or not we believe England and France right, or Finland right. It is a simple matter of—do we want our brothers, friends, sweethearts, husbands, fathers, killed? Do we want another twenty years of aftermath as these twenty years have been?[45]

Barron's opinions were typical of many in the United States.

April 19, 1940, was declared national Student Peace Day.[46] At Rockford College, program organizers presented reasons for nonintervention and collected funds for student victims of war. These actions paralleled not only Addams's approach but also the goals of the National Student Federation of America, which was affiliated with the AYC. The federation worked to bring students of other countries together for dialogue and to give aid to student victims and refugees. The result was that American students were moving from debate to action. National newspaper reports claimed that roughly one million college and high school students across the country showed their opposition to American involvement in the war with peace demonstrations organized by the United Student Peace Committee. Although similar demonstrations had been organized in past years, student participation in the peace mobilization effort in 1940 far outweighed any earlier involvement. Demonstrating under the slogan "The Yanks Are Not Coming," many American students were determined to, as they said, "live and not die for democracy."[47]

On the Rockford College campus, Student Peace Day was observed as "M Day," that is, "Mock Day." The April 25, 1940, *Purple Parrot* covered the events. Students gathered in the college chapel, where a large U.S. flag had been hung,

to sing "America" and to listen to speeches and take part in debates on U.S. entry into the war. Student Ann Ripley ('41) gave a World War I replica speech to arouse feelings in favor of conflict and to forecast what a speaker might say if the nation went to war—exactly what the day was planned to prevent. Although students in the audience responded to what they heard with clapping and some laughing "boos," their reactions were meant to reflect the intense division of emotions being felt across the country as war became an increasingly real possibility. During the day, some students entered classrooms, breathing hard, acting very serious, announcing that war was declared and giving orders of where students were expected to report, saying those without orders must go to the chapel. Above campus mailboxes, signs were hung proclaiming "censored," and newspapers were taken away. Some students went into downtown Rockford wearing "RC Peace Day The Yanks Are Not Coming" sashes and sold "The Yanks Are Not Coming" buttons. Donations for buttons ranged from one cent to one dollar with proceeds going to students in small war-stricken countries. Sales were good, and students engaged in meaningful dialogue on the momentous issues facing the nation.[48]

"Shall 1940 become 1917?" became the central question. Increasingly, World War I was viewed as a war marred by what one Rockford College student described in the school newspaper as "pettiness and false patriotism." Quoted in the paper was Charles F. Thwing, president of Western Reserve University, who claimed that during World War I, "the colleges became, like the railroads, essentially government institutions. All students who entered American colleges in the autumn of 1918 . . . became by their entrance, soldiers of the United States." While young men were called off to military duty, women's colleges were tightly controlled by government restrictions of materials needed to support the war effort. Thwing reported that college professors of the World War I era were forced to make statements such as "Anybody who says this is a capitalistic war simply does not see what is going on" and "This is no war of conquest. This is a war to unify and to free men." If they instead taught what they believed to be "right," then these professors lost their teaching positions, according to Thwing.[49]

When a former mayor of Rockford urged that German should not be taught in the local schools because it was the language of the enemy, one student responded in the college paper by asking:

> Can we, simply because we disapprove of the government of the last few years, let centuries of achievement be blacked out? Shall we, because of one man, ignore all that the people of a nation have given us? Shall we, because of one person's lack of humanity, forfeit our own?[50]

Rockford College women were not shy about expressing their beliefs, and the *Purple Parrot* was a busy forum for student voices.

Students were urged to recognize the dangers of propaganda. When a pamphlet titled *Polish Atrocities against the German Minorities in Poland* reached the campus, one student reporter was quick to point out that a reader must read with a critical eye:

> The pamphlet is crammed with statements allegedly sworn to by eyewitnesses under oath, about the slaughter, mutilation and dishonoring of German men, women and children living in Poland by Polish citizens. ... The whole thing is a conglomeration of tragedy, brutality, and stupidity too crude and extreme for most of us but unfortunately well enough done to appeal to many uneducated and unaware people.[51]

The editors of the Rockford student newspaper recommended the following guidelines:

> Distrust the accuracy of any news story which begins: "It was rumored today in official circles," "It was learned today from a reliable source that," or "According to a prominent official of the British (or German or French) government, whose name cannot be given." Do not give credence to any "unconfirmed report." And remember that a general or vague statement means either that the reporter can't learn more or that censorship is in force, and incomplete information is a very poor basis for any decision, especially one involving our national peace.[52]

Just as the U.S. government was working hard to inform citizens about the dangers of propaganda, students at the college were well aware of the intent of such materials and believed that an intelligent approach to such items would allow a reader to distinguish between reliable and inflammatory information.

As the American population became increasingly aware of the powerful tools of propaganda and public opinion, organizers of the ASU and the Committee to Defend America by Aiding the Allies quickly recognized the importance of involving college students in taking political action. Both organizations established chapters on the Rockford College campus and on other campuses across the country. At its peak between 1936 and 1939, the ASU mobilized over half of the roughly one million students who were then enrolled in American colleges and universities in one-hour annual strikes against war. The ASU also organized students to speak out on issues ranging from academic freedom and racial equality to federal aid for job programs and education.

Although the ASU was solidly behind the peace movement in the United States during the 1930s, the organization supported Republican forces in the Spanish civil war. When communists involved in the ASU forced the leadership to support the Soviet Union's nonaggression pact with Nazi Germany, the organization crumbled. The ASU collapse left a void on campuses that had once been very engaged in the politics of the times. On the Rockford campus, faculty encouraged students to become actively involved in the Committee to Defend America, as Americans came to realize the inescapable fate of U.S. involvement in the war. The Committee to Defend America, also known as the White Committee for its founder, William Allen White, opposed the actions of another group, the America First Committee, which aimed to keep the United States out of another European war by enforcing strict neutrality.[53] While the ASU eventually broke apart over the American neutrality debate, the Committee to Defend America remained unified in its advocacy of American involvement, which was limited to U.S. aid to Britain and France until the Japanese strike on Pearl Harbor.

Frieda Harris Engel, the student who initiated efforts to save the passengers on the *St. Louis*, helped to organize the ASU chapter at Rockford College and was one of the most actively involved students in the chapter. In a later reminiscence, Engel described her own interest in seeing that the ASU was an established presence on campus:

ASU students were the most active. . . . In 1940, Miss Abbott and Miss Brush[54] helped students organize the Committee to Defend America by Aiding the Allies as a reaction to the ASU. They were very vocal and even disrupted chapel, something that was just not done. . . .

. . . I thought that the ideals of the ASU were those that were familiar yet were still anti-communist. . . . I must have immediately started talking with other interested students, and in a short time we had signed up the entire faculty and student body in one fell swoop to the American Student Union. This was in 1937. They apparently were so surprised in New York when our subscription reached them that they invited me to come to New York that summer and [attend] their training school in Poughkeepsie.[55]

Engel's social and political interests came from her family's own record of activism in czarist Russia in the early twentieth century. She clearly recognized the connection between the ideals of Jane Addams and her family's work against the United States entering the war, but she was cognizant of how their otherwise nonpacifist stance was not in keeping with Addams's full beliefs. Engel remembered that

at Rockford, we had a fine time because we were carrying out what we thought were the model and ideals of Jane Addams . . . although we were not pacifists at that time. We were for the Spanish Loyalists, fighting back and trying to hold their country against the forces of Mussolini and Hitler and Franco.[56] And so there are twin ideas coming up for me: one, my interest in social work, led by the model of Jane Addams. [Through] a committee sponsored by the YWCA [Young Women's Christian Association] [we went] out to homes for crippled children. . . . So our concerns for the underprivileged or for those who were discriminated against had these two twin outlets: social work and helping and political action.[57]

Engel's reminiscences articulated some of the most significant issues facing Rockford College students and other college women. The passion with which the campus community joined the ASU is another example of how significant was the desire to have a voice on the national stage. Using the legacy of Addams, they recognized the crossroads the United States faced, and the international events placed issues of peace and justice in high relief.

Connections to the Spanish civil war through their classmate Elane Summers Hellmuth's brother energized the students to raise funds in addition to following the news of events.[58] "The cause of the Spanish Loyalists excited all kinds of creative activity at school," according to Engel. Hellmuth created a dance and other students wrote poetry intended to pattern her movements for a program that was a fund-raiser for the cause. Somehow Ambassador Julio Álvarez del Vayo, foreign minister of Loyalist Spain, learned of the program and the large amount of money that the students were able to raise, an amount even larger than what University of Chicago students contributed. "This too was an example of our passion and dedication to 'the cause,'" Engel noted.[59] Engel remembered that the conflict between peace and justice in Spain clarified the complexity of world events and illustrated the difficult position Addams found herself in years earlier over her opposition to U.S. entry into World War I. The competing notions of pacifism, isolationism, and interventionism were legitimate topics for discussion and action by Rockford College students.

In 2003, Charlotte Bode ('42) wrote the following reminiscence that described her involvement in the ASU and the general political climate on campus and in the Midwest:

As for the Student Union—the national association split, but the Rockford group so far as I remember was almost entirely against intervention and those of us who were for aid to the Allies just left. . . . I remember while I was collecting signatures having a few reproachful looks and I think two

outright reproaches, but they were really rather sad and not angry.... Of course the faculty was all quite internationalist, although they were not proselytizing.... I am sorry to say that I don't think there was a really widespread reaction among the students until Pearl Harbor.... The whole Middle West was quite isolationist and students were no exception.[60]

Many young women were facing hard truths about life and tough choices that they never expected to make about their futures.

Facing the Hard Facts of War

After a hot summer of debate, President Roosevelt signed the Selective Training and Service Act of 1940 into law in early September—on the heels of Germany's invasion of Poland and Great Britain's declaration of war on Germany—and draft registration started almost immediately. By October 1940, one Rockford College student was facing the impact of her own duties as a clerk registering American men for the draft. Mary Ann Cassiday's ('43) thoughts, expressed in a newspaper account in which she described her volunteer work for the draft board, question both the decision to require men to register and her own emotions as she recognized the fate that many of those men would face.

Cassiday opened her story by explaining the disparity between her own feelings about registering men for the draft and the headlines on the evening newspapers that read "Draft Spirit High" [61]: "The only high spirits I heard were the words of the fair, ruddy, black-suited ward boss who rubbed his grimy hands together and said, 'Shut the window. There's a draft going on in here.'" The men tried to joke with each other and with her, using lines such as "They're measuring you for a uniform already, Pete," and "If it doesn't get us sooner, it will later," but according to Cassiday, "the joking was grim, grim like the dull room, grim like the severe autumn sky, grim like the reality for those who understood—and those who didn't." The men who came in to register were from all walks of life:

Plump, rising, young party members who were given welcoming smiles by registering ward workers, smooth traveling salesmen who stopped on their way to the home office in Chicago, important young business-men looking patriotic but disapproving, hair dressers, milkmen, mail carriers, policemen, priests, professors, and then the unending line of men who worked in the factories.

"Joe Cravetta, Barber-Colman.[62] Wife's name Maria."

"Jay Langdon, 21, married three months. My wife is the one who'll always know my address."

"Merchandise Mart, Chicago. North Shore Apartments."

"Don't you want the names of dependents?"

"You'd better put me down missing fingers."[63]

Beginning at six o'clock in the morning, registration went on until nine that night. Cassiday wrote that by the end of the day, "I wanted to write but the only thing I could think of was to print GOD! in large letters on a blank sheet—but that seemed too humorous."[64]

Cassiday and others like her were faced with the difficult repercussions of society's call of men to arms, danger, and possibly death. As she closed her account of the day, her words echoed a mixture of bitterness and guilt:

> All that seems to be left to do is to ask forgiveness for the society that is forcing these men into disciplines offensive, offensive to what has always been called "civil rights," "liberty," and "conscience."
>
> To the politicians, I can give little remorse. They seem too much a part of the vicious scheme. . . . But most of all I ask forgiveness from the hundreds of other men, men who sign up because the law is made, men who take the beatings, fight the battles, and stand to lose whatever little security they have.
>
> Can they ever forgive us?[65]

While the government could more easily clothe military service in the cloak of patriotism, history, and masculinity, women felt the loss of their male loved ones most acutely. The traditional role of women to stay behind in wartime did not soften the suffering and even the guilt they felt of sending men to fight to protect homes and families. The strong desire many women had to make their own contribution to the war effort often stemmed from the sentiment expressed by Cassiday when she asked for forgiveness from the men being sent off to the horrors of war.

As in most cultures, American women had an expected role to play during wartime. The size and scope of World War II, however, was so large that it forced women into new roles in order to fill the shoes of the men gone off to fight on their behalf. For the first time, women were almost equal partners in making war, but Cassiday could not foresee in 1940 how she, and other women, might be part of the war effort. She could see only the senseless loss of life—especially promising young lives—that war would claim. While many men of draft age complied with the new conscription laws, eventually the Justice Department investigated over 300,000 suspected draft evaders; some 16,000 were convicted. In 1940, the prospect of so many men going off to war was a daunting thought for Americans, especially when war seemed avoidable still and far away.

Another young woman's reflection of her feelings mirrored those of many around her. In a letter written years after the war in 2002, sociology major Lois Pritchard Fisher ('40) remembered a talk by Englishman Hardy Wickwar, a professor of political and social science at the college. Wickwar spoke passionately about the importance of the United States coming to the aid of Allied forces by joining the war effort. His speech to the college campus on May 21, 1940, was also broadcast by a local radio station. Fisher abruptly left the talk, hoping her departure would be a strong statement against American involvement. According to another student, Fisher was "sobbing wildly."[66] "That chapel service is the one I have always regretted," Fisher wrote in 2002. "The reasons are many. I did not do it to set an example, or ask other students to follow me. I just acted as a person without responsibilities."[67]

Although Fisher's actions might now seem minor, for those times her reaction was one that would have been viewed as inappropriate for a young woman. The following passage from her letter explains her reasons for refusing to listen to the speaker and illustrates the internal struggle many Rockford College women were having over the question of American involvement in the war:

> Even when I was in high school, I read the book *All Quiet on the Western Front*, and it made me a Pacifist. . . . It made me very upset to wake up early each morning to listen to Ed Morrow on radio, capsulizing the day to day struggles and battles in Europe.
>
> Then we had a chapel service with an Englishman, who seemed to be very methodical about presenting reasons why this country should seriously join the Allied World at war. I just got up from the second row and unceremoniously ran out of the chapel. I did not even think of my leaving being such a big deal.
>
> . . . I was president of the student government at the time and I should have thought of my position and the impact my exodus would have. But I impulsively left the speaker! I believe I thought I was showing my strong feelings against the U.S. going to war.
>
> . . . Of course, I now understand why the English people desperately wanted U.S. support and, knowing more about Hitler, know why many felt we should have joined the Allies sooner than we did. . . . But at that time, I wanted only PEACE!![68]

Certainly, Rockford women like Fisher understood in a practical and intellectual way why the Allied powers wanted—and needed—U.S. support and involvement, yet they knew the sad effects of World War I. No one wanted to see that experience repeated; they all weighed the value of getting involved against the cost of lives, and many were unsure of which path to follow.

At least a dozen area newspapers ran an Associated Press story in May 1941 about a plea to Hitler that came directly from the Rockford College community. The campus chapter of the Committee to Defend America by Aiding the Allies, headed by Professor Dorion Cairns, wrote to Hitler, appealing to him to end the war that raged in Europe. Addressing the cable to "Warmonger No. 1, Berlin," the group made the following demands: "You abide by your pledged word and stop bombing defenseless women and children and open towns and cities; return all territory you have seized unlawfully and which you pledged in 1939 you had no designs upon; keep your pledged word to the German people, 'There will be no war.'" Cairns said he hoped the message would start "a national movement of all true peace-loving people." Their goal was to stop the war "at its source," for then it would "be unnecessary for our President to take additional offensive steps which may lead us into war."[69] While the nation debated the merits of war, students and professors mirrored international conversation on the subject.

Pearl Harbor and Its Aftermath

As the school year began at Rockford College in September 1941, a new class of freshmen began their college years with typical eagerness and excitement. Little did these young women know that they would become known as the "War Years Class." The Christmas dance that year was held on December 6, the night before Pearl Harbor was attacked by the Japanese. Descriptions of the dance recalled a fanciful, carefree time. "Sparkling" snowflakes and other decorations transformed the Crystal Ballroom into a winter wonderland complete with "beautiful 'femmes' and grand refreshments." One classmate reminisced that the dance was "wonderful. We all looked forward to tomorrow, but tomorrow was Pearl Harbor Day. And that changed the course of our years at college." Another classmate recalled, "I remember that horrible Sunday. Going from room to room in the dormitory with people crying, people in shock. Just too shocked to even talk about it. We all had our radios on to the same station. Life suddenly became very serious."[70]

In November 1943, a letter arrived at Rockford College telling of the bombing from a first-person perspective.[71] Jane Smejkal Tucker ('38), who sent back the following account of the surprise attack and her experiences in the several months after, kept close ties with the college. Tucker was in Hawaii with her husband, U.S. Navy ensign Richard Tucker, when the Japanese attacked. Living about twelve miles from Pearl Harbor, the Tuckers were, as Jane noted, "enjoying breakfast" on that Sunday morning, December 7, 1941, when the bombs began to drop:

In the distance we could hear the explosions of falling bombs. When we went to our front yard we could see smoke and confusion in the harbor

and at Hickam Field adjoining; too, we could see strange planes wheeling in the sky as they dodged the black puffs of antiaircraft fire. It all looked so very unreal it was impossible to become frightened.

My husband left immediately for his ship, leaving me alone with nothing to do but wait, wonder, and hope. Rumors that Sunday ran rampant: "the Japs are landing"—"water has been poisoned"—"Jap parachutists"—and so on. It was several days before we received actual reports, and these were harder to believe than the rumors.

Finally I managed to get out to Pearl Harbor. . . . [We] drove slowly over ruined roads and passed skeletons of hangars and barracks on our way to the harbor. There we saw the overturned and burning line of ships that had been, less than a week before, proudly designated Battleship Row.[72]

The attack on Pearl Harbor resulted in the total destruction of two battleships and damage to eight other battleships, three destroyers, and three cruisers; in all, nineteen ships were destroyed or disabled. More than 2,400 U.S. servicemen and civilians were killed, and over 1,100 more were wounded.

After the attack, nothing was the same, and Tucker recounted the changes for those back at the college:

The first few weeks of the war were very strange. Blackouts and curfew came at 6:00 PM every evening. We were neither prepared nor knew how to blackout our homes. There was nothing to do but have an early supper and then sit and visit with the nearest neighbor. Daytime was filled with the feverish activity of packing belongings, or helping some neighbor get ready to leave, for sudden departures were the order of the day.

Honolulu was an entirely different place. Barbed wire filled the beaches, air raid shelters and cement block houses sprang up like toadstools everywhere, and one seldom saw a man that wasn't either a defense worker or in uniform. The soldier was not in the spotlessly neat uniform of the month before, but in khaki with a gun at his side.[73]

Right away, roles for women opened up, mostly the traditional ones that Tucker reported: "Everyone worked. We made bandages, did Civilian Defense Volunteer Work, and gave Red Cross assistance." The harsh realities of wartime existence also surfaced quickly for her as their "leisure life [did] a quick about-face." She and other military wives now faced the difficulties of providing for themselves and their families in a time of rationing and shortages of both gasoline and food. Everyone, according to Tucker, had to carry a gas mask and tin helmet. "Not an uncommon sight," Tucker wrote, "was the sign in a butcher shop, 'Meat today,' with lines of people waiting their turn to buy

some." She added that without the banana and papaya trees in their backyard, they would not have had any fresh fruit to eat.[74] Tucker's account showed the fleeting nature of her situation and the shock of adjustment that came with the outbreak of war, especially for women.

The quickness with which the nation switched to a war footing is evident in the changes that Tucker observed in Hawaii. The establishment of the War Production Board (WPB) in 1942 aided the nation's ability to meet war needs through rationing, conservation, and production regulation. Tucker, like thousands of women living on the nation's coasts who geared up for war immediately after the Pearl Harbor attack and joined various war efforts near their homes, recognized that the situation changed overnight, and it demanded commitment to a new national purpose.

Back in Rockford, students were clearly shaken by the events taking place across the ocean. Ruth Ann Bates ('42) wrote years later of her memories of the Pearl Harbor attack:

> I had gone home for the weekend, and somehow no one turned on a radio that Sunday, so I returned to Rockford College in the evening without knowing Japan had attacked Pearl Harbor. When I walked into the dorm, it was the supper hour and everyone was in the dining room. I think every student radio in the place must have been on. What an eerie feeling it gave me to hear those radios echoing the war news in those deserted dorm rooms![75]

Another student, Aimee Isgrig Horton ('44), wrote the following account decades after the bombing. Her words express the frustration of Americans who suddenly felt helpless to control the world situation. Horton wrote of retreating to the school library to read a favorite book:

> *Sticks and Stones* by Lewis Mumford. . . . It wasn't the specific book, although the book was one I found very innovating, but to stay in the library, to continue to learn and work seemed to me more important because all this was in preparation for our making a contribution.[76]

Horton seemed to understand the value of her education and the role it prepared her to play. The war to come called women to do all sorts of things society never expected nor usually allowed them to do. American women, like their counterparts in Great Britain and the Soviet Union, completed their nation's war machine.

The true impact of war was slow to sink in for that younger generation to whom World War I was not a memory; it was just something they had heard

about as children. Alumna Frieda Harris Engel was in graduate school at Columbia University at the time of the attack, but the recollections of her feelings that day mirror those of many other young women. In the 1990s, she recalled that on the morning of December 7, 1941, she heard about the Pearl Harbor attack on the radio. She decided to "keep it a secret" because she was worried about her husband-to-be becoming a soldier. That afternoon they went to see a popular play titled *Pens and Pencils* at City College. In the middle of the play, the curtain went down, and an announcement was made: "War has been declared; Pearl Harbor has been bombed." According to Engel, "I was coming into shock that the world had changed. Everything would now be different." Engel remembered the attack as an event that prompted Americans to join in a unified effort against Hitler: "We knew that our lives would be forever changed. . . . It would mean that we would be part of a world war. . . . We wanted to fight Hitler. . . . We were a unified country."[77]

The national mood shifted immediately. Soon, quiet were the voices of caution and restraint. The congressional vote for a declaration of war against Japan passed with only one negative vote. The lone dissenter was Representative Jeanette Rankin (R-MT), the first woman elected to the House of Representatives who also voted against war in 1917.[78] The lopsided vote illustrated the dramatic shift in the level of war support in the nation.

In a speech at the campus chapel two days after the Pearl Harbor attack, Rockford College president Mary Ashby Cheek urged students to adopt a view that would not be commonly accepted across the nation when she emphasized that students should not become hysterical and should treat those Americans of Japanese, German, and Italian descent with respect. Fear, as President Roosevelt told the nation less than ten years before, was its own great foe, "nameless, unreasoning, unjustified terror which paralyzes needed efforts to convert retreat into advance." In fact, this was what Cheek hoped her students would avoid and combat within themselves and in their communities.[79]

On December 16, 1941, the school newspaper printed the following letter by student government president Marsha Fisher ('43) under the headline "A Plea for Intelligence and Sense" as an effort to focus students on the long road of war ahead of them:

To the Editor and the Student Body:
We've lived deeply these past days. There have been many hollow moments and a few tears. It's hard to realize and even harder to change our habits of thinking and acting in accepting this situation. We've lived our young lives under freedom, democracy, and no more war. And today we

face a different world at our own door. . . . We usually think of ourselves as the fortunate few who are able to come to college, and I know that many of you now are thinking of how useless it is to study and go about your usual tasks here in the light of this graver situation. But when I heard the term victory spoken in such bitter revenge, I realized what responsibility we fortunate few have. If we are going to have a victory with kindness and real peace, it is up to us, and those like us, in the colleges and universities of America, to be objective and scientific in our attitude towards the war and those belligerents we regard as our enemies. It is up to us to help in the activities, but what is more important, if those activities are to have meaning for the future, we must be intelligent and understanding of what is happening now.[80]

The lessons of peace and justice hit home with students like Fisher, as did a recognition that one must be involved in the war in order to have a stake in making the peace. Fisher realized that if their actions were to provide aid in the future, then for now, "we must direct our energies into useful and intelligent activity."[81] She recognized the power of involvement by women in the war effort and in the peace that they hoped would follow in the future.

In almost an instant, college students went from debating the issues of war and peace to fully preparing for the work of war in which they would engage as young adults. Their academic debates on history, philosophy, and politics were all amply illustrated in the world events unfolding around them. Alumnae connected war-era students to the outside world as it became absorbed in the war effort and helped activate Rockford College women's engagement with the needs of a society at war. Their activism fit well with Jane Addams's care ethics. Addams viewed care as concrete—not abstract—action that considered the complexities of relationships in the context of specific needs. In contrast, war was the breakdown of that caring, described aptly by Joan C. Tronto when she wrote that "a disintegrated care process is likely to result in conflict."[82] As a counterbalance, Mary Ashby Cheek saw the purpose of a liberal arts education for women as a preparation for rebuilding a postwar culture of caring in a democratic framework, consistent with Addams's view. This charge to the students to care was clearly received and understood by Rockford students. Frieda Harris Engel said years later, "It wasn't that you gave; it's that you worked."[83]

Students' feelings about the war were powerful. Much later, those emotions came out in various ways, as in the poem "Patterns" by Joyce Marsh Roos ('45) printed in the 1946 *Rockford Review,* a creative arts publication of student work:

Everywhere I look
I see patterns . . .
Old patterns of peace,
Mission bells,
And quiet inlets
Where the sea whispers
To the listening sand.
New patterns of war . . .
Bizarre, incongruous.
A mighty stream of destruction
Moving out of the harbor
And heading West.
The setting sun
Leaves an angry
Blood-red
Trail.[84]

2. A Crisis of Opportunity

At the opening of each academic year, President Mary Ashby Cheek spoke to the Rockford College community gathered in the college's chapel about goals for the year and the issues she saw at the forefront of their work together. The beginning of the 1940–41 academic year was no different, but her message seemed to carry even greater urgency, not only because of the war that was already raging in Europe and the Far East but also because of its implications for American women. In fact, Cheek used a phrase that might be totally unexpected in relation to war: she called it a "crisis of opportunity."[1] Although the United States had not officially entered the war and the bombing of Pearl Harbor was still over a year away, Americans were increasingly torn by the implications of remaining isolated and uninvolved.

Despite the negative consequences of war, educators like Cheek came to view World War II as an opportunity for young women not only to take more active roles in serving their communities but also to recognize the importance of understanding the political and cultural workings of fascism, racism, and religious intolerance. Noting that even in medium-sized cities like Rockford, "racial intolerance . . . is said to have increased sharply from 1938 to 1940 [more] than at any other time," Cheek called for Rockford students to abide by four guiding principles that she hoped would shape their college lives and their futures:

- Cultivate a sense of perspective and power of analysis.
- Strive to aid needy students and refugees deserving of our help.
- Maintain a sense of tolerance and respect for racial groups, political ideas, and religious beliefs other than our own.
- Cultivate democracy in our ideas and group attitudes.[2]

This guidance from Cheek was aimed at making her students better citizens. Some historians have suggested that the roots of the 1970s women's movement can be seen in part in the efforts by women of the 1940s to rally against prejudice and intolerance. In effect, Cheek's list of goals looked back to the traditional expectations of women as caretakers but, more important, it looked forward by emphasizing the role of women as intellectuals schooled in understanding the world beyond the home and as full participants in struggles against injustice in American society and abroad.

Cheek's view of education bore a striking similarity to Jane Addams's. Both championed a liberal arts education, believing that greater breadth added to greater adaptability, especially for women, and both believed that history, the arts, and the social and natural sciences were essential in educational classes and activities. Addams saw Hull-House as an applied university: "The ideal and developed settlement would attempt to test the value of human knowledge by action, and realization, quite as the complete and ideal university would concern itself with the discovery of knowledge in all branches."[3] At Hull-House, where women were the chief educators and largest group of students, courses, debates, and activities were all designed to address particular social needs. Addams was also a charter member of the National Association for the Advancement of Colored People and of the American Civil Liberties Union. She believed that education provided the resources for women to bring about political and social changes, which in turn enabled them to realize their full potential. Cheek saw her work as following this tradition, as she noted in her address to the 1941 conference of the International Student Service at Rockford College: "We are neither wholly bespectacled nor withdrawn in an ivory tower from the life of the world."[4] Addams promoted community action on behalf of immigrants, disenfranchised classes, women, and children. Cheek emphasized the importance of helping refugees and sharing in the work of reshaping the postwar world for democracy. There was more than enough work for educated women to do.

Other colleges were promoting education for women in a similar vein. The president of Coker College, a woman's college in South Carolina, urged the South Carolina Association of Colleges to further the education of women and "to put new emphasis on social sciences and develop intelligent and practical individuals who understand the issues that are shaping their lives. Education should help women to evaluate the ideals of democracy in order to save what is worth saving and to develop non-military techniques for defense of democracy."[5] Texas State College for Women, praised by the U.S. Office of Peace Administration as "the nation's model wartime educational institution," offered a wide range of applied science and social science courses all projected to meet needs during and after the war.[6]

A chain of influence linked Addams and Hull-House women to Rockford College. Addams greatly influenced, and was also influenced by, women connected with Hull-House, many of whom went on to accomplish substantive political and social changes. Ellen Gates Starr and Mary Kenney were active in forming labor unions for women, and Florence Kelley worked against sweatshops and promoted child labor laws. When Cheek accepted the college's Jane Addams Medal, she urged alumni (by that time both female and male) to "re-educate" themselves about Addams in order to follow in her tradition.[7] The students at Rockford College during the World War II years emulated not only Cheek but also Addams. Frieda Harris Engel reported that "the image and model of Jane Addams is what really inspired us . . . to the commitment to social action."[8] The chain of influence had numerous links.

Remaking the College Woman

In many ways, the American population at large also came to recognize the war as "opportunity." Historian Allan M. Winkler explained that "most home-front Americans . . . shared a feeling of well-being that had been missing a decade earlier."[9] While the Depression years forced many young people to delay marriage and starting a family, the war brought jobs, the baby boom, and in many ways a better way of life for Americans on the home front. Despite the rationing of products ranging from rubber to sugar, Americans had jobs, and morale was high as they focused on their common goal to win the war. According to Winkler, "by the middle of the conflict, nearly seven out of ten people in the United States said they had not had to make any 'real sacrifices' as a result of the war."[10] Over 400,000 servicemen and servicewomen died during the war, but the loss to the United States in human lives was far fewer than the numbers of civilian and soldier deaths suffered by other countries. The Soviet Union lost 18–20 million people, China over 10 million, Germany almost 7 million, Japan 2 million, and Great Britain almost 400,000 citizens during the war. U.S. territory was bombed at Pearl Harbor, but Americans on the home front did not suffer under occupation as did the French, the Poles, the Chinese, and many others.

"Opportunity" for Americans also meant increased responsibilities for American women. Growing numbers of women on the home front ran households because their men were off at war, and large numbers of women moved their families to urban areas where jobs in war industries were available. Many of those jobs took women out of their traditional roles and into defense plants as they left their children in day care and donned pants and work shirts or even coveralls and uniforms. Women's opportunities beyond the home were increasing so rapidly that Margaret Mead told in her essay "The Women in the

War" of young men fighting overseas who worried that when they returned home, they would find the rumor true that American women were smoking pipes.[11] Young women also had greater opportunities to attend colleges. As Constance Warren, president of Sarah Lawrence College, located in Bronxville, New York, explained in her April 1944 President's Report, greater numbers of women were able to enroll at Sarah Lawrence because larger numbers of families were not paying to educate their sons, more money was in circulation and few luxuries were available, and more and more Americans were coming to recognize the significance of educating women to be self-supportive in "an uncertain world" and to engage in the important work of bettering that world.[12]

Women's education during the war years understandably came to offer greater opportunity and flexibility. Because vast numbers of American men were serving in the armed forces, colleges and universities across the nation saw a drastic decline in male enrollments and decreased numbers of male faculty. Rockford College lost not only male faculty to the service, including Meno Lovenstein, who taught economics and political science, but also female faculty and staff members such as Mary Bragington of the classics department and Louise "Billie" Wilde, director of the college's public relations office, who both served as WAVES. The depleted numbers, however, left room for more women to take advantage of opportunities in higher education. Although high numbers of women chose to work instead of attend school, the years 1941–45 offered what Susan M. Hartmann calls "the brief promise of greater educational equity."[13] Increasingly, young women were encouraged to enter fields once dominated by men. Historian Barbara Miller Solomon explains that "sweeping changes in opportunities during World War II fed the educated woman's sense of new choices within her grasp, waiting to be seized."[14] At least for the years of war and national emergency, the curriculum at American universities and colleges offered what Solomon describes as "opportunities that seemed to belie sex labels." Although fields such as engineering and the hard sciences were not yet freely open to women students in the 1930s, "the war overturned this educational block at the training level."[15]

In many ways, what was happening in American education was similar to what was happening in the American media. Just as the Office of War Information re-created the image of the American woman by encouraging women to leave the home for the workplace, American educators increasingly worked to remake the woman college student. The goal at many colleges was to transform and expand traditional female education in areas such as literature and the arts, teaching, and nursing into more traditionally male-focused disciplines such as the sciences and mathematics. Of course, while many administrators and faculty in higher education attempted to create new opportunities for

young women because of the necessity of educated war workers, others like Rockford College's President Cheek saw the need to reconstruct the education of women not only to support the war effort but also to groom women for a new role in the postwar world.

In fact, Cheek had an overarching philosophy that she referred to as "realistic idealism," that is, a belief that women could make a worthwhile and lasting contribution to world peace, democracy, and human rights, even while confronting the hard and destructive conditions that existed during World War II.[16] As early as 1938, Cheek urged Rockford College students to work for peace and to meet the challenges of the world crisis without giving up. She charged students with the task of taking up the cause of peace in a speech she made on campus: "There is no achievement without long struggle and development. There is a need for builders who will lay their stone without becoming tired."[17] This spirit of action reverberated through the college. One student outlined seven ways that human rights activism could be implemented within the microcosm of college life. The student International Relations Club sent delegates to conferences to consider the tasks set before American college youth. The college debating team argued the pros and cons of U.S. isolationism. The college's League of Women Voters chapter ranked first among other college leagues in Illinois on their knowledge of the Neutrality Act. Students and faculty met together out of class to discuss pressing issues of the day. So visible was this combined love of learning and of active involvement that in an issue of the *Purple Parrot*, a 1939 visitor to campus wrote about Rockford students: "Efficiently and happily 300 women solve the problems of life and living while they pursue the wisdom of the ages."[18]

As students gathered for a Victory chapel service on October 23, 1942, to hear details of a civilian defense program, President Cheek encouraged them to think beyond their tight-knit college community singing in the chapel to a much broader worldview. Cheek believed that those who attended college had the opportunity to take up the important task of becoming leaders in bringing the war to an end and in looking toward the postwar world. Pointing specifically to the League of Nations as a model, Cheek explained, "There is a job for each of us in carrying on the fight for freedom." Students signed the Victory Pledge, committing themselves to a covenant with "all people in all lands who are going our way," according to Professor Mildred Berry, who also spoke at the service. It was "a constant reminder that the battle for freedom must be won every day by everybody in every country."[19]

Drawn up by the college's Defense Council, a committee composed of two faculty members and three students, the Victory Pledge outlined four goals for those who signed the pledge as a way of giving students "a compensatory

feeling of usefulness in the tremendous struggle—of steadying the shaking world around us."[20]

Education for Freedom: An affirmation of faith in the liberal arts tradition, the members of the college community pledge themselves to try to understand the past and the present and in the light of that knowledge to build the future so that all men may truly become free, to preserve the best of our cultural heritage in art, letters and science, and to create in themselves and in others the proper national and international attitudes for peace.

Fitness for Freedom: Recognizing that the maintenance of good health is the personal responsibility of every individual, the college community pledges itself to a regimen of regular exercise, regular sleep and balanced diet.

Skills for Freedom: Skills for Freedom considers long-term planning for participation in the reconstruction as well as immediate participation in the emergency. Besides pledging to consider seriously training themselves in one of the professional fields in such critical need of workers, the students agree, time permitting, to prepare themselves in an emergency skill.

Funds for Freedom: The entire community is doing its utmost to buy War Bonds and Stamps and to contribute to relief causes. The students have brought all other fund raising, except for the Red Cross, under one head, with the establishment of the Student Fund. Out of this, at the end of the year, will come the room and board of the refugee student, whom the students have made their personal responsibility for the past two years. The rest of the money will be apportioned among other charitable causes—Chinese Relief, Russian Relief, Foster Homes, etc. Each member of the student body has pledged to give at least the minimum of ten cents a week and many have subscribed more.[21]

Students were encouraged to ask themselves the following question before they signed the pledge: "Does the winning of this war mean enough to me to contribute wholeheartedly?"

Cheek's opinions and goals were shared by many educators across the country. At Sarah Lawrence College, President Warren wrote in her December 1942 President's Report, "Never has there been a moment in the world's history when so many doors of opportunity were open to women or so much assumption of responsibility was expected of them."[22]

Role Models

Prewar discussions concerning women in higher education were complicated ones. Although many women attended coeducational colleges and universities, the leaders in promoting a "liberal education" for women were in the women's colleges, including the "Seven Sisters": Mount Holyoke, Vassar, Smith, Wellesley, Bryn Mawr, Barnard, and Radcliffe colleges. Rockford Seminary was founded upon the ideals of Mount Holyoke, in particular, and became known as one of its "daughter seminaries." The Seven Sisters colleges remained so significant in women's education in the view of young women who attended Rockford Seminary that Anna Peck Sill, first principal of the seminary, worried about Jane Addams's strong desire to attend Smith College. These concerns contributed in part to Sill's drive to transform the seminary into a college.

The oldest of the Seven Sisters, Mount Holyoke took a principal role in the education of women in the first several decades of the twentieth century in large part because of its president, Mary Woolley. Beginning her presidency in 1900, Woolley served for thirty-seven years, one of the longest presidencies in American higher education history. Only thirty-eight years old in 1900, Woolley was also one of the youngest college presidents of her time. Her presidency brought dramatic increases in the Mount Holyoke endowment and the number of buildings on campus, and her work in faculty and curriculum development was highly praised. Increasingly interested in taking an international perspective, she was the only woman delegate to the 1932 Conference on Reduction and Limitation of Armaments in Geneva, Switzerland.

At her presidential inauguration, Woolley not only reemphasized the college's focus on service to society but also maintained that women's education need only be supported by arguments for women's intellectual development. Women were capable of entering any field, she believed, and if they had not done so already, it was because they had not had the training available to them for the job. Woolley firmly stated in her inauguration speech her belief that "the time seems not far distant when it will be conceded that the ability to master certain lines of thought is a question of the individual and not of sex."[23] When she stepped down in 1937, she was replaced by Mount Holyoke's first male president. The reaction to a male president was strong from alumni and students alike, and Woolley refused to ever return to the campus.

Mary Ashby Cheek taught history at Mount Holyoke in the 1920s and served as dean of residence at the college from 1931 to 1937. After her move to Rockford to assume the college presidency, she kept in close contact with Woolley. As a trustee and honorary trustee at Rockford College during the war years, Woolley often visited the campus. In late February 1940, she was

invited to Rockford College for Charter Day, to celebrate the founding of the college and to help lay the cornerstone of the new library. In a speech that placed women's roles within the context of war in Europe and the Far East, Woolley explained that with the complexities of the "human problem," and with the backdrop of the modern world of industry and technology, "women as women have a peculiar contribution to make in the solution of this problem." Noting that women have "more interest in human relationships than men," she argued that women, in fact, have "more experience in solving problems of human relationships":

> That familiar refrain of "Go, ask your mother" has left its mark on the feminine side of the household. Human difficulties, the clash of human temperaments and interests, the need of adjusting human claims, reconciling human points of view—is not the ability to do that, just what is needed among classes and races, nations and inter-nations?[24]

Woolley believed that a liberal arts education was a necessity for women "in every walk of life," for even those whose work is in the home or through social organizations such as the church and clubs have "boundless opportunities for influencing other human lives." "Let them be thoughtful and well-informed if they wish to serve our democracy," she explained. Women should not be limited in their education just because they are women, Woolley argued. Instead, they should have an exceptional education because they are women.[25]

The strengths and abilities that Cheek saw so prominently in the work of Woolley at Mount Holyoke no doubt informed her own presidency. Cheek had social brilliance and charisma that endeared her to faculty, staff, and students, while her confidence, optimism, and sheer physical stamina had a contagious and inspiriting effect in generating action. The students had a deep respect and lasting affection for Cheek, and a number of college songs were written about her. The following verses praise her indomitable spirit:

> She took some young ladies walkin'
> Thirty miles or more
> They dropped by the wayside exhausted
> Their feet were weary and sore.
>
> Our Mary was fully indignant
> "Arise girls," she then did implore
> For she was as fresh as a daisy
> And could have done thirty more.[26]

The guiding force of Rockford College during the war, Cheek created a presi-

dency endowed with qualities such as encouragement, passion, strenuous effort, and excellence.

Cheek came from Danville, Kentucky, a small town outside of Lexington where her family had been leaders for generations. Her grandfather was the first academic head of the Kentucky School for the Deaf; the story passed down through the family told of him riding his old white horse to Hartford, Connecticut, to study deaf education. Her father was treasurer and a trustee of Centre College in Danville and a mainstay of its financial strength as an institution. Mary Ashby had multiple strong models in her family for leadership and education. She carried on the tradition of being a distinguished educator, but she was exceptional in her interest in international affairs. Between the two world wars, she pursued a doctorate in Geneva, Switzerland, at the League of Nations and also studied in Munich, Paris, and London before her tenure at Mount Holyoke. After her retirement from the Rockford College presidency in 1953, she taught at Kobe College in Nishinomiya City, Japan, a women's college founded in 1873 by two Rockford women, one a Rockford Female Seminary graduate. It was this interest in being a citizen of the world that fueled Cheek's broad multinational focus at Rockford College during the war.

Cheek's resounding theme was that hope for the postwar world rested on democratic ideals that would foster respect and goodwill throughout the world, and she stressed again and again the key role women would play in building this world, especially women who had benefited from a liberal arts education. In an address to the Rockford College class of 1941, Cheek said, "A liberal arts education, paradoxical though it may seem to some people, is the best preparation, I firmly believe, with which to meet the world of 1942. With your major intellectual interests well-defined and with your well-rounded personal growth . . . you have a discipline of mind, a breadth of interest and outlook and a vocational adaptability in a rapidly changing world."[27] World awareness, democracy, and education were the highlights of all her speeches. In a talk at Beloit College in 1943, she stated:

> It is a great moment in history, as we fight to combat that revolution of nihilism which fights against truth, integrity, fair dealing and the dignity of man. The war, however, is only the beginning and not the end of our effort. We must recognize that an exacting task lies ahead but at the same time remember the terrific cost of this war and determine to go ahead and build an open mindedness and generate good will.[28]

In effect, Cheek saw involvement in the war not only as a means to restore democratic ideals but also as a way for women to advance their efforts toward equality.

Cheek brought many women speakers to campus during the war years knowing how their stories and achievements exemplified her belief in the power of women's education. In January 1944, for example, Florence Janson Sherriff delivered a series of lectures at the college about her imprisonment in a Japanese internment camp in China and her repatriation to the United States. After initially escaping them, Sherriff was interned by the Japanese in February 1943 and held for seven months.[29] On December 1, she returned to the United States aboard the *Gripsholm*, an exchange ship that carried 1,223 American repatriates home from China.

When Sherriff spoke at the college soon after her return to the United States, her lectures were closely covered by the student newspaper. Her talks about her experiences in a Japanese internment camp drew overflow audiences. Sherriff told of the "farewell parties" given by her Chinese friends, the warm clothing that others gave her, and her friends' anguish over the internment of an American woman in a Japanese camp.[30] The connections Sherriff made with her Chinese friends echoed those made by Rockford College students with refugees attending the college and with several Japanese American students who were released from American internment camps in the West to attend Rockford College. Describing Chapei, where she was held, as a "primitive place," Sherriff explained that the prisoners mostly ran their own lives in the camp.[31] Located on a former campus of greater China University, the camp of two large buildings was situated on a desolate ten acres.

Sherriff shared a room with twenty-seven other women, whom she described as ranging from "derelicts to missionaries." Prisoners were each allowed two trunks, two suitcases, and a bed with bedding. Because camp conditions were well known outside the camp, interned Americans were advised to bring food with them. According to Sherriff, the food that Americans brought into the camp lasted three or four months. A typical camp menu included bread and tea for breakfast, a tiny piece of fish and a vegetable for lunch, and vegetables cooked in water for dinner.[32] Male prisoners built benches and better living quarters for all those at the camp. "Their pride was the construction of showers with hot and cold running water," Sherriff noted. The facilities had limited medical and educational facilities or equipment for the 1,100 prisoners. Despite the improvements the prisoners were able to make, the routine weighed heavily on them. "I found myself getting a great release from the clouds," Sherriff said. "I used to watch the clouds a lot—and the birds flying about." Like the other internees, Sherriff was envious of the birds and their freedom to fly where they chose.[33]

The strength of women like Sherriff was exactly what Mary Ashby Cheek wanted to instill in her students. Cheek wrote in a 1936 article for the *Journal*

of Higher Education that "the ideal of a liberal education" is "to enrich the life of the individual and to prepare him through intellectual discipline for able and effective group living."[34] For young women of the war era, that meant understanding the implications of the war around them through the eyes of those who had experienced the war like Sherriff. Cheek fostered goodwill and open-mindedness at Rockford College. Essentially, she created a community on campus where everyone had "a chance to understand better the meaning of 'One World,'" as she put it.[35]

College presidents such as Woolley and Cheek recognized the value of models of womanhood who represented the possibilities of education for the new American woman. As more and more American women studied in the college classroom, increased numbers of women joined the faculties of colleges and universities across the country. One study estimated that at the largest of the women's colleges in 1940, roughly 75 percent of faculty members were women.[36] Although the new model of American womanhood still clung to traditional values of decorum and female beauty, it also represented higher standards in education and more significant social responsibility.

"War Adjustments"

Across the country, colleges and universities responded to the war with changes to their curricula and in the ways their courses were taught and administered. In May 1942, President Warren of Sarah Lawrence College reported that "psychology courses train students to care for children in times of stress and particularly in nursery schools where women may leave their children while working in war industries. Students in the social sciences are being prepared . . . for positions as junior economists and statisticians." Courses such as Science in Wartime were added. As war demands shifted, courses in nutrition and first aid gave way to others in occupational therapy and "hospital recreational work."[37] At Texas State College for Women, new courses were offered in "the geography of the war, meteorology and navigation, bandage rolling, radio, and group discussion and leadership." Students there were also able to take classes in nutrition to help train them for work as army dietitians.[38]

The need for skilled war workers also encouraged many colleges and universities to offer accelerated programs. The May 1943 President's Report for Sarah Lawrence indicated "it was evident that this coming shortage [of young people with a college education] was a source of worry to the large war industries." Summer sessions became a necessary way for students at Sarah Lawrence to fulfill degree requirements more quickly.[39] Students across the country were encouraged to continue their studies in the summertime so that they might graduate in three years rather than the usual four and enter the workforce as

quickly as possible. Some state boards even decreased the number of weeks required for a semester in order to accelerate the graduations of potential war workers.

The *Rockford College Annual Catalog* for 1943 clearly enumerated the "Wartime Adjustments" at the college. The core of a woman's education at Rockford, whether she graduated with a degree in English or nursing, was the liberal arts program. Firmly believing in their responsibility to help preserve Western culture and civilization in the college's curriculum, liberal arts colleges like Rockford focused courses "to make more evident to the student the nature of our civilization, with its roots in the past, and its expression in the literature, arts, science, and social conditions of today."[40] Along with a work-study plan for students interested in working for three days a week in war industry and three days in the academic classroom, the college also offered a defense council program and an engineering program for newly enrolled male students.

The ultimate goal of coursework at Rockford was to encourage students to recognize their place in the world and their responsibilities to that world. In one new course for entering 1943 freshmen, students examined the ways in which information about the war was presented to the American public through media such as newspapers, radio, and newsreels. Courses in the literature of Western civilization explored "ideas of the just state and the just man" within the texts of ancient Greece and the "rebirth of the spirit of order, social consciousness, and freedom" in modern texts by writers from William Shakespeare to Edmund Burke.[41]

The courses were designed, according to the college catalog, as a way "to make clear the meaning of the world crisis in the light of the past and to afford an awareness of our inherited civilization, its achievements and failures, and the danger in which it now stands." In a course offering called "Our World of Today and Tomorrow," sophomores at the college focused more specifically on students' future responsibilities to the democracy in which they lived and on problem-solving related to the needs of the postwar world. New courses included Education in a Democracy, Problems of Government and Economics in Contemporary America, and Russia and the Near East. During their junior and senior years, students took courses focused specifically in their majors. Better able "to understand and carry on the tradition she has inherited" because of her focus on the liberal arts, a Rockford graduate was expected "to do her part to solve the challenging problems of a democratic society."[42]

Due to the needs of war, college women were also encouraged to pursue studies in math and science because of the growing need for persons trained in those fields. Descriptions of the coursework appealed not only to students' sense of patriotism but also to the increasing desires among women to seek

employment outside the home. One admission brochure from Rockford College proclaimed:

> If you're a girl in search of a career—and are that rare [sic] avis (Latin for rare bird) who actually likes science and math, then your career will practically up and take you by the hand. You'll be as popular as a deb at her coming-out party. Everybody will want to give you a job. Hospitals, laboratories, aircraft companies, government, and business will all clamor for your services, and your ego will rise like dough in a hot oven.

Although the wording of this call signaled new freedoms for women, the reminder of women's sphere was as close as the rising "dough" that the appeal conjured. In effect, science and math were feminized for the wartime "deb."[43]

Even though a premedical program had long been a part of the curriculum at Rockford College, an expanded nursing program actually became more popular among the student body. Described in National Nursing Council for War Service materials as "war work with a future," nursing gained huge numbers of majors in higher education across the nation as nursing schools located in hospitals found that the demand for nurses far outweighed their ability to graduate students. The first collegiate program in basic nursing opened at the University of Minnesota in 1909. Although numbers of nursing programs dramatically increased during World War I, by 1942, over a hundred American colleges and universities were in the process of developing programs or already had programs in place.[44] The nursing arts department at Rockford College graduated its first major in 1945, with a required two years of science and psychology in Rockford and three years in the nursing school at Evanston Hospital, located in the Chicago suburbs. Even studying to be a nurse meant a woman was helping to do her part for the war effort because in doing so she helped release a nurse for war service.

War also brought greater concern for physical health within the American population. As a result, physical education classes took greater prominence in college curricula. Compared to today, the requirements for physical education at Rockford College before the war were much more intense: all students had to complete four years of physical education and a course in hygiene. With the war, physical education became a focused program at the college with a minor offered to students interested in teaching in the field. The college catalog described this new program as a response to a "national demand for physical fitness" that "will require hundreds of carefully trained leaders."[45] Fitness was seen as an important way of fighting against the Axis powers, in large part because a firestorm brewed when large numbers of American men failed the physical standards for entrance into the military.

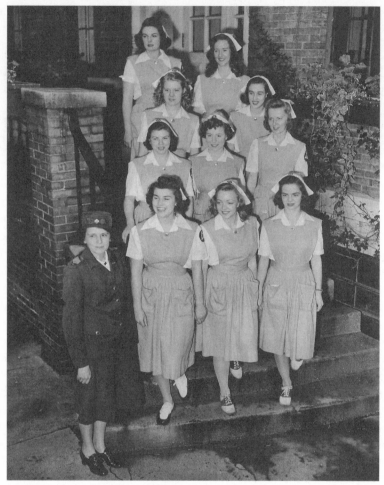

Student nurses at Rockford College.
(Copyright *Rockford Register Star*; used with permission.)

While many women bristled against notions of occupations appropriate for women, the demand for workers in traditionally female fields, such as home economics, child care, and secretarial work, was high. Although some leaders among the women's colleges, such as Mary Woolley, believed that home economics was an outdated program of study at a woman's college because of its limited focus on the domestic setting, the focus of home economics programs was increasingly shifted into coursework more practical for the war. Nutrition, for example, was promoted as "a major factor in total war." Rockford's catalog described an "unusual need" for persons who were trained in nutri-

tion, dietetics, and institution management. Secretarial Studies at Rockford College included training in typing, shorthand, and "office practice," skills that offered young college women "unusual opportunities in Civil Service, in business, and in industry."[46]

While large numbers of women's colleges like Rockford became coeducational institutions in the postwar years because of financial needs and the dramatic increases in the numbers of males attending college, the first men to attend Rockford College actually enrolled during the war years. Because of the increased need for skilled male workers such as engineers, the college developed a mechanical engineering program with the Illinois Institute of Technology that started in 1942. Students in the program studied their first two years at Rockford in a liberal arts program and the last three years alternating semesters between work at Illinois Tech and in local industries. The reactions to males on campus by women students seemed to be insignificant, probably in large part because the students were seen as an important part of the American effort to win the war. Following the war, the college returned to its women-only status until 1955, when the college officially became coeducational. Increasing numbers of women's colleges began to admit men during the 1950s, largely because of the needed revenue produced by higher student enrollments created by the addition of male students.[47]

Probably one of the most significant ways in which a Rockford education promoted a woman's independence and her ability to take an active role in her community was through the emphasis on self-government at the college. The honor system at the college was administered by the upperclassmen. Rather than faculty members policing for plagiarism and cheating, students agreed to hold themselves and their fellow students responsible for ensuring academic honesty. Students sat on the judicial board that made decisions concerning student infractions, which were rare. Likewise, student government became an important part of the "practice of citizenship" as students put into practical use what they learned in the classroom about the nature of government. The ultimate goal of self-government was to prepare the student for "a full and fruitful personal life and for trained and responsible service to her country."[48]

Although the war was an ever-present part of life for American women on the home front, Mary Ashby Cheek recognized that the distance of most American women from the battlefronts also kept them from understanding the true nature of the suffering of European citizens held under Nazi control and of the men on the frontlines. While the media of newsprint and radio were increasingly prominent tools for communicating information to the public, community lectures and rallies played significant roles in educating the public about the nature of war and what citizens could do to help the Allied efforts.

When Florence McDuffe Nevin spoke on campus in October 1942 in a lecture open to the Rockford community, she told of witnessing the German occupation of Paris. Nevin, whose mother attended Rockford Female Seminary in the 1860s, toured Europe with her daughter, a Red Cross ambulance driver during the war, and her son, an Associated Press correspondent. A story published in the college newspaper described Nevin helping to care for starving refugees and driving an ambulance "in and out of a Nazi concentration camp."[49] Nevin's account of the camp's conditions was compelling before the world truly knew of the Holocaust, yet her story also conveyed a lesser imagined side of the enemy.

"In these camps," Nevin explained, "the people are living like animals out in the open, exposed to all kinds of weather. They contract terrible diseases, have very little food, and only their old uniforms as clothes." According to Nevin's account, she carried carloads of food into Nazi concentration camps, which were situated in old stadiums or race tracks, and brought out "load[s] of sick people." She also described for her audience the severe punishment allotted to Nazis who broke the law, referring specifically to one Nazi youth who took a French woman's purse during a blackout. He was shot and killed. Nevin indicated that "the discipline is extremely harsh and cruel, their aim being to try and convince the French people that the Nazis are really their friends. All Nazi soldiers are given very strict orders to treat the women and children with firmness and yet courtesy."[50]

Visitors like Nevin were frequent on the Rockford campus. Alumnae of the college and their family members not only wrote frequently for the alumnae publication, telling about their war work and what they had seen of the war firsthand, but also visited the college and spoke of their experiences. Without the tremendous flood of information that came from television broadcasts of later decades, Americans of the 1940s were more apt to attend lectures and join in community discussions about the war and its implications.

To many college students, both at Rockford and across the country, carrying on with their studies must have seemed at times inappropriate and certainly incongruous with the war raging throughout the globe. One student, Patricia Talbot Davis ('45), wrote years later of her initial reaction to her studies when the world was at war:

> Somehow Wordsworth and Racine, Kant and Keyes seemed irrelevant. Mary Ashby Cheek was a calm but formidable presence, convinced of the importance of liberal arts even during wartime. And she was right. Freedom to study in a safe, tolerant environment was a luxury among the many we enjoyed that so many others did not.[51]

Rockford women like Davis came to recognize that an "Education for Freedom" was not just an education that was isolated in a classroom. Instead, that education and the "Skills for Freedom" that Rockford students valued so highly were actually working models for active citizenship.

The "Earn and Learn" Program

The work-study program at Rockford College, called "Earn and Learn," provided students with a way both to pay for their education and to support the war effort and laid claim to being the first of its kind at any institution of higher education in the United States.[52] Students attended class for three days a week and worked three days a week at a Rockford company, Woodward Governor, which produced governors, a part essential to controlling the pitch of an airplane propeller. Women in particular were needed for the production work at Woodward because making precision parts for airplanes called for the delicate attention that women were believed better able to provide. Work at another local factory followed soon after.

In a November 7, 1942, article titled "Women in War Work," the *Chicago Tribune* noted that to an outside observer, Rockford College and its women seemed very far from the realities of war: "The historic old buildings, the handsomely appointed library, the ancient oaks on the 12 acres of the Rockford College campus along the meandering Rock River—all this seems remote, indeed, from war and war production. Yet the city of Rockford is not only an industrial center but also the location of Camp Grant. . . . Rockford College, alma mater of Jane Addams, appears to have found another means of training women for service."[53] Describing the women's work at Woodward Governor, the *Tribune* story explained that students' vocabularies were rapidly expanding to include words such as "micrometers, indicators, scales, plug gauges, comparators, ball-cups, elbows, ball-arms, and studs." "To most of you," the reporter wrote, "these words may mean anything from trigonometry to top-hat and tails," but to "the Work-Study girls at the Woodward Governor Company," the words identified the instruments and parts involved in their important war work as inspectors of airplane governors.[54]

The *Tribune* writer was quick to note the significance of the governor in war: "On every fighting front the governors are doing their part. . . . Battleships, cruisers, destroyers, P-T boats and submarines equipped with the Woodward governor were in the American naval victory at Midway. The governor is on its way up the road to Rome, and it is flying high over the Japanese-held isles in the Pacific."[55] Detailed information about the students' activities directly connected them to other war workers across the country as

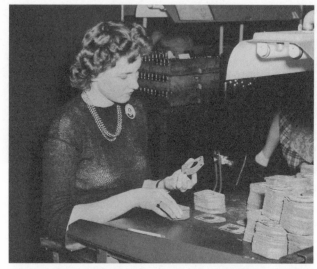

Rockford College student Dorles Caldwell working at Woodward Governor, a company that produced a part essential to controlling the pitch of an airplane propeller. (Courtesy of Rockford College Archives.)

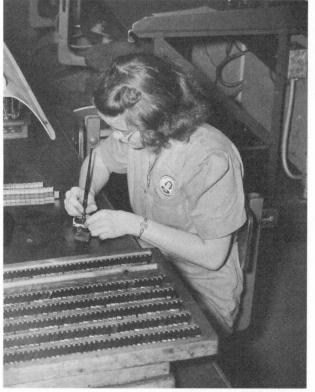

Rockford College student Nancy Brochen working at Woodward Governor. (Courtesy of Rockford College Archives.)

readers' recognition of the main warfronts made the value of these students' work that much more significant.

The national coverage garnered by this program brought these new roles for women into clear focus for the women at the college. The school newspaper reported that newspapers across the country, ranging from the *Paducah Weekly* in Kentucky to the *New York Times*, featured the program in their pages. "So extensive was the work of the College News Bureau and Admission Office," according to the *Vanguard*, "that by this fall forty girls have come to college on the co-operative program." The newspaper did not, however, downplay the difficulty of the work:

> A Work-Study students' schedule is a complicated one. . . . The girls are divided into two shifts—day and night. When an alarm clock down the corridor wakes you up at quarter of six in the morning and you open an eye to a dark and dreary world—give a kind thought to that defense-working neighbor of yours who's off to punch the time-clock for the 7:00 AM to 3:30 PM shift. And around 9:30 PM. . . . when you see the girls walk wearily into Middle Hall . . . give them needed sympathy, for they have worked eight long hours since 12:30 that afternoon!
>
> During each eight hour shift the college girls work at long benches lighted by the best that Woodward's could buy. . . . The girls are put on a different operation each day so they have yet to experience the monotonous drudgery of pushing in the same plug . . . a thousand times a day . . . week in and week out.[56]

Like much of the government's efforts to encourage women to join the wartime workforce, the article also played up the lighter side of this new sphere for women:

> Ten minutes out of every hour recorded music is played over the public address system . . . from the Harry James favorites to Gene Autry and his guitar to the *Scheherazade Suite* . . . (and a little bit of the inevitable Sinatra, of course!). The food served in the plant cafeteria is something you "non-defense workers" must dream about . . . not much steak but plenty of chicken. . . . Yearly, they are given complete physical examinations, and their teeth are x-rayed.

According to the article, the work-study program was "an experience [these students] will never forget."[57]

Although the program was described in the college newspaper as an opportunity for "fun"—"teasing the plant guards . . . the daily contest for the

first place in the lunch line . . ."—the strong patriotic tone of Office of War Information messages infused the article, too:

> There's the work of it . . . eight hours can be very long . . . sometimes you wonder if it's worth it! But there's more to it . . . the red, white and blue sign on the wall that reads "Every Minute Counts!" . . . the badges of Woodward men, now in the service, arranged in a "V" on the wall . . . knowing that you are one of millions who punch time-cards all over the nation for defense . . . knowing that your small part is a necessary part.

The article closed with the necessary message: "Yes, it's worth it!"[58]

The *Indianapolis Star* described the Rockford College program as pioneering not only because it was the first of its kind in the nation but also because of the unique and significant opportunities it provided for women. "'Earn as you learn' is the new slogan at Rockford College," the *Star* explained. "The college is not only meeting the challenge of the times but is also satisfying the emotional need of young women whose patriotic urge is paramount."[59] The program combined two powerful tenets of Cheek's Rockford College vision of educated women contributing to the nation.

Attacks on "Democratic Education"

Cheek believed that preparing young women to defend their country meant that women's colleges should teach courses in nutrition, food conservation, ambulance driving, aviation, home nursing, and first aid. Even more specifically, she believed that defending the country meant defending democracy itself, and women's roles in protecting democracy were essential ones. When Cheek attended a national meeting of the Association of American Colleges in 1941, the *Los Angeles Examiner* interviewed her about her defense work at Rockford. "Most predominant of all," Cheek said in the *Examiner* article, "is the trend toward the study of democracy and its ideals. There is an increasing feeling that we should know what we mean by democracy and that it is something to be prized."[60] Students were encouraged to think about the sacrifices that other students were making.

November 17, 1939, was a day remembered by students around the world. The previous day, Jan Opletal, a twenty-four-year-old medical student at the University of Prague, was shot and killed by the Gestapo during a demonstration for freedom on Czechoslovak Independence Day. On November 17, Hitler ordered his storm troopers, the SS, and units of the regular army to converge on Prague. By that evening, the university was surrounded. The Nazis raided student dormitories and homes, beating and shooting students and carting off many of them in cars and buses. Newspaper reports indicated

that 156 students were executed and another 1,200 were taken to concentration camps in Germany. Many professors were also arrested and suffered similar consequences. In a further effort to crack down on student populations, the Gestapo also closed all Czech universities.

As a way to commemorate what had happened to their friends, students who survived the November 17 massacre in Prague worked with English students to establish International Students Day. "From a single meeting in London," the Rockford College newspaper reported, International Students Day "was transformed into a commemoration and dedication reaching New York and Chungking, Delhi, Canberra, Moscow and Jerusalem."[61] A tribute to students and faculty who had "fallen victim to the brutality of the attack of aggressor powers on free, democratic education," International Students Day also served as a pledge of "all the energies of free students to the winning of the war and to the winning of the peace." According to the *Vanguard*, students in the free world hoped to "learn how to truly live for what these fellow-students died."[62] The Rockford campus commemorated the anniversary in 1943 with a special chapel service, as did many other colleges and universities throughout the world.

News also reached the United States in 1943 that German students had revolted against the Nazis and that seventeen students from the University of Munich had been executed because they helped to organize the revolt. A hope for democracy in Nazi Germany yet flickered, news reports declared. The International Student Assembly encouraged campuses across the country to sponsor rallies with the Munich incident serving as a symbol of student sacrifice and as encouragement to the anti-fascist underground in Germany and in countries occupied by the Germans.

The safeguarding of "democratic education" was of primary importance to many Rockford College students. When poet and Librarian of Congress Archibald MacLeish visited campus on October 20, 1940, to dedicate a new library, he reinforced the urgency of fighting against an enemy that threatened freethinking and Western education as American students knew it. The son of Martha Hillard, who served as president of Rockford College from 1884 to 1888 before she married, MacLeish later became assistant secretary of state and a distinguished Harvard professor who won three Pulitzer Prizes and the Medal of Freedom. That day in 1940, MacLeish spoke, in particular, of the importance of building libraries in a democratic country and fighting against the Nazis who burned books that supported points of view other than their own.

Not surprisingly, MacLeish's speech gained the attention of newspapers across the country, which published summaries of his speech under the headline "Nazis Hate Books, MacLeish Asserts." What follows is a portion of his speech from one of those news reports:

There was a time—and not so long ago—when the establishment of a new library in an American college would have seemed a thing so natural and ordinary and almost inevitable as to pass without comment save the formal comment of polite congratulation.

That time ended seven years ago with the burning of the books in Berlin. What has happened since in other countries—what is happening now, for example in France where the nazification of the libraries has already begun . . . and a long list of banned books has been removed from the French book shops and libraries for destruction, and whole collections have been shipped to Berlin "for study." . . . Even here in the valley of the great central river of this continent where a thousand miles of America gives the illusion—the false and very dangerous illusion—of remoteness and security—even here in northern Illinois the establishment of a new library is an act of faith, and affirmation of belief in the vitality of the human spirit which becomes, the more one thinks of it, the more impressive. To establish a library is to assert the belief that learning—that the free mind—will endure.[63]

MacLeish spoke not only to the campus community but to Americans at large. The war was both a political struggle and an intellectual one.

Women Respond

"Education for survival" became a prominent concern not only on the Rockford campus but also in colleges and universities across the nation. With the absence of large numbers of male students from colleges and universities, women took on more and more leadership roles on coeducational campuses, serving in greater numbers as editors of student newspapers and in leadership roles in student government associations and clubs. At Rockford, the International Relations Club sponsored discussions on various topics including "studying different plans for world organization aiming at economic and political cooperation and the preservation of world peace" because the members of the club believed this was a part of their contribution to the war effort.[64] The school newspaper also interviewed students, asking them for their opinions on conscription, the bombing of historic and culturally rich cities in Germany, and drafting women.

Rockford student Margaret "Peg" Bates attended a Conference on the Mobilization of College Woman Power at Monticello College in Alton, Illinois, in January 1942, where Dean Ruth Buffington, who served the Red Cross overseas beginning in 1943, presented a talk. With titles such as "You Can't Do Business with Hitler" and "After the War, What?," presentations covered topics

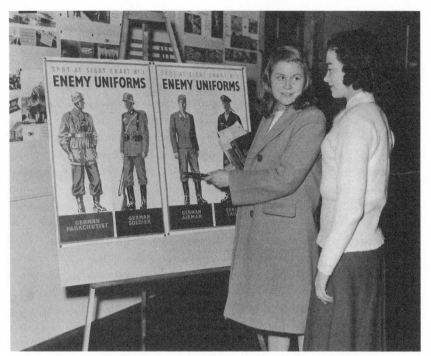

Two students examining "spot at sight" charts of enemy uniforms displayed at a defense show. (Copyright *Rockford Register Star*; used with permission.)

ranging from the defense of the home front and ways that colleges might be involved in war efforts to what was called "Patterns for Living in a World at War." The cover of the conference program featured a quote from Isaiah Brown, president of Johns Hopkins University, who explained what he saw to be the tremendous importance of colleges and universities in the future of the United States. After all, he explained,

> victory will be in two fields, combat and recovery. The impoverished nations of Europe have not the force to handle victory alone or recovery alone. America will lead the way in organization, in answering the tormenting question: How do we want to live, in the just care of our soldiers, in the fair distribution of the national income, in attempting to reduce unemployment, and in world organization?

Higher education in the United States would be able to answer the call to see that Americans—and especially those just reaching or recently reaching adulthood—would be "trained in leadership, trained in analysis, trained in agreement."[65]

A number of women across the country were interested in having a say in U.S. plans for peace and playing a role in the postwar world. Like Mary Ashby Cheek, they recognized the opportunities for women to take on new responsibilities and achieve new goals. While some women worked through already existing organizations, such as the National Council of Negro Women, as early as 1943, another group of women formed the Women's Action Committee for Victory and Lasting Peace. Because of women's insistence that females be given seats at peace conferences, the White House even organized a conference called "How Women May Share in Post-War Policy Making." As a result of the conference, several women were named as delegates to international peace conferences. In addition, state governments, such as Texas, organized conferences like the one held at the White House to give women across the country a stronger voice.

Many women came to recognize the ways in which their individual efforts might have consequences. Two of these were Rockford College student Frieda Harris Engel and her friend Claire "Nikki" Neikind, who were both involved in the American Student Union. Harris met Neikind, a student at Brooklyn College, at an ASU training school in Poughkeepsie, New York. They continued their friendship via letter writing. Neikind went on to become a well-known writer and correspondent, recognized for her work on terrorism and crime.[66] Her 1984 book, *The Time of the Assassins*, became her most widely known work, arguing that the 1981 assassination attempt on Pope John Paul II was backed by a Bulgarian spy ring.

In a letter to Harris during World War II, Neikind explained her desire to make positive changes for American workers, recognized that organizing workers at the Winchester Rifle Company would help the war effort, and poured out her anguish over the war, for both national and personal reasons:

> Of course, when I went to visit people at first, I worried about whether or not I could talk their language. I shouldn't have worried. Of course you can talk their language when you're both working for the same thing. There's no pretense here, no attempts to impress, no far-reaching intellectual abstractions, no blah. You give 'em the works . . . straight talk . . . this union's yours for the making, and if you don't join the union nobody gains but the bastard company . . . so why the hell not?
>
> The thing that struck me immediately was the essential and stark truth of the slogans we used to hurl around. . . . For example: when we say that you need better wages to improve the workers' morale . . . you see it every hour of the day at a plant like Winchester. When you say we need organization of the workers in order to improve production in an unorganized plant . . . boy, oh boy, that's true.[67]

Neikind felt that power of actions. She said, "I love the work, and that's that." It was tiring, but she knew it was important for keeping up the war effort. She also recognized the different class perspectives that came into play in her activities.

> Most important . . . when we say that the American workers support this war, but don't fully understand all its implications, and are not yet fully mobilized for active support . . . we are saying a mouthful. You know, it doesn't do to be romantic about the "Working Class." . . . In other words, they are not conscious, many of them, of their problems as a class . . . or say rather, they haven't tied their *personal* problem to a class angle. It would be unfair, however, to say that this is true of all or even a majority. But it's there. . . . [M]oney madness is a vicious little weed among many of these guys, who are making 60, 70, 80 bucks a week and want more, despite everything . . . and let this goddam war go hang, etc.[68]

Neikind also wrote of the strong bonds between young women who were increasingly better organized in student networks. These networks helped them make connections with women in other parts of the country who were dealing with similar concerns about war and their future as women.

The letter examined the satisfaction of a woman's work during the war but also the many complications of her involvement. The satisfaction of work well done was, however, not enough for Neikind as time wore on:

> I've been depressed about the war. It suddenly becomes very real. So many young girls whose husbands have just been drafted. So many young men who are about to go. So many Vets I have met . . . some of them not even yet readjusted to peace-time conditions . . . scheduled to go back any day. So many homes broken, aching insides, brave smiles of "bye now," so many *utterly wistful* faces.
>
> . . . I burn so at these thoughts that if I were not so convinced that organizing Winchester would be a big help to the war effort, I think I'd volunteer to be a nurse or something so I could see some action, and maybe sneak a hand grenade at a couple of Nazis.[69]

Young women like Neikind experienced not only the frustrations of wanting to fight the war and the difficulties of trying to figure out how best to do so but also the complications of marrying and starting a family in a country where the number of young men had been greatly diminished.

When Rockford College student Reka Potgieter ('46) wrote to her fellow students a letter that was published in the college newspaper to mark Thanksgiving 1942, she wrote with a conviction that education for young American women was an important step in both achieving and sustaining world peace. While she

and her fellow students remained at Rockford pursuing their studies, Potgieter recognized the significance of their undertaking and the importance of women enriching their minds and taking an active role in the future of America.

On Thanksgiving day stop for a moment and think—what would happen if I should fail in my duty; what if the soldier should win the war on the battle front, while I fail on the intellectual front. Think what a hollow, meaningless victory it would be if the great legacy which the allied nations are fighting to preserve should be lost because there were not enough eager, diligent students to help preserve it. What a tragedy then. . . . We must prepare to fit ourselves for our work that will begin when that of the other's [sic] is finished. It is the student of the present who will educate the world of the future. Let us not forget this. Let this give a new purpose, a new direction to our studies.[70]

With the efforts of young women like Reka, the foundation was laid.

In fact, though, the journey would be more complicated than they assumed. Historian Susan Hartmann reported that even though the number of American women graduating from colleges and universities with bachelor's and other first-level degrees increased from 77,000 in 1940 to 104,000 in 1950, the actual percentages of women graduates dropped from 40 percent in 1940 to one in four by 1950.[71] The GI Bill provided educational opportunities for servicemen and servicewomen, but it also dramatically shifted the percentages of male and female students. Even the numbers of master's and doctoral degrees granted to women decreased in the 1940s, from 38 to 29 percent for the master's and 13 to 10 percent for the doctorate. Likewise, the number of women faculty members at colleges and universities also decreased, even at the largest of the women's colleges, where the percentage dropped from 75 percent in 1940 to 60 percent in 1955.[72] Increasingly, men assumed the presidencies of women's colleges, including Rockford when Mary Ashby Cheek stepped down in 1953. Although by 1940, despite the fact that more and more educated women made their own choices about important matters in their lives, such as marriage, children, education, and career, American women still lived within a patriarchal society, and thus their lives were not totally their own.

3. Rescue Stories

A simple encounter between Jane Addams and "an old Italian woman, her distaff against her homesick face, patiently spinning a thread," captures the story of Addams's care for immigrants in late-nineteenth-century Chicago. Addams's words tell it best: "Suddenly I looked up and saw the old woman with her distaff, sitting in the sun on the steps of a tenement house. She might have served as a model for one of Michelangelo's Fates, but her face brightened as I passed and, holding up her spindle for me to see, she called out that when she had spun a little more yarn, she would knit a pair of stockings for her goddaughter."[1] This brief connection was a moment of epiphany for Addams. She was inspired to bring Saturday evening lectures and exhibit rooms to Hull-House, explaining and demonstrating the Old World crafts of Greek, Russian, Italian, and Irish immigrants from the neighborhood. Her purpose was to show the children and grandchildren of these immigrants that their parents and grandparents possessed the skills and ingenuity for doing by hand what the factory machines of their daily work now did instead.

Addams had a genius for understanding how to make care effective. She knew it had to go beyond moral principles and bureaucracy: effective care had to be relational, contextual, and experienced. She believed that direct experience between people of different cultures helped the social partners understand each other's individual perspectives, bringing clarity to the meaning of democracy. She fully accepted that "women's ties to the well-springs of tradition" as "providers of bread" ideally fit them for carrying these same traditions into civic life.[2] Caring for others gave mutual benefit to both givers and receivers, and women were best suited to take this responsibility. Addams believed that immigrants should receive care because they deserved it and were

in need, but also because they enhanced the larger society with cultural richness. Society was improved by the infusion of diversity, according to Addams.

For Mary Ashby Cheek, the motivation for offering scholars and students a refuge from war was grounded in thinking similar to Addams's. In large part, refugee students and faculty found their way to Rockford during World War II because of Cheek's leadership and because of Rockford College's location in the Midwest. Cheek strongly supported philanthropic efforts to aid refugees, and she was involved in collegiate organizations that assisted displaced persons. Her interest in a more international approach to education and her attempts to ground women's education in service to society also meant reaching out to those in need. Although many European scholars who immigrated to the United States as refugees held positions at prominent universities in their home countries, U.S. colleges and regional universities were typically more likely to hire them. The West Coast and Midwest were regions of the country where refugees were more readily accepted, so larger numbers of refugees tended to move to these areas.[3]

The rescue stories in this chapter are illustrative. Faculty member Vera Fisherova Beck studied at Rockford College in the 1920s, then returned home to Czechoslovakia where she pursued her doctorate, secured a university position, and married Frederick Beck, an international lawyer who dealt with the settlement of claims involving changes in national boundary lines after World War I. As war spread throughout Europe, the Becks made plans to come to the United States. Cheek created a teaching position for Beck that allowed her to enter the United States, but she was forced to leave her husband behind. Working frantically to help him escape, she traveled to Washington, D.C., where she assisted in securing passage of a law by Congress that would have allowed him to enter the country as well.[4] Her efforts, however, were unsuccessful. Because of the German government's suspicions of him, Frederick Beck was denied visas to leave Czechoslovakia and was later killed during the German occupation.

Students Marianne Ettlinger Cohen ('45) from Nazi Germany, Sonni Holtedahl from Norway, and Teru and Hisa Nakata (both '45) from a Japanese internment camp in the American West all received refuge at Rockford College, as did famed psychologist Bruno Bettelheim, who had been imprisoned in German concentration camps at Dachau and Buchenwald. Ettlinger studied at Rockford through a program that sponsored German-Jewish refugees, while a Quaker program in Washington State helped free the Nakata sisters from their concentration camp in Idaho so they might attend Rockford College. Professor Bettelheim taught at the college as he worked on his classic essay

"Individual and Mass Behavior in Extreme Situations," which detailed the ways in which captivity shaped the psychologies of concentration camp prisoners.

Soon after they arrived at Rockford College, refugee students and faculty were typically interviewed by the school newspaper. The editors of the paper recognized the importance of telling these stories of captivity and rescue, and the refugee students and faculty were generally very willing to share. Austrian refugee Fritzi Berne worked as an assistant to the college librarian and told the college newspaper, "I'm thrilled by America and American ways,—there's no other country in the world to equal it."[5] Vera Beck told the terrifying story of her brother's death in the concentration camp at Buchenwald in March 1942 after he and 1,200 other captives were, as a report published in the *Vanguard* described it, "declared unfit for labor and thrown into a stone quarry, where the whole group was killed with gas bombs."[6] Some, like Marianne Ettlinger, also related their stories through the local press and on radio shows in the Rockford community. Professor Bettelheim made his scholarly work on captivity a part of classroom discussions.

Others were more hesitant to tell their stories. Anna Barer, a Viennese sculptor who arrived in the United States in April 1941, was quoted by the school newspaper as "not eager to talk about Europe, but she's more than glad to discuss America and particularly the colleges here, which, she says, 'are made for being happy in.'"[7] Although the Nakata sisters were quite open in relating their experiences, some students who were released from concentration camps in the American West for study at the college level were reluctant to call attention to themselves, perhaps in part because of the prejudices against Japanese Americans.[8]

These stories of captivity and rescue were part of the long-standing tradition of the American captivity narrative. American studies scholar Melanie McAlister notes that "for more than two centuries our culture has made the liberation of captives into a trope for American righteousness."[9] World War II was no exception. Stories of captivity and restoration were intended to empower both the person enduring the captivity and the society that freed the victim. Ranging in American history from stories of settlers held captive by Native Americans and their restoration to white communities to the more recent media stories of servicewoman Jessica Lynch's capture by Iraqis and her rescue by American military, the captivity narrative tells the story of someone held prisoner in a supposedly more primitive enemy world who struggles to preserve individual and cultural integrity. Although captivity narratives were certainly used in very negative ways to rationalize the removal of Native Americans during the American colonial era, the captivity narrative during

World War II became a necessary way to garner more support for the defeat of fascist governments.

Readers of captivity narratives are usually interested in discovering both what happened during the captivity and also how captives made their escape. World War II narratives emphasize not only the dangers of losing individuality and self to a fascist government but also the consequences of losing democratic freedoms. Rockford College students who read and heard of these captivity experiences also became part of the narratives themselves because of the role the college played in providing aid and refuge. Offering protection was one way they could "fight" the war, and these narratives were important tools for showing women that their ability as caretakers was both valued and necessary. Young women at the college gained a sense of empowerment because they became part of the story itself. They were rescuers.

The Impact of Refugees on American Higher Education

The immigration of refugees into the United States was itself a complicated political matter. During World War I, the massive departures of Europeans for the United States that had held steady since the late 1800s quickly ended. Over the next four decades, immigration was severely limited, in large part because of nativist restrictive immigration laws passed in the 1920s. With migration of Europeans severely cut back during the Depression years, immigration patterns during World War II instead reflected the migration of refugees and displaced persons rather than movement because of economic opportunities, a pattern that persisted until the 1960s. Emigration from Asia was an even more complicated matter, with roots in the Naturalization Act of 1790 passed by the U.S. Congress that limited citizenship to "free white persons." Following the Civil War, the act was successfully challenged in favor of African Americans, but many restrictions still applied to Asians seeking citizenship. Not until 1952 did an act of Congress eliminate racial barriers to immigration, although the national quotas remained in use until 1965.

In many ways, academia in the United States was unique among other professional areas because many American scholars across the country had strong ties to European colleagues and thus had personal contacts with scholars in countries being overrun by the Nazis. Academic and professional organizations across the United States quickly took significant steps to help both students and faculty displaced by the war. The American Psychological Association, for example, established a Committee on Displaced Foreign Psychologists, working, in particular, with philosophers, other scholars, and persons with medical backgrounds, while the American Philosophical Association established a Committee on Exiled Scholars.[10]

American higher education was in many ways reshaped by the large-scale immigration of refugee scholars and students from the early 1930s until the end of the war in 1945. Describing the addition of large numbers of foreign scholars as bringing about "a significant change in higher education," scholar Marjorie Lamberti argues that the assimilation of these scholars "remains one of the least appreciated aspects of the history of the Central European migration."[11] In an introduction to *The Intellectual Migration: Europe and America, 1930–1960*, editors Donald Fleming and Bernard Bailyn qualify this migration as not one of "mass" proportions, instead emphasizing that the migrations of these scholars from "Hitler's Europe" to the United States had a powerful influence on American "intellectual life in the broadest sense and at the highest level."[12]

The field of psychoanalysis, for example, in large part gained prominence in the United States because of this migration of scholars. Even as early as 1933, psychoanalysis was banned in Leipzig, Germany, because it was labeled a "Jewish science." That same year, psychoanalysis was also banned from the Congress of Psychology in Leipzig, and not long after, psychoanalytic literature was destroyed in book burnings. Largely centered in Berlin, the community of psychoanalysts, including Sigmund Freud, quickly scattered. Freud settled in England, while others migrated to the United States. Although not a "pure" psychoanalyst, Bruno Bettelheim was part of this community of scholars that actually had greater influence on the American psychological community than perhaps they might have had in their native countries. Whereas psychoanalysis had become rather outdated in continental Europe by this time, the discipline saw a revival when a large number of psychoanalysts migrated to the United States.

The war was also a turning point in practices in American higher education based on prejudice and resentment. Although the number of Jewish students in American higher education was relatively small during the 1920s, quite a few universities across the country—including Harvard, Yale, and Princeton—established quotas to limit the number of Jewish students admitted.[13] In the postwar years, the American drive to compete with the Soviet Union led the United States to see itself as representative of a new world model—one not bound by discrimination and prejudice. In order to avoid criticism by the Soviets of a segregated society (evidenced by racial controversies from the Scottsboro Boys in the 1930s to the segregated armed forces in World War II), the U.S. government fought to improve its image in other ways such as embracing Jewish and foreign students. An evolving global marketplace increasingly based on technology also encouraged universities and colleges to offer more opportunities for American and foreign students.

Despite the open arms and encouragement that seemed to greet many refugee scholars and students, the reality was actually much more complicated. Historian Lewis A. Coser explains that in Europe, the professoriate was typically held in higher regard than in the United States. Because refugee scholars were often hired by colleges and regional universities rather than by more prominent American universities, European scholars often took positions that were not as prestigious as those they had left. Many also found themselves in "exceedingly demanding" positions at undergraduate teaching institutions, and according to Coser, the results were often "disastrous." The American undergraduate classroom was new to many of these scholars, while "refugees frequently had an aloof and condescending personal and scholarly style that did not sit well in the more open and democratic atmosphere of America."[14] In many ways, these descriptions of refugee faculty in the United States seem to reflect the experiences of Bruno Bettelheim at Rockford College.

While World War II immigrants to the United States faced the complexities of transition and assimilation into American society, over 120,000 Japanese Americans (including over 80,000 U.S. citizens) lost their livelihoods, their homes, and their educational opportunities when they were relocated to what were essentially concentration camps in remote locations in the western United States. Many of the interned young men and women were pulled from U.S. universities and colleges where they had been studying and were forced to relocate with their families to the camps. Almost three months after President Franklin Roosevelt signed Executive Order 9066 in 1942 that required Japanese Americans to move to the camps, the National Japanese American Student Relocation Council was founded to help college-age students locate colleges and universities where they might continue their studies. Financed in large part by private sources, the council was headed by Clarence E. Pickett, a prominent Quaker who was appointed to the post by President Roosevelt. The council was a joint group of educators, State Department officials, the American Friends Service Committee, and the national YMCA and YWCA, all of whom were concerned that Japanese American college students be allowed to complete their educations. Although reduced to half the number of Japanese Americans in college before the evacuation began, students who gained clearance attended sponsoring private and public schools throughout the country.[15]

Even though most were Nisei—that is, second-generation Japanese Americans and U.S. citizens by birth—students oftentimes found themselves relocated to parts of the country where there was little, if any, racial and cultural diversity. Helen Matsunaga, who was one of a group of half a dozen young Japanese American women released from the concentration camps to study

at Rockford College, wrote to the council that she hoped to study music and sociology so that she might "become a leader in culture after the war." She explained in another letter to the council after she was resettled in Rockford, "[I am] keenly aware of the responsibilities I bear in accepting your aid. I shall surely strive to show our fellow Americans the hearts of us Americans with Japanese faces."[16] In her comment, she seemed to note not only her thanks for the opportunity but also an awareness of the difficulties and challenges she faced because of the racial divisions still apparent in the United States.

Although foreign students and the children of more privileged immigrants had long been a part of the student body in American colleges and universities, in the years immediately following the war, the GI Bill greatly expanded higher education opportunities not only for American men and women veterans but also indirectly for foreign students, who benefited from increased capacity at American universities and colleges. The expansion of American higher education, including the development of community colleges and the increasing focus on the sciences as a way to fight against the Soviet Union in the Cold War, also resulted in the need for greater federal support of public education. Likewise, a bill introduced in Congress in 1945 helped to found the Fulbright program. Signed into law in 1946, the bill called for the sale money from surplus war materials to be used to fund a student exchange program intended to promote international goodwill.[17]

A similar exchange was already taking place during the war as refugee scholars and students on college campuses across the country gave firsthand accounts of their lives suffered under tyranny. Living with the memories of prejudice and isolation, and often the nightmarish images of concentration camps, the refugees who taught and studied at Rockford College in the years before and during the war told their individual stories about how war shaped their lives. Professor Hardy Wickwar worried on clear nights about the danger of German attacks on his native England and often spoke on the campus and in the local community about war-related issues. Student Marianne Ettlinger Cohen recounted her experiences as a Jewish girl born in Germany and the ways in which the German educational system prepared young people for service to the regime. Sonni Holtedahl told of the resistance movement in Norway and the bravery of the Norwegian people as they confronted their Nazi occupiers. Bruno Bettelheim found temporary refuge at Rockford College from the demons of his past. Telling their stories became not only a cathartic measure for them individually but also a tool for empowering Americans with the knowledge that their struggles against injustice were both winnable and necessary.

Bruno Bettelheim

The story of Bruno Bettelheim's immigration to the United States and his work at Rockford College is a complex one. A survivor of both Dachau and Buchenwald concentration camps, Bettelheim was released by the Nazis after a wealthy American family whose child had been in Bettelheim's care paid a sizable sum of money for his freedom. Immigrating to the United States in 1939, Bettelheim was offered a couple of teaching positions on the West Coast, but because of his preference for the Chicago area, he worked briefly at the University of Chicago and then accepted an appointment to teach art courses at Rockford College in the fall of 1941. During the several years he taught at Rockford, Bettelheim wrote and published his classic essay "Individual and Mass Behavior in Extreme Situations," a study of the effects of captivity on human beings based on his observations in the concentration camps. Bettelheim claimed his essay, which was first published in 1943, was required reading for American military and government officials serving under General Dwight D. Eisenhower in Germany.[18]

An account of the horrendous tortures and hardships suffered by captives in Nazi concentration camps, "Individual and Mass Behavior" was not only an analysis of the captivity narratives that Bettelheim was able to collect but also a means for him to maintain his own individual integrity in a hostile environment. Arrested by the Nazis in his home in the spring of 1938, Bettelheim was first sent to Dachau, near Munich, Germany. "Individual and Mass Behavior" described the ways the Nazis stripped prisoners of their individuality and their personal beliefs by exposing them to extreme situations. In the essay, Bettelheim addressed both the Nazi goals of changing the prisoners into "docile masses" and making them *more useful subjects* of the Nazi state" and the psychological implications of exposure to extreme situations on the prisoners themselves.[19]

In the concentration camps, analyzing the psychological situations of the other prisoners became for Bettelheim his own tool for survival. He explicitly stated in his essay that the "main problem" he faced in the concentration camps was "*to safeguard his ego in such a way that, if by any good luck he should regain liberty, he would be approximately the same person he was when deprived of liberty*" (emphasis in original).[20] Losing one's self meant acting in "the most anti-social way," accepting what happened in camp as "real," cheating fellow prisoners, becoming a spy, losing one's "sense of propriety," losing self-respect, becoming "shiftless," or losing the ability to "form a life pattern" by following the patterns of other groups of prisoners.[21] For Bettelheim, maintaining that selfhood also meant preserving his identity as a psychologist.

Two other prisoners "trained and interested enough to participate in his investigation" helped Bettelheim interview prisoners. Because prisoners were frequently moved from one labor group to another, the three were able to interview large numbers of persons held in captivity. Bettelheim stated that he "came to know personally at least 600 prisoners at Dachau (out of approximately 6,000) and at least 900 at Buchenwald (out of approximately 8,000)."[22] Working with two others trained in the field was, according to Bettelheim, "very helpful in clarifying mistakes that were due to taking a one-sided viewpoint."[23] Because they were not allowed to keep paper records of the material they collected, they were forced to memorize the accounts told to them. Bettelheim noted that his work was hindered by the fact that extreme malnutrition causes memory problems, and he at times "doubted whether he would be able to remember what he collected and studied."[24]

Taking a more clinical approach by writing about his own experiences in the third person was perhaps, in part, a mechanism for survival similar to what he suggested that other captives used. Bettelheim pointed out that detachment, or "rejecting the reality of the situation in which the prisoners found themselves," was likely a way that they coped.[25] Likewise, Bettelheim was aware of the importance of encapsulating himself in the known—in his work—as a way to detach himself from the realities of his imprisonment. "The study of these behaviors was a mechanism developed by him *ad hoc*," Bettelheim wrote, "in order that he might have at least some intellectual interest and thus be better equipped to endure life in camp." Bettelheim described his "observations and collection of data" as "a particular type of defense developed in the extreme situation." Because his work was on "behavior individually developed, not enforced by the Gestapo, and based on this particular prisoner's background, training, and interests," his studies reemphasized for his fellow prisoners and for himself the importance of their individual stories and lives.[26]

Arriving in the United States in April 1939, Bettelheim discovered that many Americans did not yet understand the atrocities occurring in the European concentration camps. In the following passage, he explained the task he undertook to educate anyone who might listen about the realities of the camps:

> From the moment I arrived in this country, within weeks after liberation, I spoke of the camps to everybody willing to listen, and to many more unwilling to do so. Painful as this was because of what it brought back to mind . . . I was anxious to force on the awareness of as many people as possible what was going on in Nazi Germany, and out of a feeling of obligation to those who still suffered in the camps. But I met with little success.

At that time, nothing was known in the U.S. about the camps, and my story was met with utter disbelief. Before the U.S. was drawn into the war, people did not wish to believe Germans could do such horrendous things. I was accused of being carried away by my hatred of the Nazis, of engaging in paranoid distortions. I was warned not to spread such lies.[27]

In part, "Individual and Mass Behavior" has been described as a "classic" because it was one of the first analyses of the psychological tools that the Nazis developed in the concentration camps.

The complexities of Bettelheim's story stem primarily from recent criticisms of his seminal article itself and questions surrounding the legitimacy of his credentials. In 1996, a former editor for *Newsweek* and the *Nation*, Richard Pollak, published a biography of Bettelheim that described him as a man driven to live by his statement "We must live by fictions—not just to find meaning in life but to make it bearable."[28] Some reviewers of Bettelheim's work, including Pollak, have pointed out that although he was held in the concentration camps, he was at Dachau and Buchenwald when the camps were used primarily to hold political prisoners and before the years when the Nazis began their mass exterminations of prisoners. The Nazis regularly attempted to erase all records of academic degrees and accomplishments of Jews. For this reason, Bettelheim was able to exaggerate his credentials after he arrived in the United States, according to Pollak, and it was at Rockford College that Bettelheim's "fiction" first seemed to evolve.

Perhaps still struggling to maintain the self that the Nazis tried to erase, Bettelheim was revising his story as a way to survive. The résumé that Bettelheim presented to Mary Ashby Cheek indicated he had completed doctorates from the University of Vienna in philosophy, art history, and psychology, whereas he actually completed a doctorate in philosophy only. Pollak argues that Bettelheim also overstated his experience as an assistant at the Vienna Museum, as a participant in archaeological digs, and as a notable authority in psychology. During the years he was purportedly studying toward his three doctorates, he was actually working in his family's lumber business. Validating his credentials would have been nearly impossible for Cheek, or any other prospective employer, as the academic records from the University of Vienna were destroyed by the Nazis in 1941. Although not as much emphasis was placed on academic prestige in American universities and colleges, Bettelheim was from a European system that did, and he craved that respect. Even though he was praised for both his teaching and research, he was always in need of money. Most probably, says Pollak, Bettelheim's reason for exaggerating his credentials was because he needed income. When his first child was born in December 1942, the importance of a steady income became particularly important.

At Rockford College, Bettelheim was at once loved and feared by students, while many of the professors viewed him as an enigma. "He sometimes sat up late into the night at Maddox House, where seniors gathered over coffee and Cokes, talking of Secessionist Vienna or the Italian Renaissance and prodding them with guttural insistence to shake off their provincial thinking," according to Pollak.[29] Bettelheim was at once an inspiration for many, a torment to others, and a frustration for some of the professors on campus. Professor Mildred Berry, a noted researcher and teacher in the field of speech, was asked by Cheek to share an office with Bettelheim, which she agreed to do. Years later, Berry described a man who left many on the campus quite puzzled:

> He came in a tattered old raincoat and cap. He said, "I'm Bruno Bettelheim," and I introduced myself. He sat down at his desk, unpacked a few books, and then left without saying goodbye. He came to the office every morning but seemed not to want to talk. He was chilly; he never visited or made small talk. He seemed not to want to tell me anything about his past.[30]

Despite an unease that many on campus felt about Bettelheim, Cheek wrote in a letter to Professor R. W. Tyler of the Department of Education at the University of Chicago that "everything points to the fact that [Bettelheim] is an excellent and genuine teacher as well as a scholar of parts."[31]

Before long, Bettelheim became a controversial figure at the college. Among the students were two camps of opinion. One group was fascinated by his extensive knowledge of art and Freudian psychology and awed by his concentration camp experiences. Marianne Ettlinger Cohen, for example, described Bettelheim as having "a very large following of students who spent a lot of time with him, really adoring him."[32] The other group of students seemed either intimidated or strongly put off by Bettelheim's dominant style of teaching and relating to them. Pollak quotes student Veronica Dryovage as saying, "He literally reduced me to tears three or four times, and I would stomp out. He kept challenging me in a way I wasn't used to, and I didn't know how to deal with it."[33]

Sharing his "Individual and Mass Behavior" essay with his students as he wrote it, he used introspection and self-examination to understand his experiences and encouraged his students to do the same. Some of the students responded positively to this self-analysis, whereas others were alienated by it. In an attempt to understand his varying behavior, alumna Aimee Isgrig Horton years later described him as an individual with "a lot of personal needs. He needed to make others understand what he went through in the concentration camps." He was "in a real sense studying us," she explained in a recent

interview.[34] Such intense feelings during her college years led Isgrig to write a poem about Bettelheim that was published in the *Rockford Review*, the school literary magazine, in May 1944:

> Two lives
> Have I lived.
> Two sets of roots
> Have been nourished
> In two soils.
> The old roots,
> Cut without warning,
> Linger on—
> Wanting to believe
> They will be cared for
> And sprout
> Tender and guileless
> Once more. . . .

Titled "Refuge without Refuge," Isgrig's poem suggested the difficulties faced by refugees who might now be "captured" by a new place of security and freedom. "Wanting to believe / They will be cared for / And sprout / Tender and guileless / Once more," the refugee was still torn from and separated from home.[35]

In 1944, Bettelheim left Rockford College for a position as head of the Orthogenic School at the University of Chicago; he held that position for the rest of his career and became renowned for his work there with emotionally disturbed children. Bettelheim's book *The Uses of Enchantment*, a psycho-analytic interpretation of fairy tales published in 1977, received high acclaim as well: a National Book Award, a National Book Critics Circle prize, and a place on the New York Public Library's list of the most influential books of the twentieth century. "His impact on both professional psychotherapy and general American culture turned out to be pervasive," Lewis A. Coser wrote of Bettelheim. "One is hard put to think of many other refugee intellectuals who have contributed with such apparent ease to so many crucial areas of American life and experience."[36]

In March 1990, Bruno Bettelheim took his own life by a drug overdose. The words he wrote forty-seven years earlier in his essay on "extreme situations," describing his cruel treatment by the SS, may give haunting speculation about the thinking of this complex and productive man: "The writer can vividly recall his extreme weariness, resulting from a bayonet wound he had received early in the course of transportation and from a heavy blow on the head. . . . He

wondered all the time whether man can endure so much without committing suicide or going insane."[37]

Marianne Ettlinger Cohen

Marianne Ettlinger Cohen was born in Karlsruhe, Germany, in 1923 and was ten years old when Hitler became chancellor. In 1936, her widowed mother decided to send Marianne's two brothers to the United States. Marianne, her sister, and her mother planned to follow them, but because of immigration quotas, they first moved to London. Forced to travel separate from her mother and sister on their way to England, the fifteen-year-old Ettlinger carried with her only a few possessions, including her guitar, which was confiscated by the Germans. Ettlinger and her mother and sister were finally allowed to enter the United States in 1940.

In the fall of 1941, Ettlinger enrolled at Rockford College. Other students were very curious about her life in Germany, particularly about how children were educated, the ways Nazis swayed the loyalty of German citizens, and the treatment of Jews. Soon after she arrived at the college, Ettlinger wrote an essay describing her experiences in Nazi Germany. She was not held in a concentration camp, but as Bettelheim explained in "Individual and Mass Behavior," what happened in the concentration camps "happened in less exaggerated form to most inhabitants of that large-scale concentration camp called greater Germany. It could have happened to the inhabitants of occupied countries if they had not been able to form organized groups of resistance."[38] Although her essay—her narrative of captivity that described her experiences as a Jewish girl watching Hitler's "new community" forming around her—was certainly not unique, her account is rare in that she told her story during the war rather than years later. Dated October 2, 1941, and presumably written for a college course, the essay circulated around campus among the students. Ettlinger's narrative highlighted several of the ways that the Nazis attempted to control the German people through censorship, false information, coercion, and force.

Ettlinger recognized the value and power of freedom of expression and the dangers Germans faced if they disagreed or spoke out against Hitler's regime. Living in a medium-sized German town with an active Jewish community, she attended public high school and was the only Jewish girl in her class. The stories of her experiences, no matter how negative, could never have presaged the greater horrors faced by European Jews held in the concentration camps, and she described herself as "comparatively lucky in not suffering too much from the Nazis." Ettlinger tried to explain what was happening in her native Germany and to show that the German people were redeemable as a part of her attempt to persuade her readers to help support the Allied cause:

Before the war all the news consisted of propaganda for Nazism either by direct praise of the Government or by some kind of agitation against Germany's so-called enemies. . . . The people did not get a chance to know what was going on in the world, for all the news were misrepresented. They could never get a true picture of the political situation in France, England, America, Russia or anywhere else. Also there would always be a great deal said about Germans in other countries, especially in Czechoslovakia and Poland, how they were ill treated as a minority race. This, of course, was to stir up the wish for war.[39]

Although she certainly did not absolve the Germans of their guilt in the atrocities committed against the Jewish people, particularly as she pointed to the massive pogrom of November 1938, she nevertheless represented Germans as a people who had been manipulated into becoming part of Hitler's Nazi state.

Ettlinger recognized as well that in many ways, Hitler's creation of Nazi Germany hinged on his ability to convince citizens to think not as individuals but as a group, to break down the bonds and structure of the German family, and to reshape the education of Germany's youth. Her essay focused, in particular, on the ways that Hitler created what he called a "new community" for Germany's young people that both severed their bonds with their families and recreated them as Nazis. In large part, those new communities for young people rested in Germany's schools and in the Hitler Youth program. In fact, in the last few years Ettlinger lived in Germany, Hitler dramatically increased his efforts to focus on Germany's youth as a way to build his regime. Ettlinger described those efforts in her essay:

The schools aren't what they are here [in the United States], that is: a free institution that prepares youngsters for life in a free country. No, they are part of the political machine. . . . Every time the teacher enters the room the students greet him with "Heil Hitler." . . . [T]eachers, in order to be popular and in order to keep their job, must continuously praise the Government and also see that their pupils get a really bad idea of anything that conflicts with Nazism. Especially history is turned round to fit the Nazi purpose and to contradict the truth. . . . [T]he German boys and girls, when they meet, sing their songs of hate, hate of the Communists, of the Jews, of the English, of the French.[40]

Even though every German boy and girl was required to join Hitler's youth organization, one of Ettlinger's friends refused to participate in the Bund Deutscher Mädel (League of German Maidens) because, as Ettlinger noted, she "knew better."[41] When the girl's unwillingness to join was discovered, her

father's employer threatened to fire him. Because the family could not live without the support of the father's job, "the only thing my friend could do," according to Ettlinger, "was to give in."[42]

Ettlinger recognized that a powerful interest—and a powerful motivator—of her American audience for her paper was family and home life. Her story of a German family broken apart by the Nazis served to warn not only of the power of Hitler over Germany's youth but also of the decline of the inherent social structure that women readers would have typically prized:

> During the war, all this censorship is intensified. . . . [W]hen Germans have been hearing nothing but lies for so many years, how are they to know what is right and what isn't? There surely must be quite a few who realize that Germany is being misled by Hitler. But it is frightfully hard for anyone to keep his viewpoint when he is never allowed to express it and doesn't know whether any of his friends or even his family agrees with him or not.
>
> . . . [T]he following happened in our town: . . . the father of a family made some remark against Hitler. The next morning he was arrested, and he was kept in prison for a year. . . . [U]pon his return he gathered his family . . . and tried to find out who could possibly have betrayed him. Whereupon his son got up and announced: "I did my duty to my Fuehrer. He tells us what is right and those who oppose him must be taught by force to follow him." . . . This incident shows you quite well the atmosphere of suspicion and fear in which the Germans have to live under Hitler and which is so harmful to the morale of the people.[43]

Noted journalist and historian William L. Shirer argues in his classic book *The Rise and Fall of the Third Reich* that because the youth movement was so well established and strong in republican Germany, Hitler became "determined to take it over and Nazify it."[44] As early as November 6, 1933, Hitler explained in a speech:

> When an opponent declares, "I will not come over to your side," I calmly say, "Your child belongs to us already. . . . What are you? You will pass on. Your descendants, however, now stand in the new camp. In a short time they will know nothing else but this new community."[45]

Perhaps this in part explained how the German son that Ettlinger told about in her essay could report his father's negative remark made at the dinner table and how he could seemingly have a greater allegiance to "the Fuehrer" than to his own father.

Hitler attempted to create with the Bund Deutscher Mädel and the Hitler-jugend (Hitler Youth) programs a system that provided not only entertainment and comradeship for German young people but also a rigorous program of physical fitness.[46] Physical education, according to Ettlinger in a radio interview conducted in Rockford in early 1942, "became more and more stressed" under Hitler's rule. While boys participated in physical activities to groom them as ideal figures of the Aryan race and as future soldiers in Hitler's army, girls were likewise prepared for their role as future mothers of the Nazi regime. Girls needed to be cognizant of their health and fitness so that they might produce strong, fit children. Although their "minds were deliberately poisoned, their regular school interrupted, their homes largely replaced so far as their rearing went," explained Shirer, the young people who were part of Hitler's program "seemed immensely happy, filled with a zest for the life of a Hitler Youth." Shirer carried his point a step further by noting that he remembered the days in May 1940 when he found himself on the road between Aachen and Brussels and noticed the obvious difference between the German soldiers who had been raised as Hitler Youth and the British soldiers who were prisoners of war: "One saw the contrast between the German soldiers, bronzed and clean-cut from a youth spent in the sunshine on an adequate diet, and the first British war prisoners, with their hollow chests, round shoulders, pasty complexions and bad teeth—tragic examples of the youth that England had neglected so irresponsibly in the years between the wars."[47]

The "bronzed and clean-cut" facade, nevertheless, hid the "brutish instinct" that Ettlinger noted in her essay. Underneath lay young men who had been raised as part of a "political machine." Trust and loyalty to family became instead an allegiance to Hitler and the Nazi regime. Likewise, those German citizens not in the military lived in a society where German was turned against German and where laws restricted even the most basic of choices and essential human rights such as life and liberty. "[Hitler] acquired the idea that we, the Jews, have caused all wars," Ettlinger wrote, "that every individual Jew must disappear from Germany in some way or another." Persecution was harsh and swift:

> Most men, holding a state position, such as judges, ministers, post office clerks or some similar job, were dismissed right away. . . . Nazi officials saw that no one bought in Jewish stores, that people dismissed all their Jewish employees, that nobody worked under a Jewish employer. . . . There also were certain parts of the country and certain districts of each town where Jews were not allowed to live.[48]

Ettlinger seemed to close her essay intentionally with reference to her personal knowledge of "many people who kept and demonstrated their loyalty to

their Jewish friends" and to the "brave Christians and liberal-minded men" who fought against the injustices of the Nazis and suffered persecution in concentration camps. Surely she was thinking of fellow students in her audience and their intentions when she asked them to consider those who "kept and demonstrated their loyalty to their Jewish friends." With these words, she encouraged them not only to think about the implications of the story she told but also to consider ways they could become part of the narrative, ways they might help their Jewish friends still facing persecution and death in Europe.[49]

Sonni Holtedahl

Framing Sonni Holtedahl's experiences within a gendered context by describing her as "pretty" and "blue-eyed," an article that was published in the Rockford College student newspaper on October 31, 1945, told the story of a young woman who was not only feminine but also patriotic as she courageously guarded weapons her countrymen would use in their struggle against the Nazis. Fighting to keep Norway from becoming like the "large-scale concentration camp called greater Germany" that Bruno Bettelheim described, the resistance movement of Norway provided both the drama of a good story and the heroic qualities not unfamiliar to *Vanguard* readers who were accustomed to reading the adventures of "The Girl Reporter" or of the WACs and the WAVES.[50]

The *Vanguard* story of Holtedahl's experience in Nazi-occupied Norway focused specifically on the importance and success of resistance. Told from the perspective of a Rockford College student reporter who quoted Holtedahl, the intent of this captivity narrative seems twofold: to frame women as active participants in the war overseas and at home. Details such as the Nazis' suspicion of "anything red in color" point to the ways in which colors and even small, insignificant items were used as symbols of defiance. A popular resistance symbol of Norwegian youth, for example, was the paper clip. Worn clipped to cuffs and collars or linked as a chain, the clip was a symbol of unity and loyalty to the king and government of Norway. The author of the narrative seemed intent on emphasizing the power of small steps—small acts of defiance—against an enemy that must have seemed to Rockford College readers incredibly overwhelming and unyielding.

The narrative of Holtedahl's "captivity," as told through the words of a fellow Rockford student, related the struggles of the Norwegian people against the Nazi regime and the bravery of the Norwegian people in carrying forth their resistance:

> During the five years of Nazi occupation of her country, . . . she helped the underground; almost everyone in Norway did so. The "underground" was actually above ground and out in the open in Norway. . . . To help a

friend, an active member of the Norwegian underground who was living in the Holtedahl home, Sonni frequently stood guard over a cache of weapons hidden by the patriots in the neighborhood.

"We had to sabotage everything," she said when asked about the work of the anti-Nazis in Norway. "On the trams, signs were placed which said that we would be arrested if we didn't sit next to a German."

Refusal to attend Nazi movies or theaters operated by Nazis, refusal to buy German books, listening to the radio, which was forbidden, and fixing illegal papers were practices in which almost all Norwegians participated.

The Nazis' suspicion of anything red in color was another evidence of their precarious hold on the Norwegian people. Sonni displayed a red knitted tasseled cap, which she said is a very popular accessory for skiing in her native land. The Norwegians were forbidden by the Germans to wear the caps. Nazis would stop groups of citizens on the street and take from them everything red in their clothing, because they thought it indicated a leaning toward the Russians.[51]

Holtedahl's comment that the Nazis "interfered with every little thing" indicated the extreme lengths the Nazis went to in order to control the Norwegian people. She also described searches of her home by the Nazis who were looking for Norwegian patriots. Perhaps one of the most concerted ways that the Nazis struggled for control was through their ban of radios and illegal newspapers, according to Holtedahl. In fact, by controlling the airwaves and newsprint, the Nazis were able to stifle communications from the underground appealing to the Norwegian people to resist the Nazi occupation.

Holtedahl's story of captivity presented to Rockford women a model of feminine strength and endurance in the face of a controlling, evil enemy. The empowering narrative showed what a people might do if they all took active roles—even small ones—to fight against the Axis powers. It also pointed out the powerful role that a college like Rockford could take in providing for a young refugee woman like Holtedahl. Rockford College offered her a place of retreat, a place where the threat of the enemy was, as the college newspaper reported, "just a dream."[52]

Teru and Hisa Nakata

Sisters Teru and Hisa Nakata were among a group of six Japanese Americans freed from detention in one of ten U.S. government-authorized relocation camps spread throughout the western United States to study at Rockford College. Interviewed for the Rockford College newspaper not long after they

arrived on campus in October 1942, the sisters described the difficult living conditions experienced by Japanese Americans interned during World War II and denied their rights as American citizens. Living conditions at the assembly centers where Japanese Americans were gathered and the concentration camps, or relocation camps as they were called at the time, where Japanese Americans lived for the duration of the war were substandard as internees were often exposed to harsh environmental conditions, poor sanitation, bad food, and overcrowding. The Puyallup Assembly Center in Washington State, where the Nakata family was first sent, was known for the oozing mud throughout the camp, while the Minidoka Relocation Camp in Idaho where they were subsequently held was plagued with strong summer dust storms.

The Japanese attack on Pearl Harbor in early December 1941 generated a great deal of fear among the American public, and some government officials, that the West Coast was vulnerable to Japanese attack and/or infiltration. At the time, almost 90 percent of mainland Japanese Americans lived in California, Oregon, or Washington; such a population concentration created national security concerns following the "date that will live in infamy" that pushed President Roosevelt to act.[53] His Executive Order 9066 paved the way for imprisonment, in camps with barbed wire boundaries and armed sentries, of all Japanese Americans who lived near the coast. Officially called "relocation" and "internment" camps by the U.S. government, the euphemisms slipped numerous times during the war when leaders such as President Roosevelt or Supreme Court justice Tom Clark called them concentration camps, acknowledging in essence that they were places holding noncriminal, unprosecuted prisoners.[54]

The debate still continues over what to call these camps. Following the revelation of Germany's extermination camps such as Dachau and Auschwitz, use of the term "concentration camps" for the Japanese American experience seemed overly harsh when compared to that of Jewish or other Holocaust victims. Calling them either "internment" or "concentration" camps adds baggage and complications. The camps were all those things—used for relocation and interning a people suspected of being a danger but never charged, tried, or prosecuted for acts of treason, thus meeting most dictionary definitions of "concentration camp," like this one: "A camp where prisoners of war, enemy aliens, and political prisoners are confined."[55] There is historical justification for using all the terms, given the role and actions of the camps during World War II. Rockford College students learned firsthand what those camps were like from those who lived there. The Nakatas' experiences in captivity, which were related in a story published in the *Purple Parrot* on October 23, 1942, showed students a very different side of the home front.

Born and raised in Seattle, the sisters were forced to leave their home city on May 9, 1942, and sent to live in an assembly center in another city in Washington State until the middle of August. The college newspaper quoted Teru, who was known as "Terry" on campus, as saying that "under the grandstands where we lived at the state fair grounds, it was dark and unsanitary, and we met all kinds of people from all walks of life." Approximately three thousand people were housed in the four areas of the assembly center, and each day in mid-August, five hundred internees were transported by train from the camp to a relocation center in Idaho. "The train stopped at the end of the track in the middle of sage brush country without a tree in sight," according to Teru.[56]

About two and a half miles long and in the shape of a crescent, the relocation center in Idaho was guarded by Military Police and surrounded by rough, wild terrain. Hisa noted that "there were porcupines, the coyotes came howling around the camp at night, rattlesnakes were always being killed, and we had a dust storm each week which lasted about 3 days." Ten thousand people were housed in camp barracks that seemed to go on forever in row after row. Six families shared a barrack and a community shower that had no hot water, and each family was assigned to one small room.[57] Many Americans were ignorant of the conditions under which these prisoners lived. The Nakatas' story kept the facts in the public eye.

Years later, in a reminiscence written in 2003 for this book, Teru Nakata Kiyohara recalled once again her family's internment at the concentration camps, this time adding more details that showed a bit more clearly the emotions she experienced in losing her rights as an American citizen. Kiyohara's reminiscence also examined their incarceration within the context of American history and described her initial emotions upon hearing that Pearl Harbor had been attacked:

> I was at home having breakfast the morning of December 7, 1941, when the news bulletin came over the radio that Pearl Harbor had been bombed by the Japanese military. My family and I were in utter shock and disbelief as we sat in the kitchen listening to the broadcast. I was then a student at the University of Washington having finished my freshman year. . . . I was concerned and worried as my sister, my two brothers and I were all United States citizens by birth. My mother, however, was an alien. Earlier laws did not allow her to establish citizenship.[58]

Kiyohara described how shocked she was over curfews and travel restrictions for Japanese on the West Coast and how her family was sent off to the camp in Idaho.

Despite the harsh conditions, the camp offered a quickly developing "sense of community," and the chance to continue her education came along soon. With the assistance of the National Japanese American Student Relocation Council and the American Friends Service Committee of Seattle, the two sisters were released from Minidoka Relocation Camp to attend Rockford College. Students released to attend college were required to be cleared by the army, navy, and the Federal Bureau of Investigation because of the proximity of colleges to war defense plants. Kiyohara explained in her reminiscence that Mary Ashby Cheek played a key role in opening Rockford College to Nisei students and noted that this act "rekindled much hope and confidence in me, especially after I had lost all incentive to continue with my education when we were evacuated from the West Coast."[59]

Travel to the college was not easy in the war environment of the time, especially for Japanese Americans:

The train ride to Rockford was a nightmare. My sister and I boarded the train in Twin Falls, Idaho, and we were to transfer in Chicago and head for Rockford. The smoke filled train was so heavily packed with unruly, drunken soldiers that it was impossible to take a nap. Suddenly at 4 AM in the morning, the train conductor approached us and informed us that we were to get off at the next stop, Dixon, Illinois, and that we were to take the bus to Rockford. We had friends meeting us in Chicago, but we had no choice but to follow instructions. As the train came to a screeching halt, the conductor threw our suitcases out the door onto the train platform. It was a chilly foggy morning, and as we got off the train, the conductor pointed us to a dimly lit bus depot in the far distance. It was scary and frightening to be wandering the streets at the wee hours of the morning, but we managed to drag our suitcases to the one room bus station where we waited for the bus to arrive. What a great relief it was to finally arrive at Rockford College later that morning, and what a warm welcome we had! Everyone greeted us and accepted us with warmth and care.[60]

Soon after, the editors of the college newspaper decided to interview the sisters. Although the story published in 1942 attempted to help Teru and Hisa create a sense of home in the Rockford College community, it also pointed to the loss of connection these young women felt moving far from their family and their hometown of Seattle.

According to the *Purple Parrot*, the sisters' experiences at Rockford College took them back to a world before Pearl Harbor where other things were more significant:

Teru and Hisa . . . cannot go back for a visit for the duration, as long as they are working or in school; and their parents cannot leave the area.

Both girls are putting aside memories of their past experiences and are enjoying themselves at RC. Terry plans to change her major from oriental studies to home economics, and besides two courses in that field, she is taking sociology, art, and English drama. She likes all kinds of sports, both as a participant and as a spectator.

Hisa is taking art, home economics, and shorthand, and is interested in music and skiing. She volunteered to play the flute in the Sophomore play during chapel hour last week. Both girls are anticipating snow because, although they have seen it in the mountains they have never lived where it has snowed.[61]

Despite this positive description, racism still remained a part of the sisters' daily lives. Kiyohara wrote later of her dating options during the war: "Camp Grant was the closest army base to Rockford during World War II. In those days, there was [little or no] interracial dating. I dated a few Japanese American soldiers who happened to be stationed at Camp Grant. I [also] dated [a few soldiers] from my hometown who happened to be on furlough from Camp Shelby, Mississippi."[62] These Japanese American soldiers had volunteered from the concentration camp and joined the segregated 100/442nd Regimental Combat Team, which ultimately became the most decorated American army unit of World War II.[63]

Although the Nakatas' story of their time at Rockford College was essentially a positive one, not all Japanese American students were as fortunate. The American Legion opposed the release of students from the concentration camps and pressured some colleges and universities not to enroll them. The president of Indiana State Teachers College in Terre Haute, for example, wrote to the council that he believed his college might be "publicly condemned" if Japanese American students were enrolled. He emphasized that although he "believed in world brotherhood," his decision was "influenced by possible reactions in the community" from groups such as the American Legion.[64] But despite the forces working against their enrollment, more than four thousand incarcerated students were helped to relocate by the council.

Cheek's work for the release of the Nakata sisters signaled to Rockford College students that they should be aware of the injustices that remained even in their own country. Young women could revise the story of where their country was headed not only by taking an active role in the war effort but also in seeking justice for all Americans. This was an instance in American history not unlike the abolitionist movement of the nineteenth century and

the civil rights movement of the twentieth century when American women tied the fight for equality to issues of both race and gender. For Cheek, taking responsibility for one's fellow human beings meant not only becoming a "bread giver" like Addams but also writing oneself into the narrative of their captivity, empathizing with their plight, and taking necessary action. In addition to helping others at the college and the larger Rockford metropolis understand firsthand what the war meant for so many in both Europe and the United States, refugees' stories gave power to women who wanted to help with the war effort in any possible way.

4. Home-Front Activism

In an age when comic strips were read widely by the American public, the introduction of the fantasy character Wonder Woman in 1941 was part of a turning point in the popular representation of females in the media. The answer to the problems of "a world torn by the hatreds and wars of men," Wonder Woman was described as a heroine "whose sensational feats are outstanding in the fast-moving world." "As lovely as Aphrodite—as wise as Athena—with the speed of Mercury and the strength of Hercules," her identity was known to no one. Her first adventure found her alongside another attractive woman as they discovered, on the "shores of an uncharted isle," the downed plane of a serviceman whom they saved from his burning craft. Wonder Woman was the answer to the world's problems: a woman who could mend a world that men had broken apart.[1]

No doubt, American females—and young ones, in particular—were meant to see their own potentials in Wonder Woman. Like her, American women answered the call in full force to help "save" their men serving in the armed forces. The popular media showed images of everyday women working in defense factories and Hollywood stars like Rita Hayworth donating their car bumpers to scrap metal drives. Popular women's magazines printed articles detailing ways to conserve food products and to write upbeat, encouraging letters to servicemen. Like other Americans on the home front, Rockford College women were bombarded with slogans printed in magazines and newspapers and broadcast on the radio meant to motivate them to action: "Every Minute Counts," "Your Red Cross Needs You," "America's Answer: Production," "Every Man, Woman, and Child a Partner," "Fighting Dollars for Fighting Men," "Kinda Give It Your Personal Attention, Will You?" American women expected to do their part fighting the war, and women everywhere quickly mobilized to take action.

The *Chicago Tribune* published photographs of Rockford College women effectively breaking gender barriers by working in a local defense plant and studying in the science classroom, part of a self-sustaining, independent community as they worked in their Victory Garden.[2] In January 1941, Mary Ashby Cheek's leadership in civil defense for students drew national attention. An article titled "College Girls Get Defense Training" published in the *Los Angeles Examiner* highlighted her work. "Already the shadow of war has crossed the campus of the woman's college," the article explained. "Courses in nutrition, food conservation, ambulance driving, aviation, home nursing, first aid, and other subjects related to national defense are enthusiastically being made part of the current curricula."[3]

The activism of American women during World War II was astounding. Women had long played active home-front roles in support of American forces during previous wars, but not until World War II did women serve in such large numbers in skilled factory jobs and in the armed forces. Like many women across the country, Rockford College women gave blood, took first aid courses, worked as nurses in community hospitals, cared for children in day care centers provided for war workers, and prepared bandages, surgical dressings, and garments for use in field hospitals in war zones. They raised funds to bring refugee students to the college and to buy a jeep for the Army, collected scrap metal, participated in the "Knittin' for Britain" program, and joined with faculty members to hold community forums that detailed ways to save grease and to salvage paper and metals. One student even teased that the most important contribution that she and her fellow students made to the war effort was attending dances at nearby Camp Grant, which at the height of the war served as the nation's largest induction site for the U.S. Army, a POW detention center, and a training camp for medical personnel.[4]

Women on the Rockford College campus were called to volunteer by students like Aimee Isgrig Horton, who wrote in the school newspaper in 1943 about the college's first students to complete a nurse's aide course. The new nurse's aides proudly wore the Civilian Defense insignia sewn on their sleeves, proclaiming, Isgrig noted, that these women had made intentional efforts to engage in the war effort. "Just remember," Isgrig explained, "that it's the girls in blue denim and the women who wear slacks who will help make the peace and not the women who were slackers."[5]

The "Precious Right . . . to Be Feminine"

Although Isgrig urged Rockford's women to "wear slacks," the efforts made to persuade young American women to action during the war were focused in large part on ways that allowed women to remain feminine. Activities

connected to women's traditional gendered roles were always highlighted for their future value when America's soldiers returned from war. American women, for example, were urged to become nurses—not doctors—and propaganda posters designed to persuade them to work in factories pictured attractive women who were nicely coiffed and powdered, even though they might actually be working in very difficult conditions. The government Office of War Information saw to it that the media, including the Hollywood film industry, promoted not only patriotism and sacrifice but also a woman's freedom to move beyond the traditional constraints of gender. In large part, however, the possibility of greater freedoms for American women was a mirage created to enlist more activism on the home front. Women were encouraged to think that traditional gender standards were part of the past and that to take a factory job or to enroll in classes in male-dominated fields meant that woman's place in American society was changing. Unfortunately, however, the postwar years produced not only a return to traditional roles but also a backlash against status earned during the war. Nevertheless, what Rockford College women saw in the popular media about their national roles no doubt had a strong influence on their education as women.

When Brigadier General John M. Willis, from nearby Camp Grant, visited Rockford College in the fall of 1942, he challenged students to join in the national effort to respond to the war. In a speech to the campus, he urged the young women onward to more profound public roles and more meaningful contributions to community than women had been allowed to join in the past. "If you wish to match the contribution of your sweethearts and your brothers who are serving, or may serve, in the armed forces of America," Willis explained,

> I would suggest that you dedicate anew, through your college work and your unselfish living, your talents and your resolution to the task of taking up where they left off, in order that we, in common with all people, may live a more abundant life, free of fear, in a new day of peace and good will.[6]

Although he emphasized the importance of a young woman's education, Willis identified a particularly feminine education that he hoped these women would preserve. He stated very specifically, "Appreciation of beauty is one of the ultimate parts of life, and philosophy, languages, literature and the arts must hold their place."[7] Rockford women, he hoped, would hold strong to the ideals of womanhood, ideals rooted in the traditionally feminine. Likewise, the young woman reporter who covered Willis's visit for the college newspaper indicated that women were needed for jobs such as "laboratory technicians,

stenographers, newspaper reporters and nurses"—that is, jobs acceptable to American society for young women.[8]

Organizations in charge of relief efforts favored similar methods of persuasion. The Red Cross, for example, emphasized that nurses' training would not only support the war effort but also benefit young women later as wives and mothers. When a scrap metal drive was organized on campus, a large cylindrical container shaped like a lipstick case was the centerpiece. A sign on the container declared, "In a case like this, you can help. Your old lipstick case is needed for scrap metal." Interestingly, the drive seemed to reflect the same sentiments as a Tangee cosmetics advertisement published during the war. Although lipstick could not bring an end to the war, the ad proclaimed, "It symbolizes one of the reasons why we are fighting … . the precious right of women to be feminine and lovely."[9] For American women, the messages they received from society and the media were mixed. Clearly, women needed to take up nontraditional roles to help win the war, but the popular media and society in general continued to remind them of the importance of remaining feminine.

Nevertheless, the political, social, and economic situations of the war years were indeed empowering for young American women on intellectual, emotional, and domestic levels. Although the public messages they received emphasized the importance of retaining their femininity and their position subservient to men, the relief work and conservation efforts that women spearheaded on the home front in fact gave them greater control of their lives and of the domestic realm. Women were empowered by their increasing opportunities beyond the home and by their growing awareness of being able to shape both the future of the war and the postwar world.

Rationing and Conservation

Perhaps one of the most important ways to win the war was an obvious one: see that the men on the frontlines had the proper equipment and food supplies to fight. The domestic world of food was a realm that women could control, and in doing so, they were able not only to find a way to influence the war situation but also to show the value of their participation in the war effort. On the one hand, they were required to follow very specific requirements set by the U.S. government for the ways in which their living spaces—whether it be their own homes, their parents' homes, or the college campus—should function, but such efforts also gave them the sense that they were "soldiers" as well, fighting the enemy through their work on the domestic front. They were soldiers of a sort, soldiers who battled against waste and misuse.

Building a self-sustaining home front that was able to produce food, housing materials, and weaponry for the U.S. armed forces meant not only a drastic

reduction in the purchased goods used by Americans but also increased production of food products within households and communities, such as colleges and universities. Although many Americans still held on to their agrarian roots, and gardening was not uncommon, the public had become increasingly dependent on the local grocery store for everyday foodstuffs in the years before World War II. Across the United States, in both rural and urban areas, Victory Gardens were planted so that citizens might become more self-sufficient producers of their own food. Encouraged by government posters displayed in their communities with slogans such as "Plant a Victory Garden: Our Food is Fighting," Americans viewed Victory Gardens as a patriotic duty, just as they had during World War I.

Hollywood helped to encourage Americans with their efforts by glamorizing the Victory Garden. Stars like Joan Crawford were pictured in popular movie magazines, working in their Victory Gardens and serving their produce to visitors. According to Robert Heide and John Gilman, "It was reported that Crawford favored growing hearty vegetables like beets, cauliflower, carrots, and squash and had a special section devoted to a variety of red, yellow, and white tomatoes." When company came to visit, she served her "Mildred Pierce Victory Salad," named after James M. Cain's 1941 novel about a self-sacrificing mother and a character that Crawford later played in a postwar film.[10]

Down the road from the Rockford College campus, students joined together to farm crops as well. Their work became part of the media's attempts to persuade Americans to activism when a picture of student gardeners was published in the *Chicago Tribune* with the caption "Girlhood at Rockford."[11] Several times the focus of newspaper stories that were carried across the country by the Associated Press, young women at the college became role models for other Americans, showing them ways in which they—a younger generation of Americans—were taking responsibility for themselves and their community. Although the photo captions identify the garden as a biology project, the college's garden became a vital part of the sustainability of the campus.

In large part, Americans' purchases of food products, clothing, and materials related to housing and transportation were controlled by the War Production Board (WPB) and the Office of Price Administration (OPA) during the war years. While the WPB oversaw the production and use of material goods in the United States, the OPA ran the rationing system developed to control use of products such as gas and food. Ration stamps became commonplace for Americans as they calculated the points assigned to various products. While a pound of butter was worth sixteen points and a bottle of tomato catsup was fifteen, a sixteen-ounce can of carrots totaled six. Certain food items were in higher demand, so point totals were higher for them. Meat products,

in particular, were rationed because meat was needed to provide the troops with the physical strength for combat, while fat products were valuable for their use in explosive devices. An article in the July 1942 issue of *Ladies' Home Journal* explained why sugar needed to be rationed: "Sugar cane is needed to make molasses. Molasses is used to make industrial alcohol which is needed to make explosives. Explosives are needed to sink the Axis!"[12]

On the Rockford College campus, student Evelyn Turner ('43), who later joined the WAC, and Miss Bailie, who headed the kitchen, were in charge of reminding students to be ever mindful of the two C's: Conservation and Consumption. The following article from the college newspaper detailed the efforts of these two women to see that the campus curtailed and conserved:

A Rockford College student cook counting points as she prepares a recipe. (Courtesy of Rockford College Archives.)

A Rockford College student asking questions of a volunteer worker at a local Red Cross display. (Copyright *Rockford Register Star*; used with permission.)

The word "consumption" needs no enlargement. (If one consumes, one enlarges.) Conservation, however, up until America's entrance into the war, was always rather a vague term—something to do with the soil and advocated by Teddy Roosevelt. But conservation now has far more vivid connotations, especially to the head conserver, Miss Bailie, and her ally and chief propagandist, Evie Turner. Recalling a popular theory which originated after World War 1—"Fat Won the War," Miss Bailie has pointed out that butter, lard, oils, etc. are used with a minimum of waste, and that the fat which cannot be utilized is sold to a rendering company. . . . The food remaining on individual plates, of course, cannot be salvaged; but it is not wasted. (Ask the lucky farmer who is raising plump pork chops on left-over morsels!)

There are other forms of conservation and economy in the kitchen. All waste paper is baled and sold, tin cans (sans contents) will be sold, and sugar sacks, without even the wave of a wand, turn into dish towels superb.[13]

The article ended by noting that readers could contact Evie for more details on conservation but that they should be careful navigating the dormitory

hallways in the evening in search of her because the halls were kept dark to conserve electricity.

Years later, alumna Judith Moyer Lundin ('47) described a course she took through the Red Cross in Rockford on ways to work within the limitations of the rationing and quotas to provide nutritious food for families:

> The Red Cross had a very real presence in the town. One of the courses offered was a Food and Nutrition course, once a week in the evening, for about 6 weeks. It was designed to help cooks use their food stamps wisely. Women with families took instruction on balanced diet, alternative choices to meats then too costly (in terms of ration stamps). Food groups were news to some of the women in the course. . . . Sharing tips and stories about the rationing situation were part of the evening. . . . Stretching meat points was a real challenge. I think calves' tongue was point free. We had a lot of that at home, since my mother loved it, and the rest of us were hungry.[14]

Courses such as this one offered by the Red Cross not only helped American women become more aware of the nutritional values of various foods but also influenced them to be more competent consumers in a society that was rapidly becoming more commercialized.

Given the scarcity of certain food items, women were forced to be creative in their food preparations. A frequent comment from alumnae of the war years at Rockford College was that ice cream was a rare and prized treat for dessert in the school dining room. Instead, students were asked to give the money that was saved from the ice cream purchase to help support the war effort. The following wartime cake recipe from Joan Ralston Duchon ('65) calls for no eggs, no milk, and no butter, making it a good choice to satisfy a sweet tooth while still conserving scarce resources. Similar recipes were used commonly in the school's dining room.

War Cake

1 teaspoon baking soda	2 cups raisins
2 teaspoons water	1 cup chopped prunes
2 cups sifted flour	1 cup chopped pecans
1 teaspoon baking powder	½ teaspoon nutmeg
1 cup packed brown sugar	2 teaspoons cinnamon
1¼ cups water	1 teaspoon cloves
⅓ cup shortening	1 teaspoon salt

Dissolve baking soda in 2 teaspoons water. Sift flour and baking powder together. Mix next 9 ingredients in saucepan. Boil for 3 minutes. Cool.

Stir in salt and baking soda mixture. Add flour mixture gradually, mixing well after each addition. Spoon into greased bundt pan. Bake at 325 degrees for 50 minutes.[15]

Historically, food and its consumption were linked to family and communal rituals. In many ways, the war created new rituals associated with patriotic duties to the nation as women systematically calculated points for various foods and redesigned their menus.

Rationing and war work also changed the way women across America dressed. Women working in defense factories chose out of necessity to wear more masculine clothing to perform their jobs. Denim overalls or pants became a standard uniform for them, and increasingly, even though women in general continued to prefer wearing dresses, many of those not employed at defense factories chose to wear pants made of fabrics such as gabardine and wool. Even though the mass production of clothing had already become a significant part of the U.S. economy, many women were still accustomed to making their clothing at home with patterns from *Mademoiselle* and *Vogue*.

Orders from the WPB were described in the following story that appeared in the campus newspaper in 1942. The author focused, in particular, on the ways that WPB orders affected young American women:

Eliminated are vents, tucks, bellows, gussets, yokes and other mysteries of the tailoring trade that usually go into the clothes in the college girl's wardrobe. . . .

WPB took the frill out of fashion and brought back the classic silhouette that is most adaptable to long and varied wear. Skirts will be slimmer. . . .

French cuffs, leg o'mutton sleeves, patch pockets, jacket dresses, redingotes, bolero dresses, belts wider than two inches are among the casualties. Wool linings are banned from coats. . . . Jackets will be shorter and plainer. Three piece ensembles cannot be sold at all.

Simplifications stretch all the way to slips, pajamas, nightgowns and housecoats. . . . Pajamas and robe combinations and other two-for-one price items are out—wool cannot be used to make sleeping or lounging clothes. College dorms will be seeing more and more quilted cottons, velveteens and cotton flannels. . . .

Shoes for both men and women can be made only in six colors: black, town brown, blue, white, turf-tan and army russet. No new shoe designs can be made.[16]

The newspaper article closed by noting that in taking "the frill out of fashion,"

the WPB hoped to save millions of yards of wool, cotton, rayon, and leather hides for the war effort.

The "Fashion Focus" columnist in an October 1943 issue of the school newspaper urged fellow students, "DON'T buy every little trinket your lovely eyes light upon . . . and DO buy what you must, carefully!"[17] Her words were similar to Keith Ayling's, whose 1942 book, *Calling All Women*, a handbook of ways women might support the war effort, was circulated around campus and found a wide audience throughout the United States. Ayling reminded women of the Consumer's Pledge and encouraged them to sign it: "I will buy carefully. I will take good care of the things I have. I will waste nothing."[18]

As women's clothing became more masculine and less frilly, the styles of the war years also took on shapes that allowed women more physical freedoms and presented them as stronger, more empowered human beings. Scholars have noted that even in women's makeup of the 1940s, "there was nothing dewy soft or feminine in the look." Lipstick shades such as Victory Red, Patriot Red, or Orange Flame were all in vogue, and "thick lipsticks left their imprint everywhere, on coffee cups and men's shirt collars." Historians have speculated that perhaps these strong colors with "a hard edge" reflected not only the harsh reality that men were scarce on the home front, and bold efforts were needed to attract those who remained, but also the growing independence of American women.[19]

War Bonds

If any savings came from producing vegetables in Victory Gardens and limiting the purchase of food items and clothing, that money could be used to buy war bonds and stamps. First available in 1940, Defense Savings Bonds were originally devised as a way to help the struggling U.S. economy. After the Japanese attacked Pearl Harbor, the bonds were renamed war bonds. With the first one sold to President Roosevelt on May 1, 1942, for $375, war bonds were guaranteed to grow in value to $500 in ten years. Available in various places such as post offices, banks, and grocery stores, bonds were widely advertised in the media as a way to fulfill a patriotic duty.

The federal government launched an extensive campaign to promote the purchase of war bonds. Ads were printed on posters displayed widely in local communities and in newspapers and magazines across the country. Often making emotional appeals, ads like one titled "Listen to me . . . before I die!" that portrayed a dying soldier were meant for a wide-ranging audience. Published in the local Rockford newspaper by the War Effort Publicity Committee of Rockford, this particular ad appealed to a reader's sense of patriotism and compassion. The ad also asked a pointed question: "We're meeting our quota

in death out here. Are *you* meeting yours back home?" Attempting to prompt feelings of guilt, the ad suggested that Americans stateside should weigh their own sacrifices against those of servicemen giving their lives for their country.[20]

The Dramatists' Guild of the Authors' League of America was also called into action to help promote bonds. The guild established a play service that encouraged organizations across the country to present plays in their communities to promote the purchase of bonds. With noted authors such as Susan Glaspell, Clifford Odets, and Eugene O'Neill serving on the advisory board, the play service promoted copies of *War Bond Plays*, a collection of short dramas written for a variety of audiences that was published by the Women's Section of the War Finance Division of the Treasury Department. The executive director of the play service explained that he and the other officers of the guild "believe we can set in motion an operation that will redound to the credit of our profession and to the success of the War Bond Program." Plays such as these were a part of many war bond rallies, local club meetings, and radio programs. One play produced in an eastern state was said to have sold more than $70,000 worth of war bonds in seven weeks. Some of the selections were winners of collegiate contests, while other plays were written by local authors.[21]

One fifteen-minute play included in the collection was written specifically for women's colleges. As three students in a college dormitory room discuss their plans for the weekend, one makes the case that the money they planned to spend to attend a dance at a nearby men's college named Wilton should instead be used to purchase war bonds. "If I went to Wilton, I'd have to buy a new dress and a railroad ticket and *(with a wry smile)* even a finger wave. And this way I can put all that money into War Stamps and help buy guns and bullets," explains one of the students, named Mary. Presenting arguments that the author of the play described as "sugar-coated," Mary ultimately persuades her friends that they could put their college "on the bond map" by setting up bond booths in their dorms, establishing "meatless and dessertless days," and putting the money saved into stamps. By asking others to "treat Uncle Sam to a War Stamp every time they treated themselves to a coke," they could save enough money to help buy a jeep for the U.S. military.[22]

Newspaper and magazine advertisements for war bonds were also skillfully aimed at specific audiences, including female college students like those attending Rockford College. The samples included here were all published in the school newspaper.[23] The War Bond Bonita series, published in 1944, appealed to women not only by emphasizing stereotypical qualities but also by including humor. Young women appeared to be focused on clothing and appearance, in large part as a way to achieve the traditional female goal: marriage. Yet they also seemed determined, patriotic, and conniving, willing to

make something as simple as a casual loan of clothing into barter for money to support American troops. Young women, according to the ads, thought not only about meeting the right man but also about the future—their own and the country's. Likewise, in the figure below, the ad suggests that a woman's value could be measured in how she responded to the war situation. Although the ad focuses, as was typical, on a female's identity through her relationship with a man, Hal recognized a woman's value in supporting the war effort. The naive young woman on the right in the ad appears a bit taken aback by her friend's response to Hal's comment, but she is portrayed as the inexperienced pre-frosh, that is, an incoming freshman, characteristically enamored with the older girl's comment.

"Welcome, Pre-Frosh!" war bond ad from 1943.
(Courtesy of Rockford College Archives.)

"These Women!" ad, one of the War Bond Bonita series.
(Courtesy of Rockford College Archives.)

Other advertisements were aimed at appealing to different emotions of *Vanguard* readers. One such ad, titled "Don't Let This Happen Here!" and published in 1943, showed the dangers of what might come to pass if the Axis powers were allowed to succeed. Clearly focused on the value of the American educational system, the ad appealed to the fears of young women and men who were not fighting in the armed forces but were studying in high schools and colleges. The menacing Nazi figure on the left appears ready to take over schools and to keep young people from the freedoms that education could bring. Planting fears that schools and colleges would be turned into "breeding grounds for lies and hate" if the Axis powers won the war, the ad suggests, too,

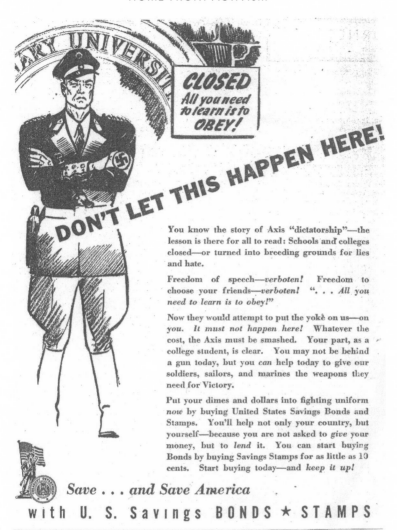

CLOSED
All you need to learn is to OBEY!

DON'T LET THIS HAPPEN HERE!

You know the story of Axis "dictatorship"—the lesson is there for all to read: Schools and colleges closed—or turned into breeding grounds for lies and hate.

Freedom of speech—*verboten!* Freedom to choose your friends—*verboten!* "... *All you need to learn is to obey!*"

Now they would attempt to put the yoke on us—on you. It must not happen here! Whatever the cost, the Axis must be smashed. Your part, as a college student, is clear. You may not be behind a gun today, but you *can* help today to give our soldiers, sailors, and marines the weapons they need for Victory.

Put your dimes and dollars into fighting uniform *now* by buying United States Savings Bonds and Stamps. You'll help not only your country, but yourself—because you are not asked to *give* your money, but to *lend* it. You can start buying Bonds by buying Savings Stamps for as little as 10 cents. Start buying today—and *keep it up!*

Save . . . *and Save America*

with U. S. Savings BONDS ★ STAMPS

"Don't Let This Happen Here!" war bond ad from 1943.
(Courtesy of Rockford College Archives.)

that those who bought savings bonds and stamps would be not only helping with the war effort but also helping to build their own futures. After all, "you are not asked to *give* your money, but to *lend* it," the ad reads. Many arguments made in the media in support of women's involvement appealed not only to the importance of winning the war but also to the necessity of preserving an American way of life—both an American lifestyle and the individual's freedom to live the life that she chose.

CHAPTER 4

"A Certain American Morale Must Be Upheld"

Mary Ashby Cheek frequently reminded her students that supporting the war effort meant working to preserve Western civilization. Completing such an ethereal task meant, in part, helping to sustain the morale of American servicemen and to keep them ever-mindful of the reasons that they served. Such work was translated into action in many ways. For instance, students increasingly came to realize the ways in which letters from home could support rather than hinder the war effort. Drives such as the Victory Book Campaign provided books not only for entertainment to the men on the battle lines but also as reminders of American cultural values with freedom of speech and a history grounded in Western civilization.

The letters that were exchanged between the battlefront and the home front actually represented a complex relationship. Letters home from the men fighting on the front became important not only for those individuals emotionally connected to the soldiers but also for the ways those communications helped garner overall support for the troops. Letters from soldiers were frequently printed in the school newspaper and circulated on the Rockford College campus, providing those back home a way to learn about situations abroad, but there was also an urgent craving for these letters by many who just wanted reassurance that the Allies were winning. Likewise, enlisted men on the front needed to know that the folks back home were behind them. Women were encouraged to think very carefully about the implications of upsetting news they might send from home, and soldiers' letters often downplayed the atrocities of combat and the difficulties of their living situations.

In October 1942, the school newspaper published the following article with some suggestions from Professor Meno Lovenstein about ways to be sensitive letter-writers to the troops. An assistant professor of economics known as "Lovey" among the students before the war, Lovenstein was by 1942 a sergeant in the U.S. Army stationed at Fort Benjamin Harrison in Indiana.

> Lovey, in his familiar role of "Brother-counselor," gave a bit of advice about writing letters to boys in the service. He said it was rather futile to tell them to "buck up," to wish them "on to greater glory," to tell them to "keep going"'—when it doesn't make any difference whether they "buck down," when any man who does his duty is a hero, and they haven't the vaguest idea *where* they are going! "Love-letters" are out. They only make the boys feel worse, as they are in no position to reciprocate. They want very much to receive news about the familiar, homely things of life, and the finest kind of letters they can receive are those written in the tone of the companionship achieved after five to ten years of married life.[24]

"The boys," according to the newspaper article, "seldom talk or read about the progress of the war, and, of course, Second Front talk is taboo."[25]

In November 1942, when student Evie Turner wrote to Lovenstein, who had been one of her teachers, she also sent along a box of home-baked cookies. The following letter expressed his thanks for Turner's kindnesses:

> I hope some of the things I said in class meant as much to you as your cookies meant to me. There isn't anything a soldier understands more than a cookie. It is such a domestic little cake, so anxious to be appreciated. I don't believe in all these years I have ever found a person who did not like cookies. Olives, yes. Green peppers, yes. But I don't believe a person could go on living if they did not like cookies.
>
> I am working from morning until night. . . . So the army gets around it by calling me sergeant. And with that title, I work from early in the morning until late at night. That means I have only a few minutes to rinse socks, sew on buttons and attend to my other *military* duties. My work is teaching a writing lecture—I write lectures for the teachers to use and then I teach them how to use them. I have several other jobs on the side so that most of the time I feel like a trained elephant in a third-rate circus.[26]

Lovenstein closed his letter by stating that if the military ever sent him to "Cooks and Bakers school," he would send some cookies to Evelyn. "Until then I can only send my gratitude," he added.

Somehow, the cookie seemed to have become a powerful domestic metaphor, especially when it was sent in care packages to college students studying away from home or to servicemen posted anywhere far from home. So many packages filled with cookies and other favorite foods were sent to members of the armed forces during World War II that the Central Illinois Electric and Gas Company in Rockford displayed samples of "boxes from home" in their Home Service window so that women might gather some ideas for their own care packages. Likewise, the company also distributed copies of their "Cookie Jar" recipes as part of their "service" to the troops.[27]

Many American women, including students at the college, took up the responsibility of writing letters to servicemen overseas—in many cases, to men the women did not know—as a patriotic duty. Women often felt it a duty to write letters so that servicemen might have the pleasure of a letter from home and the comfort of knowing that those back home were still behind them. As Americans hungrily devoured the news printed in newspapers and listened intently to radio reports, receiving a letter in return also meant more news from the front and, of course, a more personal perspective on the war.

Catey Glossbrenner Rasmussen, who studied at the college from 1943 to 1945, received the following letters from her cousin, Lieutenant Walter A. Vonnegut, who was a cousin of writer Kurt Vonnegut. A bomber navigator before he was captured by the Germans and held prisoner in Nazi Germany, Walter Vonnegut wrote his first letter home on Armistice Day, just six days after the raid during which his plane was shot down over Munster, Germany. Vonnegut mentioned the letters and packages from home that came to mean so much to him and the efforts of the Red Cross in seeing that prisoners were treated with dignity. Glossbrenner circulated Vonnegut's letters around campus so that her fellow students could hear from a serviceman behind enemy lines and know that their efforts through the Red Cross were helping even those who had been captured by the Nazis.

November 11, 1943—I am writing from a German prisoner of war camp. In a few days we will be moved to a permanent camp where we will receive numbers and where you will be able to write to me. . . . I am not hurt and am in very good health. Am with a bunch of Americans and English flyers and do not want for good company. We have plenty to read and nothing but spare time. So things are not so bad. God bless the Red Cross! . . . You can send us packages, I believe, and as many letters as you wish. I believe I will be allowed to write one or two letters a week.

November 22, 1943—Arrived new station today. The fact that I am a prisoner of war is slowly coming to my realization. So far we have been treated as well or even better than we expected. Thanks to the Red Cross, we eat quite well. The Germans supply bread, cabbage, and potatoes, and the Red Cross parcels give us tinned meats and fish, margarine, raisins, chocolate, cigarettes, etc.[28]

Vonnegut later wrote how he was using his time constructively by learning contract bridge and how to cook without a full larder, taking a business administration class taught by a fellow prisoner with a business degree, and even learning piano and some German in addition to gaining the usual prisoner skills of improvising for many needed items. The conditions Vonnegut described seem to make clear he was concerned about the worries of those back home. His letter is an excellent example of how soldiers—even those imprisoned by the Nazis—attempted to hide the true conditions of war from their loved ones. Whether he was attempting to "buck up" in the face of adversity, protect the innocence of a woman back at home, or perhaps convince himself that the situation was not dire is unclear.

Another way that women provided support for the troops was through the

establishment of libraries in military camps and bases and at USO clubs. The Victory Book Campaign became an important part of the cause at Rockford College, especially because the Nazis were known for their attacks against academic freedom, including book burnings and the murders of countless university students and professors in Europe. The local public library advertised the drive with posters pointing to "Books as Ammunition."

An appeal titled "Not the Bobbsey Twins" was published in the school newspaper on January 15, 1943, calling for an urgent effort to see that American servicemen and servicewomen had access to libraries. "Do you suppose that the boys fighting in Africa, Australia, or any of the other war fronts ever take time out to read? Silly question, isn't it?" the article asked.

> But have you considered what material is available to them in their "spare time"? Are they to be condemned to reading the foreign books and magazines which the locality offers? Or are they to have choice libraries of their own which can be transported as the Army moves . . . ?

According to the article, books filled a gap that letters, sight-seeing, and companionship could not. Mail could be late or lost. In wartime, "a man likes to relax, to wander through thought paths that other minds have trod." Even companionship "cannot fulfill the same purposes that reading a good book does," the article explained.[29]

Books were a way to hold up "a certain American morale," a morale built on education and contemplation. Libraries housed on military bases or training camps, according to the *Vanguard*, were intended to remind servicemen and servicewomen that they fought not only for freedom but also for the preservation of American culture and an American way of life. As troops sacrificed, so too were students expected to share what they had learned while pursuing their educational goals during wartime:

> When men and women (for the WAACs [Women's Army Auxiliary Corps] and WAVES share these libraries) have given up the security that we accept so casually; when they have gone into training to defend us from aggression, can't we make it up to them in some way? . . . [U]ndoubtedly we all have books that should be shared immediately with the fighting forces of America. We can never become educators or even democratic in our ideas, if we persist in keeping our knowledge to ourselves.[30]

Encouraging students to donate with the national slogan "The Book to Keep Is the Book to Give," another story published in the college newspaper in 1943 explained that the books most needed were

textbooks in such things as anatomy, mathematics, physics, chemistry, and psychology; and novels that are fast moving such as mysteries and westerns. The favorite books, however, are those containing old but lovely poems. They are definitely first on the book parade in service libraries.[31]

The Victory Book Campaign was spearheaded by the American Library Association and financed by the American Red Cross and the USO. Describing "a good book" as a "valuable and conveniently packaged projectile of morale," the final report of the campaign indicated that a total of over 18 million books were collected, and 10 million books were "carefully selected for distribution." The army was the largest beneficiary of the program, with over 4 million books going to servicemen and servicewomen in the United States and 1.3 million overseas. American prisoners of war being held in Germany and Italy were also allowed "carefully selected books" that were "unsoiled" and "contain[ed] no marks of ownership, notations or evidence of erasures." The campaign ended on December 31, 1943.[32]

The school newspaper reported in April 1944 on another relief effort in which the World Student Service Fund (WSSF) sent American POWs packages that included "a sewing kit, handkerchiefs, an eversharp pencil, writing pads, and an English-German dictionary."[33] The WSSF was also able to collect tremendous numbers of books for POWs. In one canton in Switzerland, for example, 145,000 books were collected. In the United States, the WSSF encouraged students to participate in their efforts, claiming that "through these books many soldiers were able to learn things which will be of lasting value to them, and the time of their imprisonment has not been entirely lost to them."[34] The WSSF also helped with communications to POWs in Europe and aid to Chinese students in occupied areas who had been cut off from their families. The tremendous outpouring of support from American students for the WSSF and the Victory Book Campaign showed how these organizations became important tools for empowering students who found themselves far from the battle lines of war.

Home-Front Duties

The rapid mobilization of the home front during World War II was unmatched in American history. With an American Red Cross first aid station and a canteen unit located on the campus, four USO clubs in the city of Rockford, and Camp Grant on the outskirts, Rockford women were surrounded by war activity that seemed ever-present in their lives. Jacquelyn Silcroft Forslund ('46) explained in a reminiscence recorded in 2007:

We were constantly reminded of the war day after day. Not only because of the presence of soldiers; so many of the students wrote constantly to their military boyfriends who were overseas; letters were censored or arrived 2 to 3 weeks or more after they were written and sent. It all became an acceptable way of life.[35]

And as a result, service to community became a vital undertaking.

Some students worked in day care centers in town. While the first federally funded nursery schools were established during the Depression years as a way to increase employment, day care facilities were set up in the war years to provide child care for women working outside the home. Although not widely available across the country, facilities were opened in the Rockford area for women working in local industry. Yet while the work of Rockford College students in day care was acceptable as a job appropriate for young women, the messages that were sent to mothers of the day care children were mixed. Meant to provide care for children of war workers as long as the war was being fought, the centers actually became an essential part of working women's lives as they gave women the opportunity to work with the reassurance that their children were well cared for. The centers were closed after the war ended, as were those opened by industry to provide such services for their employees. Even though some interpreted the federal establishment of the centers as an indication that a mother working outside the home was acceptable to American society, in reality, the move was done purely for the expediency of the war effort and made it easier to convince women to enter the workforce.

Wearing a uniform complete with tie also became standard for many women—a symbol of what they saw as their increased power and worth in society. Local members of the Red Cross Volunteer Service Corps were asked to follow guidelines such as "Do cut your hair shorter, give it an upward curl" and "Don't swagger or stride along in masculine fashion" and to show pride in their uniforms by changing into street clothes as soon as they were off duty. Volunteers were encouraged to practice once a week on first aid and on "stretcher bearing, loading and unloading patients in Station Wagons and on beds." The photographic department at a Rockford department store named Weises promoted what the local Red Cross described as a "marvelous offer" for young women volunteers to have their picture taken in full uniform. One dollar purchased a miniature of the young woman and a composite picture of the corps.[36]

While members of the Rockford College Chorus performed for convalescing patients at the Station Hospital at Camp Grant, other students worked at local USO clubs. Established as a governmental agency in February 1941, the

USO quickly set up centers around the country to provide entertainment, educational opportunities, and various services to men and women stationed at area military camps. Along with some of her classmates, Jacquelyn Silcroft worked at one of the USO clubs in Rockford. In the following passage, written in 2007, she described some of the activities provided for servicemen:

> Those of us who were volunteers served cokes, cookies, donuts and coffee, chatted and danced to the music from the jukebox if the soldiers could gather sufficient courage to ask us. Many of those soldiers who I met and saw were new very young recruits from all over the country and away from home for the first time in their lives. One should not picture a gay ebullient motion picture scene. There was no "big band." Frances Langford was not singing nor was Jo Stafford. It was informal and at times awkward. But we certainly felt we were "doing our part" for the war effort.

Forslund also noted that only upperclassmen were "allowed to participate" as helpers at the USO, and students walked together to the USO in small groups.[37]

The local USO clubs in Rockford served the Camp Grant area, providing activities ranging from dances (sometimes complete with orchestral accompaniment), cards, movies, suppers, bingo, square dancing, free voice recordings and sketches, finger painting, and art and camera classes. Service personnel could attend community sings and Sunday musical programs, make gifts to use themselves or to send home, take German classes, participate in physical activities ranging from basketball and swimming to boxing and wrestling, and attend Sunday evening or Temple Supper Parties. Dr. Jordan Cavan from the education department at Rockford College moderated "Soapbox Discussions" for the soldiers on a variety of topics, including "Will Jobs Be Waiting for Soldiers after the War?," "USO Contributions to the War Program," "What Will Happen to Germany after the War?," and "Should the U.S. Join an International Police Force?"[38]

Oftentimes, Rockford College graduates wrote articles for the college's alumnae publication about their work in similar programs. These women wrote not only to communicate information about their important defense roles but also to encourage other women to become involved as security and the responsibilities of citizens on the home front became key concerns. Alumna Esther Ostlund ('33), who worked at a USO station near Fort Riley in Kansas, wrote in 1943 to encourage Rockford College students and alumnae to join and support the USO. Exclaiming that "the USO is a wonderful institution," Ostlund noted that she was "convinced that it fills a definite need wherever there is an army camp or industrial area." The list of tasks undertaken by

Ostlund and her colleagues on behalf of male soldiers illustrates the wide range of assistance provided by the USO for active military men:

> We help them get rooms for their wives and do millions of little things for them such as buying and mailing presents for their wives, mothers, and sweethearts, doing their banking, visiting them when they go to the hospital, sewing on their chevrons, writing their letters, arranging for weddings—and sometimes divorces, and often serving as broad shoulders for them to weep on. There is always a group ready to gather around my piano to sing, and the boys who have brought their instruments to camp are always looking for an accompanist.[39]

Ostlund explained that the USO was made up of six national agencies—the National Catholic Community Service, the Jewish Welfare Board, the Salvation Army, the National Traveler's Aid, the YMCA, and the YWCA—that "banded together" at sites near army and navy bases to help care for the needs of enlisted men, military wives "from all over the country" who were living in the area, and "girls" who were employed as civilian personnel on the military base.[40]

Recognizing that life in a small town was hard for many of the women served by the USO who were far from home and friends and living in crowded facilities where the only private space was a single room, Ostlund identified their great need for "recreation and companionship." Gym classes were offered for officers' wives, enlisted men's wives, and, as Ostlund identified them, "business girls." Because the women had no cooking facilities in their rooms and ate all their meals at local restaurants, a luncheon club that met weekly was a welcome relief. The community meal meant both companionship and an opportunity for the women to fix their favorite dishes. Every afternoon was spent sewing layettes, overseas kits, drapes for rooms in the camp, or anything else that might be needed.[41] "At other times," Ostlund reported,

> the wives congregate in our club rooms to meet each other, play bridge, knit, embroider pillow cases that they hope to use in homes of their own some day and to do volunteer service for us. We put them to work typing, working in the canteen or running the information desk. If they need regular jobs, we help them there, too.[42]

With many women being prospective mothers, special programs were developed to help them, including weekly meetings.

> Most of them are in their first pregnancy and are far away from home. Clinic days at the Post Hospital are so crowded that the physician doesn't have time to answer all the questions the girls would like to ask, and they look forward to this opportunity of talking freely with the public

health nurse who is in charge. She works closely with the army hospital and gives them not only specific information, but above all, courage and confidence. She also has at her disposal all the baby garments that one of the clubs of army wives has made.

... [W]e are frequently called on to handle emergency cases. There was, for example, the soldier's wife who was released from the Post Hospital three days after the birth of her baby because of the shortage of bed space for maternity cases. The following day the public health nurse called on me for help in taking care of the woman and her child. We found her living in a converted garage which had no running water, no food in the house and no facilities for caring for the new baby. I talked to a group of wives and found one who volunteered to go out to the home for several hours each day until the mother could take care of things herself.[43]

Growing concern for the difficulties of new motherhood prompted the women working at the USO to keep on file a list of the names of army wives who would be willing to help care for new mothers until they were able to care for themselves and their children.

As more and more women in the United States entered the workforce during World War II, war also dramatically increased the number of marriages in the country. Historian Susan M. Hartmann notes that census records indicated that between the years 1940 and 1943, over "a million more families were formed than would have been expected in normal times."[44] The tremendous surge in marriages and births signaled the beginning of the Baby Boom generation. Marrying a serviceman also provided a bit more security for a woman because of the dependent benefits offered by the government, although many women like those whom Ostlund describes found themselves living far from their homes, waiting for husbands off at war, and often attempting to handle the struggles of new motherhood alone.

The movement of military men, women, and families around the country represented some changes from the past. Whereas nineteenth-century American history was shaped by the pioneers' movement westward to settle the vast open spaces of the North American continent, the migrations of Americans from more rural communities to industrial and military areas during World War II and in the postwar years changed American society almost as much, if not more. Ostlund points, in particular, to the ways women were affected as increasing numbers of them left their home communities to be near husbands' military bases or to secure jobs as civilian personnel in military camp offices. With World War II, the modern American lifestyle quickly evolved into one of mobility and displacement because of Americans' increasing willingness to leave home communities for better job opportunities typically found in urban

areas. This migration of a largely white population followed paths similar to those of African Americans who streamed out of the southern United States following jobs—first during World War I and again during World War II and beyond—to northern and western urban centers as part of what became known as the "Great Migration." That movement of millions over multiple decades was repeated during the war years by men and women moving for military service, military employment, and wartime industrial production.

Increasingly, the alumnae publication in which Ostlund shared her USO experiences became an important vehicle for many Rockford College women encouraging others to more active lives of service. A number of articles were written for the *Alumna* by Rockford College women serving overseas in various divisions of the military. When Agnes Andrews Jackson ('24), chairman of the Civilian Defense Volunteer Office of Detroit and a member of the Air Raid Warden Training Division, wrote to fellow alumnae of the college and current students in 1943, she stressed the important work a woman could do in her own hometown. Her message was printed in the *Alumna* in February 1943:

> None of us can go to sleep without considering the possibility that enemy bombs may send our roof tumbling about our head before morning. So we must have air raid wardens; we need fire watchers; we must have patient women who will sit in control centers waiting to take that ominous Army Flash that says hostile bombers are heading our way. These are A-1-A priority jobs, and Detroit women have undertaken them as such. We necessarily must have plans made for emergency feeding and housing and for mass evacuation. And back of the thousands of monotonous details that must be worked out to make these plans function are hours of thought and planning by women.
>
> . . . [In addition,] hundreds of women staff the Civilian Defense offices in the proportion of a hundred volunteers to one employee. Others work equally faithfully for overtaxed draft boards. Not glamorous work, certainly, to type and file and answer telephones, but basic work!
>
> Then there are the women who have perhaps the most wearing work of all—the volunteers who assist rationing boards. No more thankless post could be found, and, as a friend said, "It's a chance to see human nature at its worst." Yet without these woman volunteers, our rationing program would bog down.[45]

Women working in the Civil Defense offices were not alone in their contributions in the Detroit area and elsewhere. Whether it was as Girl Scout leaders, as blood donors, or as one of the legions of women who collected for the War Chest, women were encouraged to help in myriad ways.[46]

As a way to encourage her audience to take action, Jackson listed off numerous ways that Detroit women had had success in working for the war effort: "Women make the salvage campaigns succeed. Women spread the gospel of proper nutrition, or economical buying, and of regular War Bond purchases. Women study First Aid and Home Nursing to help themselves and others."[47] Noting that roughly 2,000 women in Detroit had been trained as nurse's aides and were currently working in local hospitals, Jackson pointed out that the Detroit program had recently graduated the largest class of student nurses in the nation with a total of 224 new nurses and that coursework had been completed in the evenings, after all of these women had worked a full day at a job outside the home.[48] The Detroit "Block Plan" put even more women to work in their neighborhoods keeping area women informed about "war programs, on conservation, and getting their cooperation in every manner in which women kept at home may help in Civilian Defense." Jackson confirmed that "every day more and more Detroit women are finding their own particular niche in the Civilian Defense program . . . [in] the spirit of willing, tireless service."[49]

One of the most interesting points in Jackson's article is that despite the "hours of thought and planning," women dedicated to civilian defense in Detroit were, according to Jackson, "largely omitted" from the Defense Councils that made decisions about priorities and needs. Although women did the "preliminary thinking-through as well as the actual spade work" for the programs, they were not granted leadership roles. Modestly, she claimed, they were "satisfied that the service, not the recognition, [was] the important thing."[50]

Even though Jackson seemed willing to keep herself and other Detroit women in traditional female roles, she could have omitted her comment concerning the lack of women in leadership. Instead, she made it one of her concluding points. She closed her article by framing civilian defense work as an "opportunity," a term that Mary Ashby Cheek used to draw a relationship between the war and women's education.[51] Through this war work, Jackson explained, the women of Detroit—even ones who had never been active before—found niches that were most suitable for them as individuals and then took action. Stating that civilian defense work "isn't exciting, but it's essential," Jackson thus suggested this work helped women find their individual identities in the numerous types of jobs available that ranged from clerical worker and rationing board assistant to nurse's aide. All, though, were called "Victory Aides," for they were all part of the effort to win victory for the Allies.[52]

Staff and faculty of the college also played their part in the war, and one of those women was Lesley Frost, daughter of Pulitzer Prize–winning poet Robert Frost. Their activities served as models for other women struggling with decisions about their roles in time of war. Lesley Frost came to the college in

1934 to serve as director of Maddox House, which was called "an experiment in the field of campus bookshops for student browsing."[53] Composed of a "tearoom, book shop, and lounging rooms" in the former home of a late president of the college, Maddox House sponsored informal talks and readings by noted literary artists ranging from Robert Frost and Carl Sandburg to Louis Untermeyer and Dorothy Canfield Banning. The Old Book Room on the second floor was said to allow the student to "imagine herself in a London Bookshop for yearly shipments from England bring a miniature Harding's into the very center of the Rockford College Campus."[54] Before taking her job at Rockford, Frost toured New England with a book caravan and ran a bookshop that she took around the world on the SS *Franconia*.

By the time of World War II, Frost was on the East Coast running a school and working for the war effort. The following wire story, which was included in the Rockford class historian's scrapbook for 1941–42, described Frost's work as an electrical "man":

> Washington.—The boys on the graveyard shift at the TWA maintenance hangar here are unanimous in their approval: "Leslie Frost? She's Tops!"
>
> They are referring to the lithe, blue-eyed lady in coveralls, precariously a-straddle the nose of a huge four-engine Army transport. Maybe she's checking wires that must be perfectly attuned, maybe she's changing some of the 28 giant spark plugs in a 2000-H.P. engine. Whatever she's doing, she's doing it well.
>
> At the hangar, she's No. J-10291 on the maintenance crew, only woman on the graveyard shift; a skillful team member getting a man's salary, doing a man's job. She knows the work. In World War I she carved mahogany propellers for wooden planes. In this war, she worked up from trainee ranks, cutting props with steel blades; riveting bolts in plane parts; weighing propellers with a skillful eye and a "good feel"; inspecting precision instruments.

"Now, she's an electrical 'man,'" the newspaper article proclaimed.[55]

Frost's work outside the factory was just as interesting to the paper's readers, for she ran a small boarding house in Washington where she conducted a "school for the open mind" that included many open, informal roundtable sessions. Run as "a sort of home," the school organized student days so that "the girls" worked in war jobs during the day and attended seminars in the evening. "Sometimes Robert Frost drops in for a few days, sometimes his crony, Padraic Colum, holds forth on Irish mysticism"—the visitors were endless, according to the article. News commentator Warren Mullin visited to talk with students about current affairs. Painter Init Kaufman from Vienna, a Wellesley

professor who fought in the Spanish war, and a Mexican political hero made stops as well: "All mingle in discussions at Lesley's school."[56]

Because Frost had done war work during World War I, her overall career was something worth noting, for it included sailing from New York to the Baltic Sea, touring New England with her caravan bookshop, and raising two daughters. In addition, she had written books, taught as a professor of English at Rockford College, and worked as an editor, author, press agent, and reporter. Her perspective on the outcome of the war seemed of clear interest as well. The news article indicated that she had "no post-war plans. In her estimation, the war won't end in this century. It may have a brief armistice, but the social and religious and race upheavals will go on through our generation, she believes."[57]

In some ways, Frost's work as an "electrical man" seems puzzling given the fact that she was described as believing that the war would not end in the twentieth century. Despite the fact that Frost had "no post-war plans," soon after the war, she served for two years as the cultural officer and director of the U.S. Informational Library in Madrid. Subsequently, she became the first woman sent by the U.S. State Department's Culture Division to lecture in South America on U.S. literature and ideology.

In an essay concerned with American women like Lesley Frost, Margaret Mead concluded with the following lines:

The man who left the country in 1941–42 will come back to a new generation of girls, who were skinny little things without curves when they went away. These girls will be, inevitably, a new kind of girl, girls bred on the war years, on a different sort of romance, with a line which has a sharp staccato beat. . . . They will bear practically no marks from the depression years. War has stood at the beginning of their young girlhood, not crashed rudely into the middle, finding them unprepared. They will be standing on tip-toe for the postwar world.[58]

But could the hopes of being Wonder Woman sustain them? Womanhood in the war years of the 1940s was unique in the United States—and, in fact, the world. Young American women entering adulthood in the early 1940s included women like Betty Friedan who were active participants in the women's movement of the 1970s; they were also the mothers of daughters who continued the movement and benefited from its achievements. Although battling from the home front during World War II tied many women to the traditional domestic realm, the struggles and the opportunities they encountered there produced a new generation of American women who, according to Mead, would "have to make new patterns" for the ways they lived their lives.

Those "new patterns" were a clear part of the story of Rockford alumna Frieda Harris Engel and her work in civilian defense. Writing of her duties as an air raid warden in New York City in 1940, Engel explained how empowering war work was for her:

> I took [my job] very seriously. . . . The fear was that the Nazi submarines would attack, and it was important that no lights would be shown. . . . I walked in the darkness armed by my tin hat and my arm band and felt very brave, but feeling like I indeed was participating actively in the war effort. . . . It was an exciting time.[59]

Although Engel was accompanied by her husband, Joe, on succeeding nights, the image of a young woman who "felt very brave" as she made her rounds through the darkened streets of New York City represented a new type of American woman, ready to walk out into the world with her head held high.

5. Women Wanted

The attraction of joining the military was a powerful one for many women during World War II. In 2002, Patricia Talbot Davis remembered not only the appeal of the armed forces but also her parents' reactions when she told them of her hopes of leaving college during her freshman year and enlisting:

> "This is London." Edward R. Murrow's deep distinctive voice filled my room. . . . The crackle of fire, the burst of bombs, the whine of sirens, the snap of anti-aircraft guns could be heard in the background. I envied him. He was where I wanted to be. . . . My parents were horrified at my request to join the Canadian Women's Air Force at seventeen and refused to sanction my enlistment. Rockford College was not where I wanted to be in 1941. . . . I spent World War II studying for a future I could not imagine.[1]

Her envy and admiration of the radio broadcaster Edward R. Murrow were shared by many students at Rockford College. Like so many other Americans, they tuned in to his broadcasts routinely and followed with interest his first-hand, vivid reports of the war from London. The knowledge that he himself flew as a passenger on combat missions undoubtedly spurred a desire to be involved. Murrow and his wife were friends of President Mary Ashby Cheek, a connection that must have enhanced his image among the students. Talbot's reason for wishing to join the Canadian Women's Air Force was probably influenced by the fact that it was established almost a year before a comparable U.S. military branch for women.

In large part, Talbot's envy of Murrow's place on the frontlines suggested her frustrations at not being a part of the war story that she heard reported on the radio news. "Wars are deeded to us as texts of a particular kind," historian

Jean Bethke Elshtain wrote in *Women and War*. "When the texts are first-person accounts, real or imagined, they invite us to enter a war of words, to familiarize ourselves with the text and the texture of wartime experience." Woman's *"absence"* from the war narrative "has to do with how war gets defined (where is the front?) and with who is authorized to *narrate*." To put it bluntly, according to Elshtain, "women are excluded from war talk; men, from baby talk."[2] Interestingly, the greatest numbers of women recording the events of American wars seem to have been writing when they were close to the battle lines. The Civil War, for example, was the impetus for a tremendous surge in the number of personal writings produced by women, as they recorded in diaries the events that they saw swelling close around them.

For the World War II era, women tended to record their stories of war more often when they were serving overseas or in a region of the United States that was distant from their home. Of course, the distance from home was a major factor that encouraged women to write letters to loved ones or to keep a personal record of their experiences and descriptions of places they might never visit again, but the personal writings of the World War II period also reflect women's greater awareness that they were becoming increasingly more and more engaged as active partners in the war effort. They were composing the text of war.

Sharing in the "Common Effort"

Throughout the United States, women from all social and economic levels were drawn to signing up. In the months after May 1942, when women were authorized to join the army, over 110,000 application forms for the WAAC were distributed. In July 1942, the number of applications for the WAVES soared as well. *Time* magazine reported that "women were so eager to sign up that many went without breakfast. Bosses waited in vain for secretaries, nurses arrived late and breathless at hospitals, dishes went unwashed and floors unswept."[3] Months later, when surveyed about their reasons for enlisting in the Marines, which opened to women in January 1943, over 90 percent of the women recruits gave patriotism and education as their motivations instead of the commonly assumed reasons of glamour and adventure. Surprisingly, the American population seemed to largely support women's enlistment. A Gallup poll taken in September 1942 indicated that the American public preferred drafting single women rather than married men with families for noncombat jobs.[4] Nevertheless, drafting women was never on the agenda for the War Department or Congress during World War II.

In large part, such momentum was the result of work on several fronts. Congresswoman Edith Nourse Rogers sponsored the congressional bill in early

1941 that established a women's branch of the army and brought the WAAC into being when it was finally passed in 1942, after the Pearl Harbor attack.[5] Rogers strongly objected to women serving as merely volunteer observers at mobile aircraft warning stations and believed the work of alerting the country about feared air attacks was so important that women observers should be given military status, training, and compensation. Before Pearl Harbor, men received military benefits as enlistees, in contrast to women who served in a purely volunteer capacity. After Pearl Harbor, it soon became evident that if the United States were to enter the war, more men would be needed for combat than were available. So despite initial reluctance from the War Department, Army Chief of Staff General George C. Marshall vigorously supported a women's army corps. On Christmas Eve 1941, the War Department gave its support to Rogers's bill with only minor changes. This early initiative later grew into women entering all branches of the military so that ultimately about 350,000 women, including nurses, provided backup support during the war, enabling more men to enter combat.

In 1942, Lieutenant General Dwight D. Eisenhower recommended to General Marshall that women be used for antiaircraft warning. Eisenhower observed that British WAACs had been skillful at these tasks. In an unpublicized 1942 experiment, Marshall assigned WAACs and men to a joint antiaircraft tactical unit in Washington. Although no arms were involved, as Congress had declared that women should not be in combat, both men and women used radar and search equipment to calculate the interval of time between spotting a simulated plane and firing on it. An unexpected outcome of this experiment (and one that was not made public until after the war) was that the women often outperformed the men in reaction time and dexterity. Because of these exemplary skills, both Marshall and Eisenhower were eager to send WAACs overseas.[6]

Later, in November 1942, Eisenhower commanded forces that took control of Morocco and Algeria, where he asked Marshall for WAACs to help with clerical tasks. Marshall responded by sending highly capable volunteer WAACs to North Africa in January 1943. The WAACs had to volunteer because they were still "auxiliary" at that point and therefore not under the command of the army. These units performed expertly and were highly loyal to Eisenhower, who in turn valued their assistance. Such early overseas successes created a sterling reputation for the WAAC and for its successor, the Women's Army Corps (WAC).

By January 1943, all branches of the U.S. military had inducted women into their ranks. The WAAC required that women be at least twenty-one, healthy, and of good character. Although technically established to milita-

rize the aircraft warning observers, WAACs handled a multitude of military needs. On July 2, 1943, "Auxiliary" was removed from the unit's name, and the newly formed WAC received full military status and benefits. The navy established the WAVES in July 1942. High standards of admission were set for the WAVES: a college degree or two years of college with professional experience and a preference for expertise in engineering and sciences such as astronomy, meteorology, or physics. In November 1942, the Coast Guard admitted women as enlistees and officers for the first time. Induction into SPAR (an acronym for *Semper Paratus*—Always Ready) required a high school education or business experience.[7] The last branch to admit women was the Marines. In January 1943, with no special designation, women were brought in as simply Marines. Additionally, opportunities for women with flying skills were available through the establishment of the WAFS (Women's Auxiliary Ferrying Squadron), which later became a foundation for the WASP (Women Airforce Service Pilots).[8]

The call for women soon found its way to college campuses like Rockford. Military ads ran regularly in the school newspaper, typically with a strong patriotic appeal for young women to play an active role in the war effort. When one Camp Grant soldier was asked his impression of Rockford College women, he responded, "If they are going to wear blue jeans, they ought to carry barracks bags and pistol belts."[9] Many women on campus agreed and joined the WAC, the WAVES, SPAR, and the Red Cross. One student who joined the WAC, Anne Saucier ('43), reported that "the war permeated our lives."[10] Among the early volunteers was Louise (Billy) Wilde, who left her job as director of the college's public relations office and lecturer in English to join the WAVES and eventually rose to the rank of captain.

Rockford women were eager to assume responsibility for Jane Addams's civic housekeeping, extending the culture of care to social needs. In no sphere was this challenge of responsibility taken up more vigorously and seriously than by women who entered service, in the military branches and the Red Cross. There was a sense of urgency to rescue and bring relief to the defenseless and to fight the good fight. A related motivation was to bring a common peace to people of diverse races and nations.

The excerpts from personal letters, diaries, the alumnae bulletin, and the school newspaper that follow contain the sentiment that there is no time to lose in bringing help to those weakened by war. Comments such as "We have an important job to do" and "We went right to work" captured the immediacy of the task. WAC Anne Saucier voiced the urgency of rescue in her concern for the prisoners of Santo Tomas, a Japanese concentration camp in Manila: "So sorry it took us so long to free them."[11] A 1945 Charter Day program at

the college reported that in the period of time between October 1, 1944, and February 1, 1945, "63 alumnae and former students are in the WAVES, SPARs, Marines, Red Cross, WAFS, and overseas government service."[12] The second theme that carried through these accounts was an emerging awareness that diverse people, like a family, share common needs. The overarching goal in fighting the war was to bring peace and democratic unity.

At Rockford College, this theme had a long tradition. From Addams's "philosophy of lateral progress"[13]—that is, people of diverse cultures and classes are so inherently similar that social progress should be spread uniformly across a democratic society—came an old international perspective. Mount Holyoke president Mary Woolley put it this way: "Racial and religious tolerance work . . . democratic procedure works . . . plain people everywhere on earth have the same plain desires."[14] Mary Ashby Cheek, in turn, inspired Rockford students to give their energies to the war effort. For many students, the incentive was to share in the common effort.

Anne Saucier *(left)* and Evelyn Turner, Rockford College students who joined the Women's Army Corps.
(Courtesy of Anne Saucier.)

The Decision

In a February 1944 issue of the *Vanguard*, Seaman Third Class Elizabeth Hoesli ('43) explained how the patriotism of others influenced her to join the SPARs. As a graduating senior, Hoesli took to heart the message of the commencement speaker, Commander Mildred McAfee of the WAVES, a former president of Wellesley College, who encouraged the women in the audience to become a part of the military. In a setting that Hoesli described as full of peonies and "black-robed seniors," the graduates were "duly congratulated" as they processed out of the courtyard of Jane Addams's alma mater. Despite their accomplishments as college graduates, however, "we were free in a world where there remained little freedom," Hoesli commented.[15]

Hoesli answered questions about why she joined the SPARs with a long list of reasons. She described the sacrifice of those spending their hard-earned pay on war bonds, those whose menfolk were serving overseas, the repeated public messages in theaters and on billboards saying "UNCLE SAM Needs You!," and the steady stream of casualties as all being factors that weighed upon her decision to enlist. She indicated, too, that "personal motives combined with patriotism: a desire for travel, for further education, and for new responsibilities" were also factors. "But above personal motives and even above patriotism," she added, "the incentive must be faith in the coming realization of a world interdependent and at peace: not armchair speculation but actuality."[16] A woman's desire and ability to help reshape the world was for Hoesli not only a significant motivation but also a reachable reality.

Hoesli's motivation for becoming a SPAR—participating in a world-changing endeavor—was shared by other Rockford graduates. Julia White Rogers ('43) joined the WAC after questioning her decision to go on to graduate school, even though she had a full fellowship to the University of Chicago. She explained why she enlisted in a letter written in 2006:

> After one quarter [at the University of Chicago] I quit and joined the Women's Army Corps (WAC). The Navy (WAVES) had much niftier uniforms, but they were not sent overseas, and I yearned to travel. I had just turned 22, and both my brothers (20 and 18) were already in the Army Air Corps. Mama hung in her State Street window a small banner with three stars on it. . . . It was not easy for a child of the Depression to walk away from a fully paid master's degree scholarship.[17]

Although being part of the "biggest world event in my lifetime" was certainly at the focal point of Rogers's decision to join the WAC, she was, like many other servicewomen, also swayed by the benefits that the federal govern-

ment promised to servicewomen. The Servicemen's Readjustment Act of 1944, more commonly known as the GI Bill of Rights, was passed to aid the fifteen million veterans, both men and women, predicted to need assistance after the war. The legislation not only subsidized housing, business loans, hospitalization, and counseling services but also provided money for attending college. Rogers took advantage of the GI Bill and returned to the University of Chicago to earn a master's degree in English. However, she was an exception. After the war, military women were not encouraged to think of themselves as "veterans" and were excluded from the Veterans of Foreign Wars. In 1956, women totaled less than 3 percent of all those veterans who used the GI Bill for college and were even less likely to use loans for housing and business than for education.

Anne Saucier initially joined the Red Cross when she graduated from Rockford College. However, her venturesome spirit drew her to military service in the WAC, where she thought she would be more able to travel and have broader opportunities. She joined the WAC in late 1943. In letters to her classmate Evelyn Turner, who was also in the WAC, she described the many facets of her military experience. Initially she had been stationed in Camp Patrick Henry,[18] where in 1944 she was dismayed at the racial discrimination she found there:

Am at a loss as to what should be done. We have a bad case of racial prejudice infecting Camp Pat. Does no good to answer back and you can't keep still. Just puts the person on the defensive to argue. Ignorance is rampant and sometimes there seems little difference between Hitler's Nazis and some of us. Guess one must keep faith in the individuals who have some idea what this war is all about. One must just keep plugging away and putting your two cents in here and there, and have patience, but there comes a time when my patience gets mighty low.[19]

Saucier's reference to racial prejudice shows the discrimination that was prevalent in the 1940s among the WACs. African Americans did not historically have the educational and employment opportunities afforded whites, so often they did not have the background qualifications sought by the military. Consequently, fewer African Americans were admitted into the services, and fewer were given officer rank. Separate eating and sleeping quarters were standard because the military was still segregated. However, as the U.S. military became more and more integrated during the war years, white WACs began to acknowledge the evident strengths and abilities of their black counterparts.

Even though she was disappointed with military racial disparities, Saucier continued to believe she made the right decision by enlisting. She described

how Rockford College and her family were both influences on her decision in a 1944 letter to Turner:

> I found out that the college's service flag now numbers 41. Miss Buffington ("Buffy") in the Red Cross in Italy, is practically in the front lines, and the most amazing reports come back concerning her unbounded energy, zeal, and ability to accomplish the impossible. Seems she purchased a piano for the fellows, Kleenex, drinking cups, etc. Miss Bomberger is over there too, and they have seen each other numerous times. Dorion Cairns is in North Africa, and Meno Lovenstein ("Lovey") in Washington, working on the peace to come.[20]
>
> Grandmother Anna Hunter Talbot (the old sweetie) crocheted covers for my dog tags—one gold and one red. Now they won't ever feel cold again. . . . It was my grandmother who found the Army Air Corps Captain at Kansas City airport who flew me back to Virginia on his B-17, even letting me share the cockpit for a time. I can still see Grandmother waving on the field as the plane taxied away and into the wide blue yonder.
>
> As I was growing up, Grandmother Talbot would often say, "You can do anything the boys can do!" She bribed me with $100 if I would go away to a college other than where my father was teaching; [and] was ecstatic that I chose Rockford. . . . She always urged me to be adventuresome, and was one hundred percent for my joining the Army.[21]

Female legacies in both her family and her college life clearly shaped Saucier's decision. Women of strength like her grandmother and Mary Ashby Cheek were the guiding influences of Saucier's life, according to her letters.

Saucier took a position in a WAC recruiting office in Philadelphia. In a 1944 letter, she described a weekend trip she took from Philadelphia into New York City, where she made regular excursions on free weekends to visit one of her former professors, Leslie Alice Koempel, who had just completed a year teaching at Mount Holyoke and was working at the Henry Street Settlement in New York for the summer.[22] Saucier noted the importance of the time she spent with Koempel: "It meant the world to just talk to someone I understand, and who understands me."

> We took a long walk around the neighborhood and down by the River. I shall never forget the lights of the Navy Yards across the Brooklyn, the gigantic, overwhelming size of the Williamsburg Bridge looming above us, and the foggy New York skyline in the distance.
>
> My WAC uniform made quite an impression on the people. They stopped us on the street to ask how I like the WAC, and whether they should join or not. This intrigued us both. . . .

Most of the way back on the train talked to a fellow with a bum leg and a Purple Heart. We consoled each other because we were both more or less stuck on this side, with dreams of what might be going on over on the other side.[23]

Wearing a military uniform signified a new role for women like Saucier, while the pride of wearing that uniform and the "dreams of what might be going on over on the other side" became increasingly powerful.

As a recruiter, Saucier was keenly aware of the arguments and attitudes that stood in the way of women joining the WAC. In that same 1944 letter written shortly after her return from a visit to New York, Saucier explained that when she came back to her office on Monday, she spent the entire day making phone calls to prospective WACs—eighty "to be exact, with one almost sure recruit." Nearly all of the women on her list to contact were working during the day, had children or a "frowning husband," were not at home, or were just not interested in joining up. "Quite discouraging," she wrote to Evelyn. "I don't enjoy talking people into joining because such a step is up to them. I take full responsibility for my decision and this needs to be theirs."[24] The support Saucier's family had given her was a source of confidence for her—in military service and in postwar life—but not something all interested women received when they made the decision to join the military.

Shipping Out

Although Rogers and Saucier, both WACs, and Hoesli, a SPAR, all expressed a desire to travel, only the WACs were initially allowed overseas. Rogers traveled to Europe, Saucier went to Asia, and Hoesli stayed in the United States. The overseas ban was finally lifted for the SPARs near the end of the war. In September 1944, the WAVES were permitted by Congress to serve outside the country, but only in the Western Hemisphere. Almost a year after she enlisted, Saucier prepared for deployment overseas. She trained in the same camp as her friend Evelyn Turner and at the same place where her father had trained for World War I.

In a letter to Turner dated 1944, Saucier explained the two weeks of rigorous training that was required for deployment overseas: "There were many lectures, training films, and demonstrations of what to do in case of gas attacks—how different gases smell, and how to use our gas masks. We took long hikes, conquered obstacle courses, learned to shoot a rifle, how to protect ourselves, how to purify water, etc."[25] The women were vaccinated against smallpox, tetanus, typhus, and cholera. Saucier was well prepared because she had received a triple typhoid vaccine the previous year. No indication

WACs on shore. (Courtesy of Anne Saucier.)

was given to the women of their destination—even in the clothing they were issued. They received clothing for the tropics and for Alaska, along with the requisite helmets, gas masks, and mess kits. "We would not know where we were going until we got there!" Anne explained to Evelyn. "This was, of course, to confuse the enemy. It didn't matter that we were confused in the process."[26] The procedures for getting ready for overseas assignment and for traveling were physically demanding. There was also a tight schedule for shipping out. Nevertheless, Saucier was eager to cooperate and excited about the prospects of traveling to another country.

The SPARs eventually numbered ten thousand recruits and one thousand officers. With the slogan "Release a Man to Fight at Sea," SPARs took on many Coast Guard roles, including high-level communications, ship operations, and navigation procedures. Elizabeth Hoesli wrote the following article for the February 1944 alumnae publication about her experiences shipping out as yeoman second class:

> We were met at the station by drivers and taken to the training school. . . . Here, behind a desk, sat a crisp and smiling SPAR officer being saluted as we reported aboard the *S.S. Biltmore*. . . . By dint of much wiggling in and out of line we found ourselves installed in the same room, sixth deck, all five of us who had been on the train together. . . .

Someone shouted, "Platoon two, muster for chow"! We continued to hang crumpled garments on hangers. An indignant head was poked in at the door. "Platoon two, didn't you hear me, muster for chow." And to this familiar refrain we were launched upon four weeks of boot school: Platoon two, Company 32.

Hit the deck at 0615, chow, classes from 0830 to 1130, chow, swimming, mail call, chow, drill, free time and lights out at 2200. We marched everywhere: to chow; to class down long corridors . . . down the palm-bordered avenue to the ocean . . . to the drill field, a sandy strip at the edge of the water where the drillmaster from Brooklyn shouted out incomprehensible commands . . .[27]

"Days flew by," she wrote while chronicling the "tests and shots and uniforms" they received before they became the experts to succeeding groups of "booties."

By the end of the fourth week of boot camp, graduation time brought the excitement of an assignment and reflections for Hoesli: "Boot school was over; now for the job." Orders were read at graduation, and Hoesli was on her way to Charleston and recruiting duty. Seeing herself as having been given the opportunity "to hold up a grand tradition," Hoesli believed she was also playing a small role in helping the Coast Guardsmen who first went ashore at Guadalcanal and Sicily and in the African invasion. Although she indicated in her letter to alumnae that they should not misinterpret her description of a SPAR's life and work, that life in service was "not always a bed of red, white and blue roses," she and her fellow SPARs received their satisfaction from knowing that they had a job to do.[28]

The "job" to which Hoesli referred was often highly technical and sophisticated work. SPARs were trained to code and decode messages relayed between a central board and harbor pilots who steered ships out to sea. They were required to learn all the transmitted "recognition signals," which were subject to frequent change. These women also helped in the involved process of locating U.S. submarines, which is explained by a SPAR in the following passage: "We received long coded messages about where a certain sub would be and the time. Those new submarines were en route to the Pacific. These messages, usually in strip, consisted of long strings of numbers and were tedious to decode."[29] SPARs were also recruited into the newly emerging field of computers.

Initial skepticism and joking about women's abilities and temperament to perform military duties were commonplace. However, military women quickly demonstrated exceptional stamina, integrity, and competence in their first year of duty. As a result, the armed services aggressively sought more women recruits. Evidence of women's successes as WACs was reported in the national media. The May 10, 1943, issue of *Time* stated, "The Army has learned

the desirability of its soldiers in skirts, not merely as ersatz men but for their own sakes and skills. . . . One replacement group of 56 replaced 128 men."[30]

When Private Evelyn Turner wrote back to Rockford College of her first weeks in the WAC, she pointed, in particular, to pride in her new job that was in large part influenced by the growing public support for the important role women were playing in the service. Turner's descriptions about her life in the service were published in *Alumna* in 1944:

> Everyone has read articles about the WACs written by critical newspaper men, old Army Colonels, Red Cross workers and many others who give a boost along the way, but I have read little written by a WAC herself. I know now that this is probably because WACs are working full shifts and have little time and also because most of us have no broad scope of army life to draw from. . . .
>
> One of the first thrills as a WAC was meeting up with a group of sailors who immediately started chanting the famous hymn, "The WACs and WAVEs will win the war, so what the h—— are we fighting for." That gave us a wonderful boost and we made the rest of the trip like veterans. . . .
>
> Those days were full days: up at 6:00; reveille at 6:25; detail, breakfast and off to class by 7:45, marching proudly and in step (most of the time) to the WAC band. Classes consisted of instructions in First Aid, Army Regulations, Articles of War, Safeguarding Military Information, Army Customs and Courtesy, Drill and multiple of others. After retreat at 5:00 we were free, except when we had extra detail, till bed check at 11:00, but of course there was laundry to do, shoes to be polished, floors to be scrubbed and letters to be written. We often felt Eleanor Roosevelt's "My Day" didn't even hold a candle to ours.[31]

Eleanor Roosevelt's daily column, "My Day," that Turner mentioned had an impact on American women in the military, in particular. Roosevelt wrote six daily newspaper columns a week, with commentary on contemporary issues, whether it was the war, economics, politics, or domestic concerns. Between 1935 and 1962, the only interruption in her column was four days after the death of her husband, President Franklin Roosevelt, in April 1945. In the October 15, 1943, column "Women at War," Roosevelt sounded an encouraging note for women: "Life in the Armed Services is hard and uncomfortable, but I think women can stand up under that type of living just as well as men."[32] Undoubtedly, many young women were influenced and inspired, including Turner.

In spite of the occasional "hard and uncomfortable" circumstances acknowledged by Roosevelt, Turner stated clearly in the continuing narrative that it was well worth the effort. On the one hand, the "new" language of the

military was confusing. After learning the meaning of nomenclature such as OWI, OPM, and WPB, more were added on, including CO, MP, KP, CQ, and OD. Turner noted the importance of "keeping straight that ODs wore rank on their shoulders and were to be saluted and KPs were not of sufficient rank to rate a salute."[33] On the other hand, however, the discomfort of the newness of it all quickly faded. Soon the women were sharing stories and making friends. Turner's unit also represented the wide range of the American female population to whom military service applied. They represented "all ages"; a variety of occupations, including schoolteachers, factory workers, housewives, and beauticians; and states from Maine to New Mexico. Turner also pointed out that the reasons the women had joined up were as numerous as the number of "girls" who had enlisted.

Orders to ship out came rapidly and, as Turner noted, came with feelings of both uncertainty and exhilaration. "As the last week of basic rolled around," according to Turner, "excitement ran to a high pitch as we pondered, worried and speculated about orders." On the first day after they completed the basic course, Turner and seven others were called to report to the staging or shipping area within twenty minutes. Turner described the scene as one of "much confusion, many goodbyes, and a few tears" as the women quickly packed their barracks bags and prepared for departure. By the next morning, they were on their way to Orlando, Florida, for their assignment in the Army Air Force.[34] After spending ten days learning the new Signal Corps system of aircraft warning, they were assigned to keeping track of the flights of all aircraft in the area.

Perhaps it is not surprising that many women ended up in medical jobs, which were considered in keeping with their historical gender roles. After her training with aircraft warning systems, Turner received orders to report with six of her fellow WACs to a hospital in Atlanta, Georgia, for what she described as a "very fine course" in physical therapy. In Atlanta they became students once again, but they were also learning "as completely and rapidly" as they could the skills needed to help rehabilitate wounded soldiers. After completing the course in physical therapy, they were trained as aides to work in hospitals in the United States or abroad, as Turner noted, "helping to make the miracles of modern medicine part of every day's work."[35]

The rigorous training regimen that Turner described also reflected the specialized roles the WACs and WAVES performed during their tours of duty. WACs worked as chemists, weather station personnel, medical technicians, and aircraft warning specialists in addition to the medical roles Turner and her compatriots filled. Included in WAVES' duties were the shipboard responsibilities of gunnery specialists, machinists, flight training instructors,

and control tower operators. These assignments went far beyond the clerical assignments traditionally expected of women.

Students enrolled at Rockford College during World War II were no doubt influenced by the stories of women like Evelyn Turner. Rita Gilbert, who graduated from the college in 1937, was also eager to share her story of life with the WAVES. Her "Living the Navy Way" article appeared in the alumnae bulletin in November 1942. Ensign Gilbert described her efforts to "keep the fleet fighting" in the form of a play script:

> **Scene**: Northampton, Massachusetts
> . . . **Characters**: The first group of officer candidates in the Women's Reserve, United States Navy
> **Vital Statistics**: The group consisted of about a hundred and twenty women, ranging in age from 21–45 years, and in rank from ensigns to full lieutenants. Their backgrounds varied from that of business executives, personnel managers and newspaper reporters to PhDs and college professors—all equipped to handle shore jobs in the Navy and release men for sea duty.[36]

Although training was rigorous, Gilbert noted that she and the other recruits "loved every minute of it!" A typical day began at 7:00 AM and ended at 10:00 PM. At night they slept in double-deck bunks. Their days were spent in intensive studies: five hours of lectures and note-taking, two hours of drills and exercise, three hours of study, and "liberty" from 1700 to 1800. "That's navy time for 5:00 to 6:00 PM," Gilbert translated for her audience. Their studies focused on "naval organization, administration, personnel, types and functions of fighting craft, history, filing and correspondence," and they learned a new vocabulary, a "strange new language" that included words such as ash cans, K guns, tin fish, AVTs, hash marks, scrambled eggs, and Scuttlebutts.[37]

Just like Saucier, Turner, and Hoesli, Gilbert felt great pride in herself and in the contributions she was making to the war effort. She noted that "we were serious about this new career. Never before had a purpose been so well defined for any effort we had put forth." She, like many other women, saw herself as helping the men in the American military to win the war, but Gilbert also noted that her work made her feel a stronger connection to other women around the world who were also engaged in active service: joining up was "a chance to do for America what English, Canadian, Chinese, and Russian girls have been doing for their countries." She also framed her duties in the context of women's contributions throughout American history: "From pioneering on the covered wagon trail to accepting executive responsibility in business, women have helped build America, have proved they can 'take it.'"[38]

WACs disembarking from the *Lurline*, November 18, 1945. (Courtesy of Anne Saucier.)

That sense of a larger mission for the women was reiterated in the words of Lieutenant Commander Mildred McAfee, who came up from Washington to "graduate" Gilbert and her fellow WAVES. According to Gilbert, McAfee "claimed no small amount of pride in our group." McAfee's goal was to create a superior branch of the navy consisting of highly educated women, often with expertise in the sciences. WAVES assigned to national headquarters in Washington, D.C., filled many positions requiring security clearances and frequently performed classified work with newly developed computers and electronic equipment. "If the Navy was pleased at our earnestness and proof of adaptability," Gilbert wrote, "you should have seen us strutting our stripes" at graduation. The acknowledgment of women's abilities in the skilled work they were assigned created a greater sense of pride and accomplishment among the women.

As Gilbert closed her story, she seemed eager for these specialized tasks that would advance the Allies' progress in the war. Gilbert described for her readers the "scene of gay farewell salutes" at the platform of the Northampton Station. The newly inducted WAVES were now on their way to their "battle stations." Neatly dressed with their hats "nearly squared" and with their active duty orders stored away in their bags, the WAVES headed out for their work "at blackboards, typewriters, teletype machines, ciphering and code charts,

radios—doing our part to 'keep the fleet fighting.'"[39] Ensign Gilbert was assigned to active duty at the Bureau of Naval Personnel in Washington, D.C., following her preparation at the U.S. Naval Training School at Smith College in Northampton.

Colleges and universities were often chosen as training sites for the WAVES because McAfee favored an academic milieu. Also, space was available due to low male enrollment from war enlistments and many female students working civilian jobs instead of going to college. Besides Smith College, other training facilities were located at Mount Holyoke College, Hunter College in New York, and universities in Indiana, Wisconsin, Iowa, Georgia, and Oklahoma. The SPARs and Marines initially shared college sites with the WAVES until they formed their own training areas.

Life in Service

Alumna Julia White Rogers wrote in 2001 that "being a WAC was not all peaches and cream. Newspapers loved headlines like 'WAC Slain in Love Nest,' and I was sometimes treated as if a scarlet letter was sewn on my uniform. Some soldiers made a similar assumption; the most useful phrase was 'I'm old fashioned.'"[40] No doubt, other women in the services faced similar responses to their gender and questions about their reasons for joining up.

Initially, many of the reactions of American servicewomen as they reached their ports of duty were at the pleasures of seeing different and exotic parts of the world, but their communications with those at home quickly turned to the important jobs they were filling and the new freedoms they were experiencing. Dorothy Carstens ('40), who served in the WAC, arrived in Africa after the fighting there was over. A letter she wrote in November 1943 to the college community appeared in the *Alumna* and gave a glimpse of the African front for those on campus. Probably because of military censorship, Carstens did not give the name of the city in North Africa where she was based. It could have been a city such as Tunis, where an Allied victory parade was held in May 1943 to celebrate the end of the North African campaign. In August 1943, her point of station experienced the stability provided by the Allied success. Her reference to the French, British, and American flags showed the joint Allied occupation of the city.

> I was on deck the day we sighted land, and I'll never forget what a welcome sight it was after seeing nothing but water and other ships for so long. Going through the Straits I had to keep pinching myself so that I could realize that the land on the left was actually Spain and on the right, Africa.[41]

We still had no idea about where we were going although we had guessed that it would be somewhere in Africa. I had hoped to go to Algiers and others wanted to go to Casablanca, but instead we finally turned into the harbor of this city. From the waterfront steep cliffs jut straight up and in the brilliant sunlight that first afternoon they were bright yellow and brown. We could see cars and buildings in the distance and an army camp on the very top of the rock.

It was evening before we disembarked, again weighted down by our belongings. . . . Army trucks took us to our new home. It was the most beautiful drive I have ever taken. The sun was still shining brightly although it was almost nine o'clock. The road wound along the coastline and seemed to be a continuous climb upward. . . . That first night we had no barracks bags with us and only bare cots to sleep on—no blankets, and although the temperature during the day had been in the 90's, it had dropped sharply after sundown and we were almost frozen. Fortunately, in the middle of the night a carload of blankets arrived.[42]

Initially, the place of arrival in Africa was unidentified and strange. However, soon Carstens and her unit settled into a routine.

For the first few days after their arrival, the women had the freedom to spend most of their time swimming and enjoying their new surroundings, but quickly they began their routine of leaving camp at 7:30 every morning for a forty-minute truck ride into the city to work their jobs. They returned back to camp at 5:30 PM after working in mostly clerical positions that required typing, shorthand, and filing. They worked Saturdays and had Wednesdays off, with no holidays and no furloughs. Carstens described their jobs as routine, "not particularly interesting, but not too hard."[43] Eventually, the WACs were moved closer to their jobs and housed in a former French private school in the city.

Suggesting that the biggest challenge was not the work but what to do in their limited time off, Carstens complained about the lack of night entertainment. Noting that there were a few civilian theaters that showed old American films and two Red Cross theaters for military personnel where the films shown were also typically old, Carstens explained that dancing options were just as limited. The only place to dance was the officers' club. Although taking walks was an option for entertainment during warmer weather, the temperature had dropped, making walks—even in Africa—not as appealing. The restaurants, according to Carstens, "charge outrageous prices for horrible meals." But the male officers had quickly discovered that the best cooks in the area were based with the WAC unit. Because so many of the men were "clamoring" for

an invitation, the WAC mess officer was forced to limit each woman to two visitors per month.[44]

For those women drawn to service by the lure of travel, it was often the cultural exploration that made any hardships worth the sacrifice. Carstens seemed keenly aware in her letter to campus that the portrait of her work and life as a WAC should be an accurate representation of her experience, but she also recognized that women might be swayed to endure the lack of home comforts if the adventure of the job was appealing. Her descriptions of the people and the places she saw would have been far distant from the realm of knowledge and experience of a typical American woman during the 1940s. The following passage is Carstens's response to the lifestyles and living situations of the people she saw in the community surrounding her post:

> I forgot to tell you how the Arab women dress. They all wear white sheets which cover them from head to toe, except for one eye. If they are not barefoot they wear strange looking shoes with flat soles and no heels. ... For three mornings in a row a man has walked past where we live leading a huge sheep and all around us people keep their chickens in their houses with them. One family has a pig that must weigh several hundred pounds up on the roof of their house.
>
> ... The streetcars here are crazy things with no sides or windows but with plenty of passengers. They hold on to the sides, and little kids sit on the bumper in back. No Americans ever ride on them.
>
> We've all become so accustomed to the stranger ways of people here that nothing seems unusual. I'll never forget this time I am spending in Africa, but every once in a while I'd give anything to be back in the States for a little while.[45]

Carstens's comments about how the local people dressed and lived suggested not only the provincial attitudes of many Americans during the 1940s but also the ways in which World War II broadened the perspectives of Americans as thousands of U.S. military personnel—both women and men—found themselves stationed in lands quite unfamiliar to them. Likewise, Carstens seemed to be aware that her experience in Africa helped expand her perspectives about other women and the societies in which they lived.

Although Carstens described living conditions that would have been at times uncomfortable, conditions in the Far East, for WACs like Anne Saucier who served in the Philippine theater, were often far more stressful. Frequently, WACs lived in tents, contended with heat, rain, and snakes, and stood in mud waiting for showers and food. Despite the difficult circumstances, the army

women generally stayed healthy and performed their assigned jobs, much as how Saucier described herself in the following letters to her family written from late 1944 into the spring of 1945. She recounted both the up and down side of WAC existence:

> We have a camp dog called "Atabrine," in honor of the daily pills we take to combat the ever present danger of malaria.[46] He is the breath of sunshine who walks innocently into one's domain, and then goes tearing out with a shower clog. But we love him anyway for his floppy ears and happy disposition. . . .
>
> Am following the Philippine campaign with the greatest of interest. We have a daily paper which gives the latest news summaries, and the Jungle network has full coverage of the news every evening on the radio. The office across from the Judge Advocate's office has a radio, and when the news comes on, everyone stops and gathers round.[47] It means so much to us here. Am driving my tent mates nuts with maps . . .
>
> It's hard to sleep all night. I'm getting mighty tired of screaming females. It's getting to be a habit. Every night one of them has a nightmare and gives forth with unearthly gusto, and everybody wakes up, and wants to know what happened . . . and then the next morning my tent mates are all crabbing cause they haven't slept since two in the morning.[48]

Everyday life for a WAC had straining difficulties. Mosquitoes were abundant, so malaria was a severe problem. Lines for preventive medication could be long and tiresome. In the midst of discomforts, dogs such as Atabrine were usually friendly camp companions who alleviated stress and broke the monotony.

WACs also lived with the constant reminders of the everyday dangers and other challenges women faced. Saucier described in one letter the very human frustrations of war and showed the humor she used to deal with it:

> Move over spiders! The Japs just love moon light and we have had so much of it lately. They have spoiled our sleep night after night. When I heard the first bomb drop the other night, you can bet I was in that fox hole in a flash, despite the spiders, who caused no problems at all. But our men quickly chased the Jap away, and we have had no more bombs since then.
>
> Japs get within a 25 mile radius, and the sirens yowl forth. . . . And we mutter about the inconsideration of the Japs, and the guards. Finally, sleepy WACs appear, dragging along their helmets.
>
> . . . Those of us who live in tents prefer to wait for the sound of a plane, and then roll out as a last resort. I lie there and think, I'd just as soon die in bed, but then decide, for my friends and family, I'll get up.[49]

On the one hand, WACs understood the hazards of working and living close to the front, but on the other, their patience with taking precautions often wore thin.

The very fact that women were part of the military also continued to be surrounded by some debate and concern. Saucier noted that their general had spoken with them about the officer–WAC enlisted personnel controversy, and "he insist[ed] we must not fraternize in order to preserve discipline, for the sake of custom and tradition, etc."[50] Referring to him as "poor General," and using a bit of sarcasm by saying "he does have his problems," Saucier explained that the situation had come to a sort of head, having resulted in courts martial and shipping to the rear. "Well, it livens our conversations," she concluded.

On a very personal level, enlisted women also shared with male soldiers serving abroad the real tribulations of being far from home and from family members and loved ones. Saucier's particular concern was that she was separated from her dying grandmother, who had supported her in her decision to enlist:

A letter from my mother says father has gone to Saucier, Mississippi, because his mother is sinking rapidly. For all I know she is dead and buried by now. That's the trouble with being overseas. What can I do? What should I write?

All I know is, Sarah Louisa Jane Walker Saucier has been everything a grandmother should be, and if she is gone from this earth, she is smiling down on me from Heaven above.[51]

Saucier's grandmother indeed had died on March 16, several days before these words were written. That the painful loss of family members could occur in servicewomen's absence was just one of the issues they dealt with while overseas.

Although many Rockford College graduates like Saucier were attracted by the opportunities offered to women by the armed forces, the Red Cross was also a popular option. Labeled "Big Sister to the Army," the Red Cross had close ties to both government and the military. Volunteers were even given honorary officer status so they would be afforded military privileges if they were captured overseas. The organization provided social work functions, distributed supplies, sponsored social "clubs," and, most important, attended to medical concerns. Requirements for joining were a college degree and being over twenty-four years of age.

At least three women who worked on the staff of Rockford College joined the Red Cross and were shipped overseas. Most probably, all three provided nursing assistance in addition to other duties. Dean Ruth Buffington was serving in Italy when Major J. Paul Wintrup wrote early in 1944 in praise of her energy

and job dedication. The letter, which was reprinted in the college alumnae publication later that same year, explained Buffington's resourcefulness, some of the tasks she accomplished, and the success of her work on duty. "I can't say that I have ever known a woman with such vigor, such dependability, and such a full desire to help our soldiers, ill and wounded, as Miss Buffington," Wintrup claimed. "She has found games, magazines, papers, photographs, maps, taken groups on tours, bought a piano, found soap when we had none, dishes when none was available, paper cups when 'C' ration cans were the best we could offer our patients."[52] Describing Buffington as "absolutely untiring" in finding "the bare necessities" to run their inadequate hospital facility, Wintrup explained that she lived among the others at the post in very meager conditions, including "very rainy days, muddy fields, roofless shelters and almost every trying circumstance," but like everyone else, at night she crawled into her "pup" tent to sleep, "surrounded by a sea of water and mud." Thanks to Miss Buffington, Wintrup proclaimed, the men now had toothbrushes and shaving cream and radios and another piano for their amusement.[53] Red Cross servicewomen like Buffington earned respect and appreciation from the troops. Before going overseas, they went through several weeks of training in Washington, D.C., but foremost in that training was the theme that the enlisted men at the front needed support for morale and encouragement.

In early 1943, the *Purple Parrot* printed a letter from another Rockford staff member who enlisted with the Red Cross. Marjorie Bomberger, former assistant director of admission at the college, worked with the Red Cross in North Africa and described her life in the nation's service. Bomberger was particularly attuned to the poverty she saw around her in Africa. Although she and her fellow servicewomen were able to "chow" at either of the two local Red Cross restaurants, they were surrounded by a people facing starvation and disease. Amidst descriptions of the army cheese-butter-margarine mixture that she found "very tasty," plenty of citrus fruits, and the balanced diets of American service personnel, Bomberger noted, too, the "repulsive beggars" that "one dares not give a franc or an army follows down the street."[54] Bomberger's descriptions seem to indicate a clear disjuncture between the local people and American military personnel, despite the fact that war gave many service personnel a broader worldview.

The reception for the Red Cross and its female workers when they arrived at camp was positive and typical. Bomberger described their arrival as "a heart-warming one":

> All women in open Army trucks were cheered, waved at, and followed down the main street. At one intersection, soldiers at a sidewalk café sent wine (Algerian "vin" is green and NOT WEAK) for toast; so all 20 of

us toasted the hundreds (*really*) of khaki lads, and they sang "God Bless the Red Cross" to the tune of "God Bless America." . . .

Walking down the street is an experience in itself; every American soldier grins and says, "Hello" or "Where are you from?" We'll all be grinning idiots from it. They are *so glad* to talk with American girls. One boy said in a café, "Just keep saying 'Hello' in English!" . . . Two *large* Red Cross Clubs are operating here now—3 more opening. That is true everywhere we've been—expansion in a hurry . . .[55]

The friendly responses from the soldiers indicated that the women serving in the Red Cross overseas were successful morale builders. Red Cross services in World War II covered the world. Eighteen hundred recreational centers and hundreds of clubmobiles were an encouraging presence. The clubs Bomberger mentioned were the primary means through which the Red Cross provided food, good cheer, and recreation to the troops. Coffee and doughnuts—of which millions were made and distributed during the war—were typically the fare. Clubmobiles, in effect mobile kitchens, accompanied the troops to the front in North African, European, and Mediterranean campaigns. Because of their proximity to the action, Red Cross volunteers overseas were often exposed to dangers similar to those experienced by WACs and nurses serving overseas.

An editorial note in the April 16, 1943, issue of the *Purple Parrot* summarized other letters that Bomberger wrote home. While Bomberger characterized life on a transport ship as agreeable and described her unit's success in planning entertainment for the soldiers, she also described (without complaint, according to the editorial) the rough water that caused seasickness. Even though the knapsacks they all wore were filled to the brim and weighed them down, carrying the load gave them a "wonderful sense of security and protection." The women had the "kindliest feelings toward officers and crew for unusual thoughtfulness."[56] Bomberger's letters reflected the meaningful satisfaction that Red Cross women, all college-educated, seemed to find in the services they provided. They enjoyed the camaraderie, opportunities, and excitement of new countries, without many of the military constraints that WACs and army nurses experienced.

Louise Ostberg, formerly an assistant in the physical education department at the college, joined the Red Cross in North Africa and wrote with similar reactions to her living conditions. Ostberg's enthusiastic description of her life in service was published in the school newspaper in November 1943:

Life is really wonderful! We had fresh meat for dinner tonight, so our morale went up about 99 44/100%. It's the first in three months and really did hit the spot after spam, Vienna sausage, and wieners in rotation

for three months. If I could get my hands on the fellow who invented Army "C" rations I'd sentence him to a slow death by putting him on them until he finally just quietly passes away of either peptic ulcers or malnutrition. . . . I'm really thriving on them [though] I've lost about 15 lbs. But I don't feel like a million dollars. We don't look like glamour girls in our high GI shoes and faded grey uniforms, but we are all in excellent health and that's what really counts.[57]

Although Ostberg was critical of military food, women in the service, as well as men, ate better than many American civilians, who were required to ration their food. Daily chow was generally good and ample. The War Department calculated that there were substantial savings in serving women, who generally ate less than men. Ostberg also commented that she had heard of the successes of Dean Buffington's unit. Ostberg took pride in the "swell job" of her colleague and the commendation she had received. Buffington was stationed nearby, but Ostberg could not divulge her location.

Alumna Dorothy Moyer ('31) also served with the Red Cross, but she was stationed in India during the war. She wrote an account of her time spent there in early 1945 and sent it home to Rockford College; her description of her assignment abroad was published in the 1945 alumnae bulletin. Shipped to India aboard a converted luxury liner, Moyer described the trip as a "calm and comfortable voyage." She and the other Red Cross "girls" aboard the ship went quickly to work planning entertainment for the "crowded and homesick 'GIs'" who were also on the ship. Moyer served as a member of the music committee and as an accompanist on the piano in the lounge area and on what she described as "a little field organ" that was set up on the deck for shows and church services. The women organized various kinds of entertainment, including community sings, band concerts, and choir programs. "It was a far cry from social work," she noted, which is what she was hired to do, "but brought back memories of college days and was fun."[58]

Upon their arrival in India, Moyer was assigned to a large hospital in Calcutta, where she served as an assistant field director. Describing her job as "a pretty strenuous combination of social work, administration and recreation," Moyer reflected not only on the physical care the Red Cross provided to soldiers but also on the psychological care that was such an important part of their recuperation:

Our casualties are more from disease and fatigue than from Jap bullets. . . . We've tried to build a recreation program to fill their time as they convalesce and take their minds off their homesickness. We have a hobby shop with all kinds of interesting arts and crafts. They make silver rings

out of Indian rupees, paper knives and cigarette holders from salvaged aeroplane parts. . . .

We have active games for those who can take them. And we plan bingo and ward parties for those confined to bed. We have a good-sized library. . . . Army Special Services help us by providing movies and bringing traveling shows to the hospital, so all in all our boys have a good many diversions . . . before their return to duty or evacuation to the States as the case may be.

Our social workers make loans, discuss personal and family problems with worried patients. . . . We have a steady stream of patients coming into our offices daily, bringing problems, big and small that may have existed before but never worried them so much till they got sick and had time to brood about them.[59]

The Red Cross not only provided recreation and diversion but also helped give peace of mind to soldiers. Both practical needs and personal concerns were met with a sympathetic ear and problem-solving assistance. Red Cross workers effectively lightened the load soldiers were carrying.

But it was not all work for women in the Red Cross, as Moyer was quick to explain. Social life continued, and women were thrilled by the opportunity to explore exotic locales. "On the social side our life here has been gay and interesting," she noted, probably in large part because Calcutta was a vibrant, cosmopolitan city. Indicating that she had "done more dining and dancing" there than ever before back at home, Moyer commented that for a woman, the dating possibilities were endless: "The balance of trade is, of course, in favor of the feminine sex and our trouble is not lack of men for escorts, but excess of them!" Trips into the countryside also provided adventure. Moyer reported on a trip to Darjeeling, a well-known mountain resort located at an elevation of seven thousand feet in the foothills of the Himalayas. "The whole trip was a thrilling experience," she exclaimed; "I felt on top of the world!"[60]

Moyer also appreciated the cultural richness of the Tibetan and Nepalese people. In detailed descriptions, she created images that conveyed cultural differences to her readers but also showed her attempts to reflect on what she had seen and experienced:

I'm going to resist the temptation to give a dissertation on the "problem of India"; of course it's very apparent here, but appears so complicated that I can't begin to make a critical judgment about it. The hold which their religion has on these people, both Hindu and Moslem, is perhaps the outstanding fact which one observes by living among them. . . . Banks and stores close every few days for another holiday, and it's very hard to

get any business done. . . . One begins to realize how many people this country holds; it seems as if a large part of the 400,000,000 live right in this city.[61]

Getting to know people of various nationalities and social levels was also an important part of Moyer's time in service. Calcutta was truly the "Crossroads of the Orient," a place where she could see "glimpses of the lives" of the British, Indians, and Chinese, the rich and the poor.

Back in the United States, women recruits might not have had the chance to experience travel abroad, but many felt a growing sense of empowerment because of their vital roles in high-security projects. Los Alamos, situated in the desert of New Mexico, was the place where the atomic bomb was designed and built and also one of the Manhattan Project sites that was designated as "army." The development of the atomic bomb was begun in 1942 on the orders of President Roosevelt after Albert Einstein's suggestion that the government quickly begin a research program to oversee the use of nuclear fission for a potential bomb before Adolf Hitler's Nazi scientists built one. In late 1942, Enrico Fermi at the University of Chicago succeeded in creating the world's first controlled chain reaction. Oak Ridge, Tennessee, was designated as a processing site for uranium, and various parts for a weapon came from around the nation to be assembled and tested by a group of leading scientists working at Los Alamos.

About two hundred women served in the Los Alamos workforce. Among this number were WACs who worked as clerks, drivers, and scientists. A total of four hundred WACs worked on the Manhattan Project at its multiple sites: in Oak Ridge, Washington State, New York, and Los Alamos. The Los Alamos project was clothed in secrecy. Some WACs and other women were apprehensive about what was happening there. Historian Emily Yellin cited the haunting words (expressed after the bombing of Hiroshima) of one of the scientists' wives, who herself worked as a technician:

> As if caused by reverberation of the atomic bomb, an explosion of feelings and of words was set off in Los Alamos. Women wanted to know. Everything. At once. But many things could not be said even then, cannot be said now. . . . They wondered, they probed their consciences, but found no answer to their doubts.[62]

At the end of the war in Asia, when WAC Anne Saucier heard of the atomic bomb attacks in Japan, she similarly reported her incredulity and deep emotion.

Witnessing the Aftermath

Many women who volunteered for the armed services or the Red Cross came from responsible jobs and later returned to respected positions. Yet they often

considered their wartime work as the most meaningful and fulfilling time of their lives. Emily Yellin captured this general sentiment in reporting the words of a club director in Wales:

At last, here in this forgotten place, I have found myself. For 5 months I have lived with men preparing for combat. I have eaten with them, laughed with them, cried with them, have shared their fears and anxieties, hardships, etc.—and wonder why I didn't get in this sort of work sooner.[63]

This volunteer's feelings were mirrored by many American servicewomen. The letters Julia White Rogers wrote to her parents recorded not only her training in Kansas and Georgia and crossing the Atlantic on the *Queen Elizabeth* with 17,000 other soldiers but also a "buzz bomb" (Hitler's V-1) overhead in London and observations of life in France and occupied Germany. As Rogers explained in 2001, "I wrote at length because Mama wanted to hear all about everything—what I saw and did and thought about it."[64] Rogers was first stationed with the Army Air Corps weather service at the European Theater of Operations located in a suburb of Paris. Following the surrender of Germany, she was sent to Wiesbaden with the army of occupation.

In a recent reminiscence written for this book, Rogers reflected on her almost nonchalant attitude about VE-Day (Victory in Europe Day). She recalled that for days prior to May 7, there had been rumors and Teletype messages about a possible surrender.[65] But expectations were repeatedly delayed. The event itself felt anticlimactic. In the following letter from May 1945, she reported how the news of VE-Day was received:

It was on Monday, May seventh, that the C.Q. who always calls at 6:30, really woke me. The tone of her voice had me wide awake. She chanted:
"Six *thir*-ty. In case you're *in*-trested, the war is *o*-ver."
I lay there quite a while, reciting it to myself. Then Gardner spoke from the depths (lower bunk):
"Six *thir*-ty," she murmured; "in case you're *in*-trested, the war is *o*-ver. Are you going to get up for breakfast?" ...
As usual, the mess line was discussing it lightly. All the WACs had heard the C.Q., but none knew the reliability, and no-one was going to look foolish by cheering or anything. ...
Finally at the table, we got the answer. In fact, we got our hands on the evidence. ... It was a teletype message, relating ... that Germany had surrendered ... that it would become effective two days later, and that no release would be made until the heads of the governments announced it.

... And it was just one more damper to V-E Day potential enthusiasm. It was over, we knew it was over, but there was nothing to do about it; no use shouting.[66]

Rogers also reported that when the official news finally did come, people who happened to be at Rainbow Corners, one of the Red Cross club centers in Paris, asked each other if it were really true and then continued to play Ping-Pong, smoke, and talk.

When the news finally sank in, the uncertainly and relief quickly turned into impromptu celebrations held round the world from London and Paris to New York and Moscow. Rogers had applied for a three-day pass, hoping that it might fall on VE-Day, and her pass did, in fact, fall on the eventful day. In another letter written ten days later, Rogers gave a detailed account of the festive atmosphere in Paris:

Swarms of people got off the train, going out to the country to celebrate. And then other swarms piled in, going into the city. The train was jammed. All the little towns we passed on the way had flags hung across the streets, giddy and festive, and people sitting in front of all the cafes.

We were riding the last mile or so when the engines began to whistle, and every horn around honked, and some bells rang. We were at the bottom of the railway cut and looked up at the houses—five stories high, hung with fluttering flags and with people at every window standing and listening to the noise. From our angle they were all up against that blue sky. It was a good picture. . . .

Well, so Churchill had made it legal to go ahead and celebrate. . . . So I went to Rainbow Corners to see what the G.I. world was doing.[67]

That was easy.—Nothing. No coupons were needed for coffee and doughnuts, but the line you stood in was the same. So was someone hunting out "Chopsticks" on the piano. . . .

Then we came out the front door of Rainbow Corners into the loud, bright boulevard, and joined the stream down toward the Madeleine.[68] There were trucks and jeeps going by loaded with people—all kinds—waving all kinds of flags and shouting . . . and the street was full of people walking . . . pedestrians' right of way that day. . . .

We wove a creeping way down from the Madeleine to the Concorde and then turned up the Champs Elysees. . . . I was watching the walk up the Champs Elysees very carefully. . . . The heat, and the brightness of the day, and the bombers buzzing the street. It isn't often a heavy bomber comes so low you can more than identify it, and here they were skimming the roofs all afternoon.[69]

Rogers noted that because "V-E days only come every 25 years," she could not count on being in Paris to see the next one.

As her letter continued, Rogers described the fervent welcome that Parisians gave to General Charles de Gaulle after VE-Day.[70] The huge turnout that heralded him as he drove through Paris established his legitimate claim as a postwar leader of the French people:

> When we were back among the outer crowd, the chant began to come up, and we figured out why all the to-do here. Not just the unknown soldier but the fameux General Degaulle [*sic*] brought out the populace shoulder to shoulder. So we saw the backs of a lot of people looking at General de Gaulle. We tried to find a vantage point, gave it up, and set off philosophically. The crowds were chanting "vive de Gaulle, vive de Gaulle," so I hollered "Hold that line, hold that line" a couple of times, and "We want a touch-down."
>
> We were well down one of the minor spokes of the Etoile when things perked up around us, and we turned to see the general hisself [*sic*] speeding toward us, away from the Arc in his car. We fetched up at the curb, and I hollered "Hold that line!" with enthusiasm as he passed. We then went on to the hamburger place and had four hamburgers apiece. . . .
>
> Suddenly it was time to be moving very briskly or miss the train. . . . But we made it. Got onto the right train, turned into the baggage-car (the nearest) and then I dropped and did some plain gasping. It took me about ten minutes to get smoothed out. The train jerked and moved off about 30 seconds after we got on.
>
> So I was home sedately and at work on time. That was when the other girls came in late, with their excited tales of being trapped in the crowds. Bed-check was set at 2:30 that morning, but actually it wasn't taken, and people were threading in from 2 and 3 o'clock on, till the next day.[71]

After all the excitement of the day in Paris, the realization that the war in Europe was over finally became real to Rogers. Later, she reflected that perhaps one of the reasons for the subdued emotion on VE-Day was the fact that, at that point in time, everyone still expected Japan would have to be invaded.[72] That was a sobering thought with the apprehension of more lives yet to be lost.

When Rogers wrote the following letters to her parents back home, the Germans had surrendered and the American military was already in Germany. Writing from Nuremberg, the city where Hitler held his Nazi party rallies,[73] she compared her mental images of what these rallies and the peak of Nazi power must have been like with a deserted Nazi stadium she saw. Actually trying along with her fellow WAC, nicknamed "Knobby,"[74] to hitch a ride to

Munich, Rogers and her compatriot were persuaded by a boy who drove by on an errand (which he quickly forgot) to take a side trip to see the Nazi stadium. "I could NOT imagine that two or three years ago they were having party rallies there, with Hitler himself and all the whooping and hollering," Rogers wrote of seeing the stadium. "The grass is growing between the slabs of rock and pushing them ajar, and it is deserted and quiet and very lovely. It seems a million years old, and Nazism an old tale like Paradise Lost. Deceptive."[75]

A chance to see more remnants of the defeated regime occupied the rest of their day. What Rogers saw and shared in her letters reflected her uncertainty about the former enemy. When the boy who guided Rogers and her friend through the Nazi stadium asked if they would like to see "a stockade full of SS prisoners," the women quickly accepted. "We were delighted," Rogers noted.

> We looked at SS men, a sturdy lot behind barbed wire, who looked straight back. I am always in a state of confused politics and principles, in the presence of guarded German prisoners. Not happy about it. . . .
>
> Then the boy remembered, and asked if we would like some Luftwaffe helmets.—Naturally. So he drove to a tar-paper shack, supply room or something, and went in to argue. . . .
>
> The boy took us back into Nuremburg then, with a quick detour past a DP [displaced person] settlement. It was a big building like a city high school, and all the windows (blown out, like most of the windows in German cities) were boarded up, each with an angled stove-pipe out of it. We murmured a little at the bleakness. . . . "They never had it so good," said he; "Food and heat and no work. . . ." It is an attitude common in our army, and I don't think it's a good one. Some soldiers explained that they used to feel sorry for DPs . . . but a few unpleasant characters must have soured them.—"*They* don't want to go home," one soldier said;— "and have to work again."
>
> Dunno; it is as tangled a question as you could find. To be a "stateless person" must be terrible; to live in any barracks is bad. . . . I think, or hope, our GIs have assumed a protective layer of callousness. It wouldn't be possible to live, sympathizing with all the misfortune around in Europe.
>
> [Our driver] was typical of all the GIs we met, thoughtful, open-handed, amiable; made one so proud and fond of Americans (—being one, of course).[76]

Rogers's concern for stranded persons alluded to the complex questions confronting authorities about civilians who were separated from their families and categorized as "displaced." With instability all around, many preferred to

be refugees in camps where they had the chance of being sent to safer havens such as the United States.

Rogers also wrote her parents in an undated letter about an encounter with AWOL (absent without leave) soldiers. Although the letter reflects Rogers's spirit of openness and adventure, it also shows the complex situations that women faced. Standing on the side of the road, still headed to Munich, Rogers and Knobby had their thumbs up signaling that they needed a ride when a truck turned the corner. Seeing that the truck was full of MPs, the women quickly "hauled [their] thumbs down" as the truck passed. They wanted nothing to do with police and knew that another ride would probably come along soon after. A hundred yards past them the truck stopped, as if the men inside had been discussing what to do. The truck backed up to the women, and after some cajoling, with questions such as, "What were you shaking your head for, didn't you want to ride with MPs?," Rogers and Knobby accepted a ride and climbed in to what Rogers described as a "friendly atmosphere." Rogers noted that the men seemed to tease them more because they knew the women had "no business" being where they were. The truckload of soldiers sang off and on for the entire trip, and some, according to Rogers, had "awfully nice voices." Knobby and Rogers "helped out a good deal in the soprano."[77] They talked with the men about Paris, the "old days" there, and the Grand Hotel and sang French songs.

"Only when we got into Munich and drove hither and thither looking for the place the MPs were headed to—I got silent and agitated," Rogers explained. The sun was setting and they were in the area of Patton's army, the "dread Third Army." When they finally reached the stockade, the "four kids who were being taken down to their new assignment" gathered their belongings, they all shook hands, and the rest of the truckload made their departure. The remaining passengers on the truck then drove to the nearest Red Cross station for coffee and doughnuts. "It was only when I saw the men peel the brassards [arm bands] off their arms that I realized the four we sang with were prisoners," Rogers explained.

Over the coffee the MPs told us about it. The prisoners had begged the driver to stop for us and begged the guards not to tell, and they didn't. They were four convicted AWOLs (AWOL in Paris?) with dishonorable discharges and sentences from 15 to 30 years. Thinking of it, I imagine we two dumb cheerful women must have brightened a gloomy ride considerably, and I feel pretty good about it. The only thing that gives me the creeps is the memory that . . . I shook hands with each of them, saying farewell at their "new assignment." . . . The guards didn't see how

we could have failed to catch on. The boys themselves kept giving hints when they saw that we didn't. . . . And I had thought the two older men who sat at the back of the truck (guarding the rear end of it, of course) a pair of kill-joys, the way they didn't join in the songs and fun.

"That is the story of the ride from Frankfurt to Munich," Rogers concluded. "They say the beer-hall we had our Red Cross doughnuts in (good fresh ones) was *the* beer-hall" where Hitler's rise to power began.[78]

Years later, in recalling somewhat risky incidents such as the encounter with AWOL soldiers, Rogers commented, "For whatever reason, or however it managed to do it, Rockford [College] gave me a quite remarkable self-confidence. Confidence that I could handle whatever life wished to present."[79] Even apart from the college, confidence was an almost universal feeling among women during the war years, whether they served in the military, in the Red Cross, or on the home front. When 1,500 WACs were given an exit interview, they all acknowledged that being in the service had substantially changed them. Most reported that they had become more tolerant of others' differences and that they had developed a sense of self-assurance and confidence not present before.[80]

While Rogers watched the Nazi regime fall in Germany, Anne Saucier recorded war events on the Far Eastern front. Manila, the site of Saucier's last letters, was leveled in February 1945, when General Douglas MacArthur led American troops into the city and liberated 5,000 Allied prisoners. Casualties were staggering for the Filipinos: 100,000 civilians. MacArthur banned air bombardments, hoping to spare the city's old Spanish and modern buildings. However, because of entrenched Japanese resistance, heavy artillery was brought in by the Allies, and the city was greatly damaged. Saucier wrote in early April 1945:

Beautiful Manila, the city of our dreams, has been devastated by the war—burned, bombed, shelled! It is hot, humid, and smells of death from the countless bodies still buried in the rubble. Once proud buildings are now majestic desolation. Sunken ships clog the harbor, a huge dump records the ravages of war. Dust is everywhere, despite paved streets.

Nevertheless, the people hold their heads high and walk with pride [a]midst the ruins. They are so glad to be free again, and to welcome us. . . . Means of transportation are a study in contrasts. It's anything that goes—bicycles with side cars, tiny covered buggies pulled by little ponies, and some most modern cars. Many of the automobiles were hidden by the Japanese. With our coming, cars, along with many other things, have reappeared.

We were wild with excitement to behold a Shell Filling Station, Coca Cola signs, drug stores, automobiles, roses, boulevards, and the Far Eastern University where we live and will work.[81] It all exceeds our wildest hopes and dreams. At night, we can hear guns in the distance, and see flashes of light, but no air raids.[82]

The Japanese army took control of Far Eastern University during the war, burning records and sparing only the buildings they used for a concentration camp. The university reopened again in the fall semester of 1945.

Close by the university campus where the women lived was Santo Tomas, a concentration camp built on former university grounds. During the three years of Japanese occupation in the Philippines, American and British women civilians and sixty-six army nurses were interned at the camp. Over the three years of captivity, conditions became increasingly severe: a shortage of sanitary facilities, overcrowding, and very little food. There were three showers and five toilets for five hundred women to share. The prisoners stood in long lines for their small portions of rationed rice. As the number of prisoners increased, general freedoms decreased. In 1944, a Red Cross ship brought medicines, vitamins, and food. Although the Japanese took some of these supplies, what remained strengthened the women. More hope appeared in the form of U.S. planes bombing nearby strategic targets in the fall of 1944. On Christmas Eve, holiday cards showered Santo Tomas. The cards bore a hopeful message from President Roosevelt that the war would soon be over.[83]

Saucier wrote in a letter about visiting the camp and talking with the internees who were still there after the liberation about the horrendous experiences they had suffered through. They were forced to eat anything, including rats, in order to survive. "They were so glad to see us and eager to talk," Saucier recounted. "Such wonderful people enduring so much. They were fortunate to have survived."[84] When the women were freed by Allied troops on February 3, 1945, most were jubilant, although physically weak. Nevertheless, even with post-liberation food available, many succumbed to starvation and tuberculosis because malnutrition had been so severe. These deaths were especially tragic as they occurred after freedom had finally arrived.

Like many other Americans, Saucier also reflected on her stunned shock at the deaths of Franklin Roosevelt and journalist Ernie Pyle. Roosevelt was loved by many Americans, for whom he was a symbol of the positive actions of government. His death unified and strengthened the resolve of the troops to fight even harder. The death of Ernie Pyle, who fought alongside GIs in the trenches, broke the hearts of the troops.[85] In a letter dated April 20, 1945, Saucier wrote about the deaths of both of these American heroes:

President Roosevelt's death last week, news of War Correspondent Ernie Pyle's death . . . came today. So it goes; war ain't good.

USASOS [United States Army Services of Supply] Headquarters had a retreat ceremony Sunday night in tribute to the President.[86] The WACs marched over in three platoons, doing company mass in front of the flag pole. The chaplain made some fitting remarks comparing Roosevelt's death to that of Moses when the Children of Israel were coming to the Promised Land. Then a bugler played, "The Star Spangled Banner."

The fighting front isn't far from here at all. We can still hear the guns and see the light flashes. I want to go to the front, but there is no hope of that. Am always stuck . . .[87]

In the midst of this general sadness, there was an awareness, reflected in Saucier's letters, that the end of the war was imminent.

Although news of Hitler's death presaged that the end was near, Saucier's hopefulness was tempered by the continued reality of circumstances. "Mussolini is definitely dead, and Hitler, too, it is rumored, but more startling yet was the fresh salad we had for mess last night—tomatoes, greens, cucumbers, green peppers," she wrote, but "come the day there is milk, I'll send a cable. I drink the condensed milk for a substitute and take calcium tablets to protect my teeth."[88] Poor nutrition was a frequent problem for overseas WACs in the Far East. Citrus fruits and milk were in chronic short supply. Saucier, characteristically, was not a complainer, but the stress of deprivation eventually broke through.

Saucier, like many other Americans, was stunned by the power and devastation of the atomic bombs dropped in Japan. It was a troubling and sobering time for many. She noted in one letter home, "I never heard of such a thing." Along with the feelings about Nagasaki and Hiroshima, however, there were also feelings of joy and elation that the war was finally over. This exuberance was conveyed in Saucier's letter from August 1945:

It was a tough fight, but we won!! Yep, we sure did. Doesn't the sky look bluer, and don't the birds sing sweeter, and the roosters crow in the morning with greater gusto, to greet a new day? . . .

All Manila rejoiced. Guns were shot into the air, flares went up, and the church bells rang. Some joined the wild celebrations all over Manila, but I refused to leave the area, fearing the reckless shooting, combined with inevitable drinking, that made it far from safe. Sadly, some were killed this night which promised peace again.[89]

The following night, after the announcement of the unconditional surrender of the Japanese, the American navy "cut loose." Saucier recalled that the Manila

harbor was full of ships blowing their horns. "I never hope to hear such a din, or see such a sight," she explained, as flares, guns, and searchlights "swept the skies" and church bells rang.[90]

A month later, Saucier was reflective in her analysis of the U.S. Philippine commander and his leadership:

> While I'm talking about attitudes, might as well mention the unfortunate feelings toward General MacArthur. I don't know how much has leaked through the censorship, but it seems that the "I shall return" man is definitely in the dog house with his troops. From what I can gather, it's this "I shall return" which infuriates them most, because he didn't do it alone. Of course, he never said he did. And then they are furious about his family always tagging along, and a million other little things they have either concocted themselves, or which had some amount of truth in the beginning. That the man is a great general can hardly be denied, but personally he is disliked—at least from a distance. I've never talked to anyone who really knows him.[91]

Saucier's letter captured the general sentiment of the troops about MacArthur. Although a brilliant tactician, he was derisively nicknamed "Dugout Doug" for his aloofness from the troops. He was considered pompous and autocratic, requiring his subordinates to execute his plans. He had been driven out of the Philippines by the Japanese after Pearl Harbor, at which point he delivered his famous statement, "I shall return." When he did return, it was with careful staging for the press as he orchestrated his arrival from the landing craft, filmed multiple times by many cameras to get it right. The troops' dislike of him was in sharp contrast to his reputation as a hero by the American public at home.

Saucier later reported her personal observations of the war crimes trial by the U.S. Military Commission of General Tomoyuki Yamashita, the "Tiger of Malaya," who commanded the Japanese campaign in the Philippines in 1944–45. He was found guilty of not controlling his troops, who had gone on brutal rampages after the 1944 American invasion of Luzon. With 123 specifications listed against him, Yamashita was charged with violating laws of war and allowing his men to commit atrocities in the Philippines. Saucier was present in the courtroom at the U.S. High Commissioner's building over several days in October–November 1945 and was close enough to gain a clear view of him.

> We sat very close to the accused, and those involved in the trial—only a couple of rows away. Am sure Yamashita saw me, and I looked directly at him.

Yamashita sat impassive throughout the day. I had very mixed feelings while listening to the unbelievable horror stories being recounted, one after the other. Here I was, actually facing the former enemy, looking him in the eye so to speak, and finally, fully comprehending a hell he had created on this earth. To make him live with it could be more cruel than any punishment to be devised. But this man had come from another world, completely alien to the one in which I had lived. What could have made him like he was?[92]

Appeals by Yamashita's lawyers were denied by the U.S. Supreme Court, and he was hanged on February 23, 1946.

Although Saucier was weary at the end of the war, her letters to her friend Evelyn Turner intimated that she accomplished what she hoped for her and her classmates in 1943: "The depression forged us in adversity, and Rockford College refined us to tempered steel. . . . It was now up to us, what we would do to win the war—how we would 'strike a blow for freedom!'—bring peace, and work for a better world." After two years, one month, and fourteen days in service, Saucier was honorably discharged on November 29, 1945, "demobilized," she wrote, "for the convenience of the government." Like many other service personnel, she experienced what was at times a difficult transition back to civilian life. In a journal entry dated November 21, she wrote:

> I was suddenly so tired last night that it was all I could do to get into the new flannel pajamas and in bed. Guess it was kind of an emotional let down after our grand arrival through the Golden Gate, debarking with bands playing, dashing around at Camp Stoneman, making the call home, having good things to eat again, our trip to and celebration in Pittsburg, California, and then the parting of the ways as my friends and I start out for various separation centers.[93]

According to her discharge papers, Saucier received a long list of awards in recognition of her service: a Victory Medal, an American Theater Ribbon, an Asiatic Pacific Theater Ribbon with three bronze Battle Stars, the Philippine Liberation Ribbon with one bronze Battle Star, two Overseas Bars, and a Good Conduct Medal. "They will make quite a box of keepsakes," she noted.[94] Medals of honor were bestowed on women in the military, but they had little else to show for their service.

When the war was over, many women in the military returned to former traditional roles in civilian life. Although American society might have initially regarded their positions as a unique response to emergency conditions, the role of women in American society was never again the same. Decades later, Julia

White Rogers recalled her years in the WAC: "Those two years crowded a great deal of experience into a short time, giving me the poise that would have taken longer in a less concentrated civilian life." Rogers, who eventually became an editor for the Central Intelligence Agency, reminisced, "Two institutions have been enormously significant in my life: Rockford [College] and the Army."[95]

Emily Yellin, interviewing numerous women who participated in World War II, was struck by their "fierce optimism." Yet there was the common refrain from these women that their deeds were far less significant than the sacrifices made by soldiers on the battlefield. Yellin, however, came to a different conclusion: "The small things, the less dramatic changes in the world, were sometimes the most revolutionary. And often those were the kinds of changes women effected."[96] The strength in Dorothy Carstens and Anne Saucier as they upheld their responsibilities under difficult conditions in North Africa and the Far East, the resourceful determination of Ruth Buffington as she ingeniously located supplies for the Red Cross, and the endurance and courage of the army nurses at the Santo Tomas concentration camp were multiplied and amplified by countless American women in service. Elshtain described "men's experience of war [as] defensive, a story of aggression held (for the most part) in check, a tale of trying to protect, to save, to prevent."[97] The women's story was a different one—one that told of saving, but saving through a network of caring, comforting, and civic housekeeping for a future world of peace.

6. Romances of War

When Catey Glossbrenner Rasmussen began her studies as a freshman at Rockford College in the fall of 1943, she was very close to Robert Gilmour Smith, a friend from her hometown outside Indianapolis, whom she started dating in 1941 when he was a student at Butler and Indiana universities. Once Smith joined the Naval Reserves in April 1942, Glossbrenner wrote the first of many poems articulating her growing feelings for the young man with whom she was falling in love:

> Someday my loneliness will be sunshine rimmed with flowers.
> Someday it will no longer be years, not even hours.
> Someday my loneliness will be all love and laughter.
> Someday when happiness is not prefaced by "after . . ."[1]

In the spring of 1943, Lieutenant Smith was designated a naval aviator, sent to naval air stations in Miami, Florida, and Glenview, Illinois, for further training, and finally shipped out in September 1943 to join Bomber Squadron Nineteen in the Pacific based on the aircraft carrier USS *Lexington*. After Smith, or Smitty as he was known, joined the service, Glossbrenner shared only three brief home leaves with him, but they wrote each other regularly, sending pictures and often poetry, including "birthday poems" she wrote for him. Through this correspondence, their relationship grew and turned to talk of a future together—illustrated by the sketch and floor plans he sent for "Hill House" to be built upon his return and her list of suggestions for "Smitty's House," which included, "Please have sliding down banister . . . for the 6 children & nieces and nephews, and you better have more bedrooms."[2] Only three, including the master bedroom, were included in the plans. There is little doubt they both envisioned their lives together after the war.

Lieutenant Robert G. Smith.
(Courtesy of Catherine G. Rasmussen.)

"For Smitty," from Catey
Glossbrenner. (Courtesy of
Catherine G. Rasmussen.)

On November 16, 1944, a national radio broadcast by Gordon Graham out of Washington, D.C., credited Lieutenant Robert Smith with participation in a major bombing raid against a Japanese submarine tender and credited his squad with bringing down over one hundred Japanese planes in a sixteen-day period. The story appeared in local newspapers, trumpeting the success of Smitty's dive-bomber group. Less than a week later on November 22, Lieutenant Smith's parents received a telegram telling them their son was missing in action. Glossbrenner's poem "For a Navy Pilot," dated November 23, expressed her initial feelings:

> I can never wake again at night
> In quiet peacefulness from dreamless sleep
>
>
>
> Without the thought of you and oceans deep.[3]

Smitty had been on the conning (pilot) tower of the *Lexington* with a group of fliers reporting in after their missions when a Japanese kamikaze pilot crashed into the tower on November 5, 1944, killing fifty men.

As Catey Glossbrenner Rasmussen wrote in a memorial scrapbook finished in 1996, "The mailroom at Rockford Women's College was the stage for many tears and sobs as students read of brothers and sweethearts missing or killed in action. Everyone knew when Smitty was 'missing' in November 1944."[4] Glossbrenner's memoir is filled with her poetry from those days, especially following the news of Smitty's fate. For months afterward, her feelings of loss, sadness, anger, and frustration were all evident in her poems. Like Glossbrenner, thousands of young women across the United States endured being left behind and accepting what fate sent their way, and the seeming senselessness of it all was often a burden beyond all others. Smitty's last letter to her, dated November 2, 1944, ended with these lines of poetry: "I loved you 'ere I knew you; know you now, / and having known you, love you better still."[5]

Courtships and marriages took on greater meaning and importance with a world war surrounding young women and men. Catey and Smitty's relationship was one among countless thousands of romances that evolved during World War II. Many women like Glossbrenner suffered the heartbreak of loss as they received word that a loved one was missing or killed in action. Others sent "Dear John" letters or received a "Dear Jane" letter from far away. While wartime stresses broke some relationships, others survived and flourished. Many women across the country became war brides, and the stories told through reminiscences and correspondence show how they endured distance and hardships. In fact, most wartime romances were carried on largely through letters. Struggling to find ways to make emotional connections through the

written page, many couples depended upon the popular media for a common language by referring to the words of songs they heard on the radio or a movie that was shown at camp or at a theater back home. As the nation's popular culture was shared across great distances, it tied couples together and at the same time—in the words of a song or the plot of a movie—reflected Americans' endurance in the face of a lengthy war.

American culture embraced romance generally in the war years—the romance of war itself, or the boy-girl variety—and it was a prominent theme in much of the era's music and film, as well as a significant component of the tons of mail sent back and forth between loved ones. Whether it was pinup girls, cosmetics, movies, popular music, or advice columns, wartime culture surrounded women at the college as it did others in the United States, making it impossible to ignore. Everyone was constantly reminded "there was a war on," and romances were strained or strengthened by the wartime events.

If romance was a powerful motivator during wartime, it was just as controlling a force after the war as an impetus for moving women back into the home. Historian Jean Bethke Elshtain wrote that American women during World War II, whether they were housewives or war workers, "expressed essentially private dreams as their most cherished postwar desire." The "ideal of postwar domesticity" evolved not because women were "crudely coerced *en masse* to 'return' to the home." In fact, most American women of the time period had never left the home, and those who had still valued "domestic dreams." "The postwar romance with domesticity ensured the survival of reigning symbols," according to Elshtain, "as did the fact that returning soldiers were greeted by a unified people as just and honored veterans."[6] The ideal of civic housekeeping or social feminism in many ways already prepared women for this retreat back into the home. This sort of feminism had, on the one hand, moved women out into society to become civically engaged, but the primary intent remained clearly focused on the necessity of women's action rooted in a relational perspective of women's social roles, rather than an individual perspective.

The story of war might be told by individual voices in diaries and letters, but the fact is that war pressed upon citizens the necessity of fighting for "the common good" and placed societal concerns before the individual. Americans embraced romance as a mechanism for survival. The struggle for women's rights had essentially focused on individual rights—the right to vote and the right to hold male-dominated jobs for equal pay. In the World War II era, the war story became one that needed the closure of a return to normalcy, and for many Americans—both women and men—that meant a return to more traditional roles. A shared language essentially drowned out the individual voices of women, while postwar participation in the world beyond the home

became a much more localized concern with neighborhood and town. Essentially, women's voices in the 1940s became characterized not by a language of care that promoted individual achievement in society beyond the home but by a much more personal language of care that was indelibly intertwined with the voices of servicemen. The love letters of this chapter capture the expectations placed on women during the 1940s as much as they discuss personal relationships. However, while these letters were written with the expectation that they would raise spirits, inspire hope, and nurture, there was also a poignancy in them, a sense of fragility and uncertainty about the future.

"This Is a Fine Romance"

Like the words of the Depression-era Dorothy Fields and Jerome Kern song, young women and men faced challenges in their attempts to do what was natural—fall in love. The women of Rockford College were close to Camp Grant where thousands of soldiers were inducted and others received medical training. Not surprisingly, there was a steady stream of "traffic" between the college, the camp, and the local USO club where Rockford area women, including Rockford College students, volunteered. With hundreds of military installations, the geographic proximities of these and USO clubs aided romantic opportunities across the country during the war years when the vast majority of eligible bachelors were members of the armed services.

Like many young Americans, Jean McCullagh ('44) and Captain Kenneth Gee were married during the war. Sixty years later, Jean penned contributions to her husband's autobiography, "Dear Ones Away," in which she recalled how they met on a college ski trip:

> The Dean had invited several trustworthy young male doctors stationed at nearby Camp Grant to accompany the inexperienced skiers. . . . Ken and I met on a ski slope . . . in Northern Michigan. I fell down; Ken picked me up. As our group traveled by train we played card games. On the return trip "hearts" was a favorite and it was reported that I spent so much time gazing at Ken that I repeatedly played the wrong card.[7]

When they returned to Rockford, Jean and Ken dated "with increasing frequency," Jean explained. They went to dances, plays, and movies and ate out. On Saturday nights, they frequented the Camp Grant Officers' Club. Ken was fortunate to have weekends free, so they spent them picnicking and hiking. On Sunday mornings, the camp obstacle course was deserted, so they ran the course together and had the place to themselves.

While the college made some attempts to shelter their students from the male population at large, it was not enough to keep Jean and Ken apart. Likewise, the natural attraction of the genders was not inhibited by the fact of war. Women like McCullagh met military men and become seriously involved with them. Because Ken was an officer, that led to more opportunities for Jean to attend social activities at Camp Grant than most of the other college students experienced. Yet like numerous young couples across the country, war became

Jean and Ken Gee, shown here at Christmas 1943. They married during the war.

(Courtesy of Jean Gee.)

the driving force in their lives. Dates spent at an army camp, including time together running a military obstacle course, point to the ways that war crept into even the very personal lives of American young people.

An article titled "Dates Divulge Opinions on RC Gals" in the March 6, 1942, issue of the *Purple Parrot* collected comments from recruits who were assembled one evening in a favorite gathering spot on campus. "Tell us what you are thinking while you sit waiting," a reporter from the college newspaper asked with a collective voice for Rockford women. After all, the news reporter noted, you have the time because "we must powder that nose again and smear on a little more lipstick." Here is what the recruits said:

> Pvt. Dan Muellhaupt was quite flattering: "The girls really are very nice. . . . As far as I can see, Rockford College is A-1."
> Jack Weber, another army man . . . suggests: "I think the girls are very entertaining and interesting to know. I think they should be more liberal in the hours here though. I should think there should be all-night pers [permissions], that is, the girls should not have to come in at any certain time. . . ."
> . . . Dick McGuire limited his classification too: "I heartily prescribe that what Camp Grant needs is more of the Freshman Class. . . . I think the hours enforced upon the Freshman class are a little severe, but in general the best way to describe RC is wow!!" . . .[8]

As the newspaper story suggested, women cared about men's views and about making themselves attractive. The newspaper also carried ads for various cosmetics, including "Remember Me" face powder with a name reminiscent of the feelings many women had for their male loved ones away at the war.[9]

Even though the college attempted to regulate its students' contact with soldiers, women from the college met servicemen everywhere they went in town or through volunteer work for the local USO or Red Cross. In 1943–44, Rockford College students needed written parental permission to attend dances or visit Camp Grant in addition to permission of the dean to attend the officers' club, USO, or any other camp functions.[10] Catey Glossbrenner recalled one day when the dean of women at the college looked out her window across the campus lawn and saw "homesick boys in Army uniforms" lining the wrought-iron fence that marked the boundaries of the campus. Some students at the college had asked them over as a joke. "We were allowed to have them all come in for tea and cookies and strolling under the ancient oaks," Glossbrenner explained. "There must have been over a hundred men quickly forming into couples and small groups of laughing visitors and 'hostesses.'"[11]

There is little doubt that the lure of a women's college a few short miles away from a large military installation was strong on newly inducted soldiers. The romantic image of women supporting the troops pervaded the whole of American popular culture. After all, women represented one of the things men were going overseas to protect, as advertisements of the era reminded everyone. Despite the pressures of war, young people still maintained the old decorum and normalcy of tea and strolling. Just as young couples were making do in the circumstances that surrounded them, women were accepting the limits of wartime society in many areas of life.

Fashions were still important despite being one of the many "victims" of wartime rationing. American women did not give up their desire to look good just because "there was a war on." Wool was siphoned off for war uses, and women's fashions were limited by fabric choices and by designs that emphasized slimmer lines that used less material. A college newspaper story in October 1943 emphasized the sensibility of accepting the limits of wartime. "In the pre-'duration' days, half the fun of coming to college or back to college was the summer restoration of your school wardrobe," the reporter noted. "Then came the dilemma of rationing and last August on your yearly 'back to school' trek down to the department store, you cheerfully accepted the 'sorry, these are the only styles we have!' and chalked it up to another minor sacrifice."[12] Practicality and sacrifice applied to so many aspects of life, and it was an important theme at the college, as it was for the rest of U.S. society, that everyone did their utmost for the war effort.

Even if Rockford College women were away from the front, they still saw themselves as part of the larger whole that supported the troops. Their relationship to the war and the sacrifices it required was not limited by their relatively sheltered existence at the college. In addition to the ideals of rationing and sacrifice, the story above ended with this reminder:

> A cute grin and color in your clothes are the morale boosters our weekend, khaki-clad visitors need. As you "hut, two, hee, fo" through the streets of Rockford with your dates, forget that the first time you wore your dress was at a High School Cotillion ... quicken the pace to double time ... and have fun!![13]

Even the smallest contributions to soldiers' morale were valuable, and the message was that these should be made with a cheerful heart. Another college paper advertisement titled "Admit it, now ... You Dress For a Man Don't You?" reminded women that "you want him to notice your eyes, not your hat ... YOU, not your clothes" and pictured a woman being admired by a ring of men half

of whom were attired in military uniforms.[14] Soldiers quickly became a part of the national consciousness only a few short months after Pearl Harbor.

Dances were a major source of interaction between young women and the male military population. Whether at a local USO or Red Cross club or at a nearby officers' club on one of the multitude of military bases that dotted the country, women served punch, chatted, listened, danced, and were a sight for the sore eyes of men entering what was for them the biggest—and possibly the last—adventure of their lives. The college held regular dances despite the persistence of war. The campus newspaper reported some discussion about the name for the 1943 Valentine's Day dance. Consideration was given to naming the dance the Heartbreak Hop, but the organizers quickly had second thoughts. "We have decided to compensate by having the dance semi-formal," the story reported. "The boys love it that way. Let's give them a good time, girrels [sic]—they are all Uncle Sam's stooges sooner or later."[15] Although the fate of the men going through Camp Grant was clearly evident to everyone, and the college students did not forget it, the characterization that "they are all Uncle Sam's stooges" also suggested a certain growing cynicism among the women on the newspaper staff.

A soldier who was hospitalized for a time at Camp Grant in 1940 remembered the college students and their dances when he wrote to Carolyn Beebe Ogden ('44) in 1943 from his POW camp in Germany. His letter was excerpted in the *Vanguard*:

> [A] few lines to let you know that I'm still alive. Am a prisoner of war since St. Valentine's Day. I have thought many times about you and our pleasant times together. . . . Trust that life has been gentle with you and that you are happy. . . . Hope the dances are still the success they were. . . . Days are long and lonesome. Have had no mail from anyone. Contact the local Red Cross for mailing instructions. Send a few snap shots if you don't mind. . . . Bet you're swimming and dancing. Dance one for me, as you always were an excellent dancer.[16]

This poignant remembrance made it clear not only to Ogden but to all the college students how much their friendships, dances, and dates meant to the young men passing through town and the nearby induction center. These were the memories young men carried off to war.

With romantic themes in many films of the day, and the exigencies of war creating extra pressures on young single women and men, plans to hurry up or delay romance often created difficult decisions for couples. In 2003, a year after Bill Keely passed away, his wife, Jean Lyons Keely ('46), sent a bundle of his letters, along with her remembrances of the time they spent apart, as

a contribution to this study. By Jean's junior year in college, Bill was a fully trained officer stationed in Battle Creek, Michigan, "just a short trip to Chicago for both of us," before he was sent off to war. In 1943, he wrote to her of his feelings about their developing relationship:

> I'm not in love with anyone else, and don't believe I ever could be—but for the (I don't know how many times) please understand the facts I've told you about the "whys" and "wheres"—When the war is over and you are finished with school, these will be times to see which way you want to turn—I could "tie you down" and perhaps you would come out the way you think, but if something should happen to me, I would never forgive myself. . . .
> . . . I'm at a loss—for I think I'm doing right, and yet you make me feel so different, because of my way of thinking—I don't know at times why I should be so sure of there being a future—and yet I feel that I will be back after this war, and everything will be so enjoyable and peaceful![17]

Bill did not want to get married until after the war was over, clearly for Jean's sake. However, she did not agree with this. They were engaged on February 13, 1945, but Jean recalled later Bill's view of things at the time: "No wedding ring until he came home. That is the way he wanted it. Not me!" It is clear from this letter how the changes brought on by war and distance affected the Keelys' relationship as they struggled with the decision to marry or wait. Bill's arguments echo those of some who felt that a commitment like marriage, in an atmosphere of uncertainty such as the war created, was the wrong thing to do. Jean had little choice but to follow his wishes, and he proved true to his word when they married July 21, 1946.

The "prevailing wisdom" discouraged hasty weddings. Marriages to men about to depart for war were considered by some to be a bad idea, one that would result in problems later, yet almost 1.8 million marriages occurred in 1942 (up from 1.7 million in 1941), followed by slightly diminished yearly numbers (1.5–1.6 million) until the war ended. Almost 2.3 million couples married in 1946. Not all these marriages were to servicemen or veterans, but the large increase in numbers suggest that a portion of them were, especially considering the millions of men who served during the war. The 1948 *Statistical Abstract of the United States* recorded the changing marriage rate during the war years, which increased from 10.7 per 1,000 Americans in 1939 to 12.7 in 1941 to 13.2 in 1942, then leveled off around 11–12 per 1,000 until war's end when rates jumped to 16.4 in 1946. There is little doubt that wartime witnessed an explosion of weddings, particularly compared to lower marriage numbers during the Depression years (from as low as 7.9 per 1,000 in 1932 and ranging from

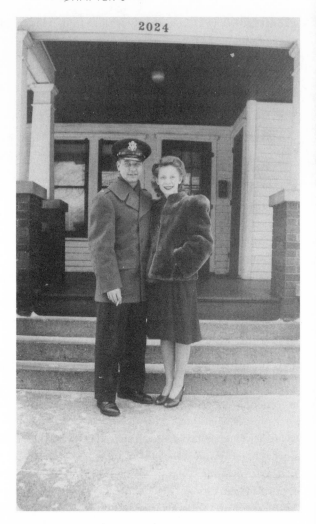

Bill Keely and Jean Lyons Keely, who were engaged in February 1945 but waited until after the war to marry. (Courtesy of Jean and Bill Keely.)

0.9 million to 1.4 million a year between 1932 and 1939), when many couples felt too much financial insecurity and uncertainty to marry.

Following on the heels of the Great Depression, World War II and the uncertainty it created wore very heavily on young Americans, both male and female. For some, most of their lives had been filled with concerns over the economy—and for many that included despair about basic housing, food, and clothing—or the state of world affairs and potential loss of loved ones in battles on distant shores. Those graduating college in 1945 were generally born around the middle of the volatile but mostly prosperous 1920s, and just when they were getting old enough to be really aware of things around them,

the Depression struck and times were difficult for almost everyone, impossible for some. Before the Depression ended, the war took hold of the nation's consciousness, eliminating economic worries but creating new fears of death and loss, plus invasion or world domination by an evil enemy. War prompted many couples to break with the advice columns and take a leap of faith in their relationships. Whether or not all the additional marriages in the 1940s are attributable to the war or just the end of hard economic times, the specter of war did not dissuade them from following their hearts in spite of what others around them said.

Of Marriage and Mail

At the college, students were not immune to the lure of wartime marriage. There were dozens of wedding announcements in the Rockford papers during the war years. Of the thirty-eight members of the Rockford College graduating class of 1944, eight were already married; in a number of cases, the new alumnae were married to active-duty servicemen. The way couples kept their connection was through letters. Like their Rockford College counterparts writing to loved ones, the nation's wives collectively wrote millions of letters, often writing multiple times each week—even daily—expressing their feelings and describing the mundane and ordinary aspects of home-front life (rationing, shortages, bond drives, scrap collection, and the like) along with news of family and friends. It is this historical record that shows how the war affected love and marriage.

The experience of Jean McCullagh Gee as a war bride illustrated some ways romance played out during wartime. With Ken stationed at Camp Grant while she was enrolled in the college, dating had been relatively easy, but once the summer of 1942 came along, the tensions of distance appeared. Jean spent the summer in California with her family and worked a job as a receptionist in an insurance company. She wrote Ken, her "handsome Captain," almost every day, but one evening in July, the phone rang. Ken was calling long distance from Rockford to ask her to marry him. She accepted. Their solution to the problem was one taken by many others and represented the other trend throughout the war.

Sociology major Lois Pritchard Fisher had already expressed her early opposition to U.S. entry into the European war in early 1940 when she ran out of a Rockford College chapel service on campus.[18] Not too long after, however, her new husband enlisted and was sent overseas. Like so many thousands of other women, Fisher faced years of separation from her husband and, of course, the constant worry he might come home disabled or not at all. Women married to soldiers usually opted for one of two paths: moving from town to town following

their husbands as they were trained and prepared for war or moving home to live with family members—usually parents, in-laws, or even grandparents. If children were involved, the most common path was moving home.

Jean Gee was faced with many difficulties after she and Ken decided to marry in the middle of the war while she was still finishing at Rockford College and then became a mother. Decades later, she described those many convolutions:

> After we were married, . . . [Ken] was transferred to Fort Riley in Manhattan, Kansas. I was eight-and-a half months pregnant and went to visit him. For some reason, I left Fort Riley in the middle of the night. . . . I almost fell asleep on my suitcase in the corner of the roomette. It was a tiny room and when the bed was down, it covered the toilet. In my very pregnant state, the porter had to boost me into the upper berth.
>
> After Natalie was born in November 1943, I . . . returned to Rockford where I was a history major with a social psychology minor. Some of my classmates were babysitters. Natalie was a class mascot. I would park the pram outside the class window if the weather was good.
>
> Ken [was] assigned to a medical corps unit to go to the Pacific. He came back for a week when Natalie was born and left in March 1944 for the West Coast.
>
> . . . Natalie, who was asleep in her pram, [was] present at my college graduation on June 6, 1944—D-Day. When Ken went overseas, Natalie and I moved to California to live with my parents in Sierra Madre.[19]

When Jean returned to her parents' home after graduation, she followed a familiar path of women whose husbands fought in the war. With limited income, an infant daughter, and husband away in the Pacific, there were few other real options for Jean and others like her. U.S. society adapted to the changes brought by the war, and war brides were no exception. In many ways, this was the last gasp of a different life, one in which extended families living together was the norm. Jean's and Ken's parents supported their decision to marry; however, not all parents did.

The proscriptions against wartime marriages were many and permeated American magazines and newspapers, emanated from the lips of family members, and were routinely ignored by many in a culture shaken by the sudden attack at Pearl Harbor. For them, the desire to have something certain—at least their love seemed certain to them at the time—in a chaotic world overrode any admonitions. For Jean and Ken Gee, their wartime romance turned into marriage that lasted for decades after the war. With the college "family" helping Jean, and her own family doing the same, their story had a very happy ending after his return from the Pacific. The difficulties resulting from a war-

era marriage were usually borne more heavily by the women who faced new lives in new places.

Six decades later, Joyce Marsh Roos ('45) wrote in a letter for this study about the early war years with her husband, Ensign Eugene H. Roos. Joyce left Rockford College midyear to marry Ensign Roos in Florida on December 23, 1944. At the time, Eugene was training in naval aviation. After their marriage, they were moved around the country to various naval bases and finally ended up in San Diego during the summer of 1945. Living in one room they rented out from a woman who offered spare rooms to servicemen, they knew that Eugene's orders to ship out from there would be unavoidable. Young couples like the Rooses not only faced the difficult circumstances of impending separation but also the very basic concern of finding a place to live during what Joyce described as an "acute" housing shortage.[20] From the crowded living spaces to the vagabond lifestyle, Joyce's descriptions illustrate the life of many war brides during World War II.

Like Roos, about sixty years after her husband left for military service, Lois Fisher wrote of her wartime love story as she remembered the highs and lows of the times:

How devastated I felt, in the summer of 1942, when my husband of six months decided he should enlist. . . . As we talked it over, I could understand how he felt. Most of his contemporaries were gone and he felt questioned, even silently by people who did not understand why a healthy looking man was still walking our streets. His deferment for his type of work did not show and he felt awkward and conspicuous for not being in uniform. I felt panic, but had to agree with him and finally concluded I would "Do my best," if he enlisted.

We asked his Mother if I could live with her, while he was gone. She was delighted and gave me the best room in the house that had a nook, containing a private wash basin and mirror. She was wonderful and I often read his letters at the dinner table, where she once said, "If you were not here, I wouldn't get all his great letters!" It was from Mother Fisher I learned to cook Dana's favorite meals.[21]

Dana Fisher faced a common dilemma of men left behind in the war, and Lois's support of his decision was a major sacrifice for her. Many couples exchanged letters quite often, and Lois's sharing of her husband's letters with his mother illustrated how important letters were to the whole American population.

Lois Fisher did what many women did during the war—got a job. At first she was concerned that she needed education beyond her sociology degree from Rockford College to apply for jobs, and she "floundered," unsure as to her

qualifications for work in the business world. One of her college classmates suggested she apply for a position at an insurance company, so she "gathered [her] courage and went 'job hunting'":

> The man in charge was favorably impressed and offered me a job, at $25.00 a week. It was not much money—even then—but I was EMPLOYED!! It turned out to be my salvation! . . . [A] nice girl, in the office, . . . invited me to her home in the country for the first of many grand weekends. Her several friends "adopted" me too and we had great weekend retreats, which helped me so much in filling in the long, lonely week-ends.
>
> As time went on, we often got silly together and they all helped with taking pictures to send to Dana, who by then, was in China—15,000 miles away!! One picture was of me in a grass skirt someone had, lying face down, in the grass and "topless"! He especially liked that one and still has it!![22]

Lois's reminiscence also points to the important role of written communications in keeping her relationship with Dana a strong one despite the distance between them. The couple wrote each other often, but after one of Dana's early letters was delivered "so cut up, it looked like a player piano roll," Lois was afraid that all his letters would arrive that way. The couple learned to avoid using numbers in their letters, which the censors "seemed to regard as some sort of code." Lois noted that it was "a great salvation" that most of his letters arrived intact. Although Dana was for a time stationed in the United States, he eventually served two and a half years in the China-Burma-India region.[23] Fisher, like many other military wives, wondered how to manage the time apart from her husband.

Fisher's reminiscence highlighted two features of wartime culture. First, her "pinup" picture sent to her husband reflects the popularity of these images of Hollywood actresses, usually in bathing suits or other similar scanty outfits, which adorned servicemen's lockers, bunks, trunks, packs, and planes across the globe. Thousands of pinups were distributed free by press agents to American servicemen. As the popular literature, ads, newsreels, and radio shows of the time stressed, such images helped to remind soldiers and sailors what they were protecting at home. In the style of many World War II fliers, Smitty named two planes—*Miss Kate I* and *Miss Kate II*—after his sweetheart Catey Glossbrenner. Certainly it is easy to understand why Dana Fisher would love the pinup photo of Lois, for it kept him motivated and illustrated what awaited him at war's end. Pictures of Rita Hayworth, Betty Grable, Hedy Lamarr, Lena Horne, or any number of beautiful Hollywood stars served a similar purpose for millions of other servicemen.

As the war dragged on, the mood of soldiers and the public shifted toward the hoped-for end of hostilities. The college paper printed a January 12, 1945, story titled "Nostalgic Theme Pin-up Favorite," which described an image being requested at the rate of almost five thousand copies per week. The illustrated image showed a young sailor hugging a relieved and smiling young woman whose wedding band was clearly visible as she was embraced very passionately in an image that was part of a series called "Back Home for Keeps." The article explained that "instead of photos of scantily-clad actresses and artists' sketches with the accent on legs—which dominated barracks' walls in the early days of the war—the fighting men are turning to pictures which remind them of home." In addition, the article noted the positive response of "wives, sweethearts, mothers and sisters of the fighting men, who see in the paintings the portrayal of their dreams," which made this series of images such hot sellers that it necessitated additional paintings and printings.[24]

Second, Lois referred to a "player piano roll" letter she received from Dana, which reflected the activities of the wartime censors. Government officials were looking primarily for any information that might be useful to the enemy such as locations or troop strength, but they were also concerned with any evidence of declining morale among the troops. In addition, mention of manufacturing or other types of war-related production was not allowed, nor were the topics of shortages or surpluses to be raised in correspondence going to the front. Any negative information of that type was considered potential fodder for the enemy. While Americans respected the need for wartime secrecy, the censorship of their letters sometimes was difficult for women to tolerate. No matter the concerns of war, women longed for information.

Lois Fisher's life duplicated that of women in the many countries embroiled in world war. Working while husbands were fighting and finding out the extent of their own capabilities was an illuminating experience. Through her job— which she fretted over and likely would not have had if her husband had not been away—Lois gained new friends and relationships, an extended support network, and some economic independence. This became the new norm for many, a life much different from those of the generations before them whose horizons did not extend very far beyond the home. Whether women were college educated or not, those broader horizons also included communicating with husbands who were often half a world away and yearned for news of their sweethearts, family, and civilian life. Letters were the only real way to maintain contact, and American wives kept up their end of the correspondence while their husbands were equally busy writing home.

Numerous advice books and magazine articles of the time were devoted to helping military wives cope with what was a new and challenging experience.

One of the strongest pieces of advice being universally given by everyone, including the federal government, was that women should be writing letters to their loved ones in the service. The campaign to promote letters to soldiers and sailors was nationwide and reached women throughout American society—wives, mothers, sisters, even strangers. Judy B. Littoff and David C. Smith included in their collection of war letters, *Since You Went Away*, a letter from an American woman to her husband in the military that explains her recognition that letters would be the only way they might stay close. They would, after all, be the only communications they would have:

> My darling, I call this the first day, for it is the first day in which I do not know where you are. . . . Maybe there will be many details which I shall never know, and that seems hard to bear. It must seem equally hard to you to feel that there are things which are going to happen to "we three" [she and their two children] which you cannot know. But I shall attempt to write as many of them down as possible.
>
> If you could see me now, pleased as punch because down in the cellar the fire is burning and it is of my creating. I am determined to master that imperturbable monster. . . . My coal came this afternoon and I got a fire built. . . . But it got away from me. The house got so hot I shut all the radiators and opened the front door, and I felt as if I'd let the genie out of the bottle.[25]

For the woman who wrote this letter and the millions like her, letters were a connection to the normalcy they craved and believed would come at war's end. The letters also trace a growing independence for American women and record the evolutions of relationships between soldiers and women on the home front. Many couples, like Rockford's Jean and Bill Keely, kept up a lively correspondence during the war, producing well over one hundred letters chronicling their hopes and dreams.

The sheer volume of mail written by Americans to loved ones serving overseas was a logistical problem for the government, which juggled mail delivery and shipping war necessities for the troops. V-Mail was designed as a way to encourage communication but also cut down the bulk of mail to soldiers and sailors around the world. The public was encouraged by the government, and even private corporate advertisers, to use V-Mail stationery, which was 8½ × 11 inches and available at post offices, stationery stores, and "five and ten cent" stores, in order to speed their correspondence to the fronts around the world. V-Mail letters were reduced to microfilm and the film shipped overseas where the letters were printed, cut, and sealed in envelopes by machine before being distributed. According to one advertisement, one ton of ordinary letters

could be reduced to fourteen pounds of V-Mail film that was flown abroad (which was considered safer from enemy capture than shipment by boat) and distributed in 4 × 5½ inch "photographs" to grateful recipients. The time for mail delivery was also shortened from as long as six weeks for an ordinary letter down to twelve days or less for V-Mail. Soldiers used V-Mail to write home as well. One advertiser promoted the "Voyager" letter-writing "kit" with V-Mail stationery, ink, and pen: everything a soldier or sailor needed to keep in touch, all rolled and fitted into a handy cardboard tube for easy carting around a battlefield or aboard ship.[26]

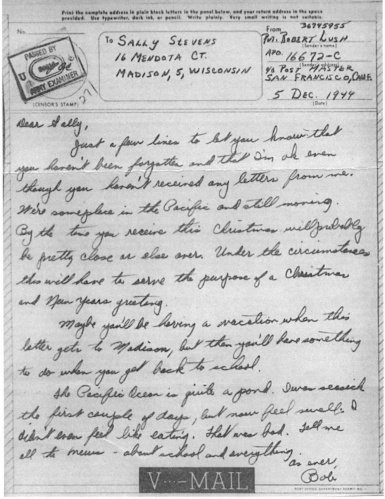

V-Mail sent to Sally Stevens from Private Robert Lush. (Courtesy of Robert Lush.)

The media was full of suggestions for young women about the best way to handle their communications with soldiers on the front. The following article, for example, was clipped from a popular magazine and carefully preserved in a scrapbook kept by one Rockford College graduate:

When Someone You Love Goes to War—
It isn't easy, saying good-by to a soldier . . .

But he has a *job* to do. A grim, unpleasant job at best—*but he's doing it*. Doing it for his country, and the things he believes in. Doing it for *you*. And you wouldn't have it any other way.

You have a job to do for *him*.

Keeping your chin up. Making the best of things. *And letting him know it while he's away.*

So write him often. Make your letters cheerful and encouraging. Leave out the news about the rainy weather and . . . the trouble with the hot-water system. Tell him, instead, the things he wants to hear . . .

That you're well, and that things at home are fine. That the baby has a tooth, or you got a raise, . . . or you've saved up almost a hundred dollars in War Bonds.

The *good* news.

The news that makes it easier for *him*.

Send it to him *often*.[27]

The article urged young women to act courageously and selflessly in the face of war by showing their men that they were able to handle the responsibilities of the home front.

A wartime magazine advertisement by Martin Aircraft for its "Martin Mars" cargo planes titled "The Next Best Thing to a Leave . . . is a LETTER" made similar suggestions but also illustrated a more national view on the importance of writing to soldiers:

Home is heaven to men overseas. And a letter is a five-minute furlough at home. . . . [F]ind time to write that man in the service. When you write, remember these 3 rules: 1. Short, frequent letters are better than occasional long ones. 2. Write cheerful newsy letters about familiar places and faces. 3. *Use V-Mail*, because V-Mail gets there quicker, saves space for vital supplies that help speed Victory. Why not read this magazine later and write a V-Mail letter now?[28]

The advertisement also included a depiction of the four-step V-Mail process and an illustration of smiling sailors unloading V-Mail film bags from the belly of a Martin Mars plane somewhere in the tropical Pacific. According

to the National Postal Museum, however, despite the popularity of V-Mail, it did not dominate the wartime mail. In 1944 alone, navy personnel received far more first-class mail than V-Mail: 272 million letters against 38 million V-Mail letters.[29] The message of advertisements and government information was universal, one repeated throughout the war about the positive power of letters, and the target market was largely female. The nation as a whole, especially the government, encouraged this communication because everyone seemed to agree that soldiers needed to be reminded of the things they were fighting to protect: home and family.

Soldiers generally reported positively on their life at war. Descriptions of conditions around them were often softened in a belief that more positive news would minimize the distress felt by loved ones at home. Bill Keely reported in a June 1945 letter, "Our Beer ration has been good—I have a doz. or so coming to me tomorrow, and I guess I could pick-up my Whiskey ration at the 52nd—all in all I have no wants—." Descriptions of the recreational lives of the soldiers and the sites they saw were also a regular part of Keely's letters home. Keely noted that he couldn't complain about the food being served because it was "excellent—steaks, turkey, chicken, etc." He also wrote of taking walks, including one through Tokyo, a place he described as "very modern, subways, trolleys, wide streets, and tall buildings—almost like in the States." On that particular occasion, he passed by General MacArthur's headquarters, adding in his letter that he saw MacArthur's "black Cadillac with its stars" in front of the building.[30] Just as women writing to husbands did not want to worry them with talk of deprivations or sadness, soldiers did not want their loved ones to be overly anxious about their circumstances but hoped to share what they were experiencing with a far-away audience.

The war experience of many stateside wives was shaped tremendously by the letters (and information) they received from the theater of war. Keely wrote in January 1946: "After seeing what one atomic bomb did to Hiroshima I was convinced the Japs were wise to give up; but to see the destruction done by 'fire bombs' on the rest of their cities, I'm sure they had to give up!" Reflections such as this one connected women to their men. To understand the warfront through the eyes of husbands and boyfriends meant a clearer recognition of the dangers and hardships that their men faced. To know how loved ones were faring was also vital to women's support for the war from the home front. Despite the attempts by magazines and newspapers to urge women to temper their letters and to avoid topics that might distress soldiers, the men on the frontlines were certainly not immune to the news they heard through other outlets, and women at home were not always quick to follow the (in many ways) unrealistic prescriptions of wartime publications. Bill Keely,

for example, wrote about hearing news over the radio about a milk strike in Detroit that ended with 100,000 gallons of milk poured into a ditch. "I about want to give up on trying to understand the situation at home," he exclaimed. "Do you know I haven't tasted fresh milk in over a year!!"[31]

One constant annoyance was difficulties with delivery of mail to and from the front. Even with every option being tried to speed mail to the troops, very often letters arrived in bundles from wherever they had been accumulating. Keely wrote in June 1945:

> Well, here I am waiting for my mail to catch-up with me again—seems like I'm always getting ahead of my mail—what a situation to have happen! It puts me so far behind on what you are doing, and then, all at once I find myself going over all your days and nights in one short sitting—I should ration myself on reading your mail. . . .
>
> Gosh, but the time seems like years between letters—and after each bundle I receive, it makes me feel like it was only a short time ago when I said, "I'll see you next week-end!"[32]

Keely worked in the mail room, which made him more conscious of the mail flow, but he articulated the feelings of many men regarding their mail. The problems Keely experienced with mail deliveries was aggravated by the massive movement of troops toward home once the war ended in the Pacific theater in August 1945. Following VE-Day celebrations in May 1945, Americans celebrated even more when the final warfront in Asia was quiet and soldiers came home. It took longer for some to return, and those weeks and months of waiting were very difficult for the Keelys who, by waiting to marry, had more fully put their lives on hold than others who had rushed to marry during the war. The anxiety to return home and the tedium of waiting were constant companions for servicemen still away from their loved ones. Eventually, reunions dominated the domestic scene around the nation.

Creating homes and families was something some soldiers did before the war, others afterward. Those who married before they "shipped out" often missed the births of their first children as many young couples immediately started families. Ken Gee was lucky he was still in the United States and able to meet his newborn daughter before shipping out to the front. Many women felt that children were important in order to "have something" of their husband should he not return from the war. Whether a woman was courting, engaged, or married to a soldier, that relationship created a close tie to the war itself as women followed news of the conflicts in both Europe and Asia, linked by their hearts to events across the globe and sharing some of the same American culture across the miles.

Music was one cultural component that tied couples like Lois and Dana Fisher together during the war. There were popular songs of the day on the lips of many Americans, including "Boogie Woogie Bugle Boy" sung by the Andrews Sisters (and later revived in 1973 during the Vietnam era by Bette Midler) or "I'll Be Seeing You" by Sammy Fain and Irving Kahal and recorded by many of the era's most popular singers. Governments on both sides of the war used music as propaganda, in addition to film. Morale was the main motivation of such propaganda, aimed at keeping spirits high and building emotion, which worked to the advantage of any government fighting a war. The wartime culture in the United States surrounded young women's daily lives. Some of the music and films of the day were shared long-distance with their loved ones. Bill Keely regularly discussed the films and music he encountered as a soldier.

From Aversa, Italy, in June 1945, Bill wrote about hearing "out of nowhere" from a nearby town the sound of bells ringing "with a ding dong daddy swing and then a little Gene Krupa beat." "Some Yankee," he speculated, must have been trying to learn to play the bells or "else he doesn't value his life very much." Bill indicated the bell ringing was "getting to be a pain in the neck!" He also wrote Jean about seeing Judy Garland in *The Clock*, noting, "It was worth my time—I recall the Station 'so long' etc—what a life!!"[33] The 1945 film *The Clock* cast Garland as a woman who met a soldier in New York's Penn Station on a two-day pass. They spent forty-eight hours sightseeing in New York and fell in love, then struggled with the decision to marry immediately. One newspaper of the day called the film "a sincere and touching examination of the war-time marriage problem."[34] Elements of the film clearly reminded Bill of his farewell in another train station.

Later that year, Keely wrote from Tokyo about hearing "O What a Beautiful Morning" on the radio and the fond memories it brought back to him of their time together. In that same letter, he described attending a USO show, a play, and a "G.I. special service show" with a band as the end of hostilities eased warfront pressures. Keely articulated the role that music played in soldiers' lives and the distant relationships of so many: "Jeannie—this has been a radio night at home—with you—I've been writing just like you were here beside me—'Summer Time,' I've always liked the tune!"[35] Keely once described radio and movies as "salvation" while he was far away from home. The connection to home that popular culture represented was a powerful shared experience. The subjects of music and movies were also something couples knew was safe to discuss in their letters if they wanted to avoid the censors blacking out much of what they wrote to each other. Even after the war officially ended, Keely still wrote about hearing "Fred Allen, Burns and Allen, . . . and the Spotlight

Band" on the radio where he was stationed in Japan and viewing *The Keys of the Kingdom* and *The Bells of St. Mary's*.[36]

Reunions and New Beginnings

Years later, when Lois Fisher recounted how the war ended for her, it was clear that she and her husband enjoyed an advantage over many other young wartime married couples:

> In May of 1945, I got a phone call from him, from New York, telling me he would arrive, by train, in Boston at 11:30 that night and could I meet him? He hadn't told me he was coming home, lest he be delayed en route and cause me to worry.
>
> YES, I could meet him and, in some ways, it was just as scary as getting married! We had been apart for what seemed so long while I lived as a single woman, but we had known each other for 12 years before marrying, so re-adjustment was not really difficult!
>
> So, in 1943–1944–1945, I was building a life of my own and so was he, but from then on, it's been "Our" life and we no longer need to write letters to each other every day.[37]

Fisher's emotions were coupled with a realization of the value of her and her husband knowing each other before the war separated them. So while they spent three years experiencing very different circumstances, they were able to reunite and move forward with their life together. Not all soldiers and wives were as lucky as the Fishers. Many marriages did not survive the war. Stress at home, distance, and many other factors contributed to the breakup of marriages—some of which were new at the time the United States entered the war in 1941. Divorce rates in the 1920s and 1930s hovered under 2 per 1,000 Americans, but beginning in 1940 the numbers rose and were 2.6 by 1943, 3.5 in 1945, and 4.3 in 1946, after which numbers started to decline again. The "prevailing wisdom" about war weddings proved true for some young newlyweds, but many, many more marriages survived the years apart and stresses of wartime.

Once hostilities ended, the anxious optimism shared by so many young couples reflected new hope for their futures. For Joyce Roos, war's end represented a new beginning for life with her husband the navy pilot. The elation and joy the Rooses shared when the war finally ended expressed what so many others of their generation felt at that momentous time:

> When the news became official that Japan had surrendered, San Diego, being the Navy town that it was, literally exploded. We left our room, walked to the nearby station, and boarded the little commuter train to

go downtown. . . . People were excited, tearful, relieved. We were no
longer strangers, but all united and caught up in a moment of history
that we would never forget.

Downtown San Diego was a sea of humanity—a melting pot of joyful
Americans of different ethnic backgrounds—Navy personnel, Marines,
Army soldiers, people young and old. We clasped hands with perfect
strangers. . . . Just to walk the teeming streets and be a part of it was a
catharsis after the pent-up emotions of four years of war.

When we finally took the commuter train back to our room, it was
as if a whole new world had opened up. Even if overseas orders were im-
minent, *the war was over.* Now it would be peacetime duty. We would
go home again, finish our educations, begin a new life. Now everything
was possible.[38]

Roos experienced what millions of women felt as the end of the war was upon
them. They faced a society that was very new and different from what they had
known all their lives. Deprivation of all kinds would come to an end, and the
postwar decades of U.S. prosperity were around the corner.

After Bill Keely's return home and his marriage to Jean, they got back to
"life." Almost three million other couples married in 1946, and just as the
Keelys did, they celebrated the war's end with a wedding ring; their love had
been nurtured through correspondence and held up until the soldier came
home. After they married, the Keelys—like some other newlyweds of the
time—moved in with family (in their case Bill's mother) due to limited funds
in the readjusting, fast-paced American economy.

The war seemed to heighten the drama of everyday romance by adding
separation, longing, worry, relief, and unimagined joy when it ended. Ameri-
can culture captured the romance of war and of American women and men
caught up in home-front struggles and on battle lines. Women's romantic roles
provided powerful incentive for men fighting abroad, giving them more to
fight for—and to come home to at war's end. Just as those who used education,
military, or other service to aid the war, wives and other women contributed
by supporting their husbands and loved ones. Like other women, Rockford
College students who dated or married soldiers experienced the war that much
more intensely because of the emotional connections that brought them di-
rectly into war's wake.

Feeling like true citizens because of their war contributions, American
women especially looked forward to continuing to make a difference in the
new world around them. Women felt great pride not only in the contributions
of their loved ones to the successful conclusion of the war but perhaps even

more especially in their own contributions to the war effort. Yet despite such enthusiasm for progress that women were supposedly making before and during World War II, the complications of war took the upper hand. Even women educators were encouraging their students to return to more traditional roles. Mildred McAfee Horton, retiring president of Wellesley College, for example, stated that "college failed to teach . . . women that most people accomplish most in the world by working through established social institutions, and that the family is entirely respectable as a sphere of activity."[39] Jane Addams's notion of "civic housekeeping" and woman's engagement with society had been more securely rooted in the home by the travesties and upheaval of war. As the United States finished with one war and moved on to the Cold War, once again women were part of the soldiery aligned for "combat," but their roles had changed. Now their "job" was to stabilize a democracy that was weathered by war and confronted with a new enemy, fighting a war of words, ideals, and competing world visions.

The newest weapon for women would be family and home, for which they made excellent warriors.

7. Twentieth-Century Feminism and New Roles for Women

Years after graduation from Rockford College and her return from a post overseas with the WAC, Anne Saucier watched intently in August 2007 as Hillary Clinton spoke about the influences on her political life in a televised debate for the upcoming presidential election. "When I was growing up, I didn't think I would run for President," Clinton explained,

> but I could not be standing here without the women's movement, without generations of women who broke down barriers, the civil rights movement that gave women and people of color the feeling that they were really part of the American Dream. So I owe the opportunity that I have here today to many people; some of whom are known to history and many who aren't.[1]

As the debate concluded, Saucier quickly picked up the phone to call her ninety-eight-year-old friend Mary Egerton Miller in St. Louis, who, years ago, while she and Saucier were both fighting for the Equal Rights Amendment (ERA), had debated Phyllis Schlafly. Saucier explained later in an e-mail that "as usual Hillary had made us proud and [I'm] sure she will be our 44th president." The two women, according to Saucier, "rejoiced together that we had both lived to see this day when a woman was running for the highest office in the land and had every chance of making it."[2]

The visual picture of these two women rejoicing together that they had "lived to see this day" brings this story of women's involvement in the World War II era to a tentative close. While the mothers and grandmothers of women who came of age during World War II were born in a time when women could

not legally vote in most of the United States, Saucier and many others of her generation had lived to see a woman running for president of the United States who "had every chance of making it." Although Clinton's words were generally framed to increase her voting base as much as possible, the language she used emphasized that the fight for women's equality was not fought just by the suffragists of the early twentieth century and the feminist activists of the 1970s—that is, by those generations who have had a prominent place in the history books. Rather, generations of women were part of the struggle. While some generations played more subtle roles, it was the continuity of the struggle and its legacy that brought Clinton to the podium.

Although Saucier and others joined the WAC during the war and later fought for the ERA, in many ways the women who came of age during World War II fought their gender battles in more understated ways. The war was their preparation for living, and the years that followed reflected both their successes and challenges as women who experienced new opportunities opened up by the war as well as a postwar backlash that left many of them in retreat from those wartime successes. Women at Rockford College looked to the prospects of life after graduation, to the postwar years that seemed to offer them promise and hope because they were just beginning their adult lives and also because their education encouraged them to step out into the world to make their mark. The end of the war was a time to begin anew. American servicemen and servicewomen came home as Germany and Japan were rebuilt, the United Nations formed, and American women looked ahead with the same determination, hard work, and involvement that was a part of their lives during the war.

At Rockford College, faculty and administration encouraged students to look forward with this hopefulness. A year before the war ended, Professor Meno Lovenstein, who was then posted at the Army Industrial College in Washington, D.C., wrote with special words for the graduating class of 1944:

> It has been over two years since I had the privilege of sharing Rockford College with you. Many of you, perhaps, do not even know me, and I regret, of course, that I do not know you. But I do know so many in the Senior Class, in the spirit, courage and intelligence with which they meet their world. I am certain it makes us all related. Graduation is like being born again. . . . This is such a wonderful world to be born in once again. Two billion human beings badly hurt. Two thousand years of history and such little gain. And yet how precious that little and how much it promises for the future. Perhaps there is not such a distance from swinging in trees to swing music, not so far from bogey to boogie woogie, but there is a distance from the mass confusion of our ancestors

to the precious truths of accumulated wisdom. . . . In spite of air-raid signals and shrapnel, we managed to salvage many of these. Keep them with you and some day, not so far away, we shall all meet again and start building anew.[3]

Lovenstein hoped to instill within the women graduates the promise of their own abilities. Despite the war that raged around them, they were part of a people who "managed to salvage" the "precious truths of accumulated wisdom." The struggle in war had been a difficult one—as the struggle of coming of age and the struggle of education had been—but with the end of the war, they were all being "born into a new world," one that Lovenstein suggested was open to the prospects of women being active, engaged citizens who spoke their minds and charted their own courses.

This promise and hope of "building anew" threaded throughout the college, and the following year, as war was won in Europe, the members of the college community gathered together in celebration. Students, faculty, and staff marked victory in Europe on May 8, 1945, as they remembered, according to an account in the school newspaper, "in pride and gratitude, the innumerable company of those whose courage and sacrifice made this hour possible."[4] Although the war in the Pacific still raged, there was finally a sense that peace was imminent. The students had reason to think they were a part of that victory. They had planted Victory Gardens, worked to build airplane parts, sold items at a local department store to raise funds for Russian war relief, and helped at USO gatherings. Those at the chapel service that day joined in singing the "United Nations Song," a song of hope that people from many countries would join together in a world community to find peace.[5]

The sun and the stars all are ringing
With song rising strong from the earth,
The hope of humanity singing,
A hymn to a new world in birth!

United Nations on the March,
With flags unfurled, together fight
For victory a free new world!
A free new world!

As sure as the sun meets the morning
And rivers go down to the sea,
A new day for mankind is dawning,
Our children shall live proud and free!

It was fitting that this was sung at the college to mark that historic day. Professor Mildred Berry's students were making trips into the Rockford community to talk with local citizens' groups about the importance of the United Nations and the ratification of the charter that created it. They believed intensely in the importance of communicating what they learned in college in support of an institution they hoped would help bring peace to the world. Two students from the college, Margaret "Peg" Bates ('45) and Aimee Isgrig Horton, actually joined United Nations service groups after the war ended. Bound together tighter as a community, Rockford women sang a song that promised "a new day for mankind is dawning," and they had hopes that a new day was dawning for all women.

Communications from other parts of the world made their way to campus to reaffirm that promise. The following letter from Slava Prochozhova Kohak ('27) was published in *Alumna* in November 1945. In it, Kohak told of her family's hardships during the war in her native Czechoslovakia and of their hopes for the future:

> I am using the first opportunity to send you a letter which I can write freely without being afraid and in which I can say the truth after six hard years! . . .
>
> This is the family history during the war: My husband was arrested by the Gestapo in fall 1941 because of his illegal activity (he was in direct connection with our London Government). It was very hard for me but very, very hard for him. . . . [I]n August 1944, I was arrested and learned what it meant to be cross-examined by the Gestapo. I was sent to Terezin, one of the worst concentration camps in Bohemia. My husband was sent to Mauthausen, a concentration camp from which nobody was supposed to come back. Fortunately we are both home, well, and the children with us! Poor kids, so brave, went through so much with us. . . . They both learn English and both hope to go for a visit to America one day.[6]

Rockford students began learning details of the hardships that women in other parts of the world had endured: how Russian women risked their lives to save others during the German bombing of Stalingrad and how the Women's Voluntary Services in Britain steadfastly reported for duty even when many had to evacuate their bombed homes. Involvement with international issues during the war and concern for refugees had sensitized students to reaching out.

Aimee Isgrig Horton helped refugees in Europe. Isgrig was editor of the school newspaper and an activist campus leader. After graduation in 1944, she studied history at the University of Chicago for a year. When she learned of the work that Douglas Steere was doing in Europe, the twenty-two-year-old

Isgrig felt called to serve with the United Nations immediately following the German surrender, helping reunite separated families.[7] Steere, a Quaker and a professor at Haverford College who organized the UN Reconstruction and Relief Training Unit, inspired Isgrig with his words, "We must melt the hearts of Europe." She worked, in particular, with all-Jewish communities and interviewed hundreds of children, trying to reconnect them with their families in other countries. Many of the people Isgrig worked with were headed to Israel, which she noted "was a very uncertain future" for them.[8] Her first assignment was at a camp outside of Munich, where the refugees were Latvian, Estonian, Lithuanian, and Polish. She wrote in the following reminiscence about the means she used to help the refugees as much as she could:

> Because you were an American, you had a kind of a strength and a capacity to get things done. . . . It was a remarkable learning experience with an opportunity to do something positive. I helped provide people with everything from toothbrushes to transportation. As a young American woman, I was given lots of leeway by the officials who were in charge of the American Zone in Germany. I was told, "You are a callow youth—You will listen and learn from the people in the camp," that is, regarding running the camp and providing leadership.
>
> I wore UN insigne, causing the Germans to use the derogatory epithet of "auslander" [foreigner]. The sense was that I was helping others, not them. They had the feeling of being a defeated people who resented occupiers. When I identified myself as "Amerikanisch Auslander," they were more polite. I think because they had to be conciliatory toward the Americans. One Polish couple helped me to be more discerning about the Germans and not to generalize: some were fairer, others were more unkind.
>
> . . . After a refugee turned 18, they were not given as privileged a status for leaving. Many falsified their ages, and I went along with this. . . . This kind of thing made a difference, and I later saw some of them at the Univ. of Wisconsin.[9]

Isgrig experienced a variety of attitudes among Europeans from both sides of the war.

Isgrig's rewarding work energized her in many ways. Her second assignment was to a Jewish camp in Wasserburg. Originally a mental institution, the camp became a Nazi extermination camp during World War II. Some of the displaced persons at the camp were physicians and others had backgrounds in theater and organized plays, so there was the additional support for medical and social needs. According to Isgrig, she was the only non-Jew and only

nonprofessional in the camp, but she was "really accepted as a person who cared." She was particularly touched by the story of a child who had been kept in a dark hiding place for so long that the child had gone blind. Isgrig was pleased to note that she found a home for him.[10]

The work Isgrig performed in Europe brought her a sense of accomplishment and fulfillment: providing goods and services to the refugees "was useful," and helping Jewish refugees relocate to Israel and plan for the future made her feel she was "making a difference."[11] It was the kind of fulfillment in social activism and international careers for which students from the college and other women might have hoped. However, at the war's end, there were fewer opportunities for women overseas. Although some women continued to serve in the armed forces, most women in the military returned to civilian life, with little direction as veterans from their former women leaders.

In the immediate postwar period, a number of social changes were occurring that had an impact on women graduating from Rockford College and other college women across the country. Because servicemen were returning from overseas to reclaim jobs and to fill new ones, women were increasingly pushed out of the workplace and back into traditionally female occupations and roles. Articles in popular magazines appeared with titles such as "Watch Out for the Women" and "Getting Rid of the Women."[12] Although about 80 percent of women with war jobs found their jobs satisfying and were in favor of keeping them, many Americans, including the government and returning soldiers, were eager to see them return to the home. Some women, to their shock and dismay, showed up for their factory jobs only to be handed their final paychecks. Men, too, were let go as defense plants closed, but women at a rate three times that of men. Servicemen and servicewomen, too, faced uncertain futures. Julia White Rogers commented, "It was a little like the curtain coming down on your play. The rehearsal, the play, then it's over. Now what are you going to do?"[13] She had considered staying with the WAC, but when no promotion was available, she left the army.

Like others who found work becoming an increasingly less viable option, Rogers chose to leave her job for a life at home. Despite her initial hopes to continue with the military, Rogers married soon after she left the WAC and later gave birth to three children. In the following reminiscence, she explained her feelings about this new role for her life:

I was a full-time housewife—enjoyed it. There seems currently to be a pervasive mental picture of the 1950s of helpless females being "good housewives" against all their finer instincts. Rubbish. The females who felt that way were the ones who wrote novels and memoirs, that's all. The

rest of us just did it, the way our husbands earned their livings, because it was to be done. I enjoyed making the girls' clothes and some of my own. I enjoyed cooking.[14]

Despite Rogers's enthusiasm for the domestic world, societal pressures also clearly influenced the return of women to the home. In postwar polls, such as the "Fortune Survey" in the August 1946 issue of *Fortune* magazine, for example, most women, as well as men, responded that married women "should not be allowed to hold jobs."[15] After the distress and anxieties of war, home was viewed as a haven from turmoil.

Activism and work by women was, in many cases, redirected toward goals that strengthened the domestic front. Building up the community and promoting peace efforts were consistent with the national goals of domestic tranquillity. Soon after graduating from Rockford College in 1946, Jacquelyn Silcroft Forslund volunteered at Jane Addams's Hull-House in Chicago as a speech teacher. In 1950, she became a wife and involved herself in a full range of activities outside her home. Forslund represented the many roles that women played in the 1950s. As the mother of a new baby, she managed the home front and also entered politics in the northwest suburb of Chicago to which her family moved. When her daughter was old enough to go to school, Forslund continued her work to improve the schools: "I started a . . . parent[-teacher] organization in order to get the entire community involved in a positive way." The efforts that she and her friends put forth burgeoned into a new grade school and a new high school. They found a way to integrate home and work effectively.[16]

World War II also meant more flexible and varied educational opportunities for women, particularly in the scientific and technical fields, but the situation changed quickly after the war ended. During the national emergency and because of the need for scientific expertise, women were encouraged to enter such fields as physics and engineering. With many male students away, professors were more likely to notice the skills and aptitude of promising women students. Harvard University, for example, opened its medical school to women in 1945, and women's colleges had peak enrollments during the war in science programs such as meteorology and electronics. When the war was over and the need for women scientists diminished, there were fewer options available in these fields for women. The percentage of female to male graduates of American universities and colleges also decreased, in large part because education funding under the GI Bill went primarily to men and because returning soldiers were given priority over women. Even though women veterans had access to GI benefits, fewer women, proportionally, used them. John

Warren Oakes wrote that "only about 2.9 percent of veterans who attended college were women."[17] Many servicewomen did not even know or realize the benefits were available to them.

Although increasing numbers of women actually entered the job market in the late 1940s and 1950s, many often chose a domestic path or returned to such traditional "pink-collar" courses of study as teaching, social work, and nursing. If scientific research and study conflicted with marriage, the majority of women, including many from Rockford College, chose marriage. Even so, the college emphasized the use of a liberal arts education for service to the world instead of for personal insularity. Jackie Forslund confirmed that this was the training she received: "I went to the college for knowledge. . . . I wanted to learn and earn an education that would allow me to support myself. I learned the great importance of a liberal arts education. I have never stopped learning or going to school. I never intend to stop."[18] Julia White Rogers appreciated that college gave her an educational background for understanding the world, especially helpful to her when she was in the WAC. The years she spent in college, according to Rogers, "provided context, provided a picture of human behavior (history, geography), into which every aspect of the war made sense."[19] Miriam Tunison ('45), a high school English teacher and administrator, beloved by her students, credited her experiences at Rockford College as the source of her view of education and of her expertise.

The prevailing message to women in the 1950s was to maintain the home as wives and mothers. Sustaining the home and raising children to be good citizens were considered necessary to strengthen the country during the Cold War. Yet even married women were increasingly going to work and engaging in public roles. After 1956, the veteran numbers decreased, and initiatives for women's education increased. Because the threat of Soviet superiority in space with the Sputnik program launched a greater emphasis on education, legislation like the National Defense Act of 1958 increased educational opportunities for women. A public and social consciousness of the need for educated, working women was growing. Although not at the level of the women's movement in the next decades, women's organizations were gaining a stronger voice, while activism for world peace and a strong electorate rose.

Cold War politics in large part shaped policies and expectations for women in this period. The growing fear of aggression from communist Russia led the United States to maximize protective defense and use of resources. In 1951, the Korean War broke out between communist North Korea and the UN-supported democracy of South Korea, with reverberations in American economic and domestic policies. Soon women were working again at levels that equaled the peak World War II numbers, in spite of the parallel emphasis

on motherhood and homemaking. Although the end result was certainly confusing, keeping women in the home and returning women to work were both believed to be in the nation's best interest. Leaders in government, research, and education encouraged the view that national security needed the work of educated women as well as dedicated mothers raising children to be well-adjusted, responsible citizens. The popular *Donna Reed Show* provided an ideal role model for stay-at-home mothers: perfectly coiffed and wearing neat shirtwaist dresses, Donna Reed served cookies to her children after school and arranged countless vases of flowers. At the same time, however, almost a third of married women were employed. Julia White Rogers, like innumerable others, was juggling marriage, the needs of three children, and a demanding job. She clearly enjoyed the job, which required high-level skills. Waiting until the children were all in school before she got a job, Rogers worked for the Central Intelligence Agency editing research papers "on almost anything under the sun."[20] No doubt the editors of *Life* magazine had women like Rogers in mind when they published a 1956 issue titled "The American Woman—Her Achievements and Troubles." One article, "'My Wife Works and I Like It,'" illustrated that the myth of the Super Woman—the woman who could do it all—had already been born.[21]

Increasing numbers of Rockford College women also pursued graduate degrees in the 1940s and 1950s, in similar proportions to other women across the country. Rogers was among them with her master's degree in English, which she received in 1946. Anne Saucier earned a certificate in social work in 1947 at the University of Kansas and then worked in children and family agencies for adoptions and foster care. By 1952, she had completed her master's degree in social service administration at the University of Chicago and soon began work at the Michigan Children's Aid Society. In 1950, Peg Bates received a Fulbright Scholarship, which took her to England and then to Uganda. She returned to England and, still on the Fulbright, completed an Oxford doctorate in international law and organization in preparation for her subsequent university teaching positions.

Vitally important though they were, these activities remained relatively quiet; the 1950s did not encourage militant feminism. The Red Scare and McCarthyism inspired caution in many groups, including women's. Indeed, allegations of communist sympathies and subversive activities were leveled at the American Association of University Women. Keeping a low profile, women's groups with activist agendas encouraged women to influence the public sphere through voting, local volunteerism, and caring for the community. This was the work in the schools so ably done by Jackie Forslund and her friends and by Miriam Tunison in the League of Women Voters.

It was the 1960s and 1970s in which major social changes erupted. Betty Friedan's revolutionary 1963 book, *The Feminine Mystique*, proposed that the mounting discontent women felt concerning the constraints in their lives stemmed from the limited roles placed on them by men and by society. Although many women were certainly content with domestic roles in the postwar period, there were also some who were growing in dissatisfaction with pay unequal to men, lack of support for their juggling of home and career, and their limited career options outside the home. Friedan's survey of her 1942 classmates from Smith College revealed that half of them felt that they had neither been able to express their creativity nor their education to full potential. Another common theme was feeling that a sense of personhood had been missing in their lives. An example of this feeling was expressed by Julia White Rogers in 1960 when she accepted her position with the CIA. When her husband asked what a woman would do for child care in her situation, she retorted, "I am not *a* woman. I am *me!*"[22] Friedan's book gave a voice to feelings women had experienced for many years.

President John F. Kennedy's formation of the 1960 Commission on the Status of Women, with Eleanor Roosevelt as the chair, was met with a warm reception by women's groups. In its 1963 report, the commission found that women were treated inequitably in almost every sector of American society. This report led to the Equal Pay Act of 1963, which addressed the growing concern of women whose pay was lagging behind men and who were not well represented by unions, and made separate pay scales for men and women for the same jobs illegal. In subsequent years, the act led to more women's representation in labor organizations, and as recently as 2009, Congress passed the Lilly Ledbetter Act, which tackled the continuing issue of fair pay in the workplace. Amending the original Equal Pay Act, the Ledbetter Act ensured that no matter the gender, race, religion, or age, workers are guaranteed the right of equal pay no matter how much time passes before they uncover the unfair compensation. President Barack Obama signed the act into law on January 29, 2009, only a week after his inauguration.

Women increasingly recognized the ways organizations such as unions could help reconstruct the lives of American workers and reshape the lives of American women. Anne Saucier was director of staff development in the Franklin County (Ohio) Welfare Department when she organized union support for the workers there. "When Local 1479 voted to strike and walked out of the department, I went along," she explained in a 2007 e-mail. "The night that Presidential hopeful Robert Kennedy rode through the streets of Columbus, surrounded by wildly cheering fans, I was leafleting the crowd for our Union and new Commissioners."[23] Saucier not only campaigned for improved condi-

tions for public welfare workers but also secured grants that provided graduate education for social workers. Increased education enabled the caseworkers to improve the services they provided. Henriette Simon, a classmate of Saucier's, also participated in union activities for the Los Angeles County Employees Association. In addition, as a member of the Los Angeles chapter of the Coalition of Labor Union Women, Simon became chair of a bargaining unit, a member of a strike committee, and a member of the organizing committee. She credited Rockford College with giving her the impetus for social involvement: "The philosophy from the college that stayed with me, obviously, is the importance of being an activist, doing what you can to make the world a better place."[24] Unions and protective legislation helped, but inequities continued.

In 1964, the Civil Rights Act was passed, making discrimination on the basis of gender, race, and religion against the law, and the Equal Employment Opportunity Commission (EEOC) was established in 1965 to enforce the Civil Rights Act. However, by 1969, fifty thousand complaints of sex discrimination in the workplace had been filed with the EEOC. Outrage and frustration with the poor implementation of the protective laws led Betty Friedan and other leaders in 1968 to form the National Organization for Women. The ERA proposed that equality for women be written into the Constitution and became a fiercely contended political goal.[25] Once again, Saucier fought legal battles for equal rights:

> In 1976, it was necessary to sue the Franklin County Welfare Department for sex discrimination because of policies which promoted unqualified men, with large pay increases to positions which I had successfully created, while keeping me in the same pay range and continuing to benefit from my expertise without proper financial remuneration. It took ten years, but finally, in 1986, I had a hearing in federal court, and a jury found my complaints to be valid. . . . I remember how happy Mary Ashby Cheek was when I took this action. Throughout the long procedure, she cheered me on, saying women had to do it.[26]

Saucier went on to work tirelessly for the ERA and was one of the leaders who brought about its successful passage in the Ohio House and Senate. Although the ERA failed to receive ratification by enough states to become law, it was ratified in Ohio. Saucier was a member of the Ohio Commission on the Status of Women as well as the Ohio Coalition for the Implementation of the ERA. She helped these two organizations merge into one and to become Ohio Women, Inc., in 1977. The goal of this group was to encourage and support women "to achieve their full potential in every aspect of their lives."[27] Saucier consistently worked to uphold this mission statement.

Through the struggle for women's rights, mainly in the 1970s, the alliance among women gained strength in an effort to capture a democratic share of decision making and policy setting with men in antiwar and civil rights protests. Similarly, women from many diverse constituencies, including education, professions, volunteer groups, and laborers, joined efforts to work on a common cause. The 1960s and 1970s were times when women discovered the importance of working together as a group to speak out for what was important to them.

Epilogue

It was 1999 when Emily Yellin, a freelance contributor to such publications as the *New York Times* and *Newsweek*, discovered her mother's letters, writings, and pictures from World War II. Her mother had just died, so the pictures of her overseas in the Red Cross were especially poignant. Yellin also found hundreds of letters her mother had written home from the war, all lovingly preserved in boxes by Yellin's grandmother. When she read her mother's words in one of the letters, she realized what a life-altering decision it had been for her to join the Red Cross:

> I just have to get out and try to do something active and direct when so many other people are doing so much. It's not enough for me to say that my husband is doing it—and that's my part of the war. I want to do something myself.[28]

It was then that Yellin decided to use letters, interviews, and diaries of women who had lived and served during the war to write about them and to honor the service that they and her mother had given.

At that time of discovery, Yellin also began to understand the magnitude of what her mother, and women like her in World War II, had accomplished and passed on to women of future generations.

> Suddenly, sitting there on the attic floor, I was beginning to realize there were more dimensions in my mother's wartime experience than I knew. I saw that it had been a transforming time for her, a time when she first came into her own, exerted her courage and took advantage of new opportunities for herself, as a woman. In these letters and pictures, and her diary, I began to see the war through a new lens, a female perspective. . . . I began to see those four years of the war as a kind of inadvertent revolution in America, a time when, while men were not really watching, women all over this country from every walk of life learned they could accomplish things they had never been allowed or asked to try before.[29]

Like Yellin's mother, the women in this book ventured onto uncharted pathways, of which they did not know the end points. Even now, in their eighth decade of life, many of these women continue to walk those paths. Henriette Simon volunteers at Weiss Memorial Hospital in Chicago and has done legal research for the Chicago Friends of the Parks. Anne Saucier wrote and campaigned for the 2008 presidential election. Peg Bates has been active in the Women's Resource Center of Sarasota, the Florida Endowment for the Humanities, the American Society of International Law, the United Nations Development Fund for Women, and the Sarasota Institute for Lifetime Learning.[30] Jean Lyons Keely explained her philosophy of service to education and to the community: "I have been a firm believer in 'paying ahead'! You can't always 'pay back.'"[31] As a teacher, she worked tirelessly for gender equity in sports for high school girls under Title IX. Also, as a member of her local historical society in Washington, Illinois, she inaugurated "Celebration of Life in the Cemetery." This program, for which she was awarded the Studs Terkel Humanities Service Award in 2004, helps her community shape the future by knowing its past.

When Jane Addams expressed the following well-known lines, she prophetically voiced a theme that would reverberate through the century:

We are learning that a standard of social ethics is not attained by traveling a sequestered byway, but by mixing on the thronged and common road where all must turn out for one another, and a least see the size of one another's burdens.[32]

Addams believed that inclusion and fairness were essential for those who needed care and who needed to have a voice—and it took a collective effort to make these possible. The young women studying at Rockford College during World War II heard the message begun by Addams and continued by Mary Ashby Cheek as they responded to student refugees in need, as they helped rebuild shattered postwar Europe, and as they later went to work for equity through the ERA and the Equal Pay Act. The message of fairness and respect continued to generate momentum.

The women featured in this book, and countless others who served in the World War II era, preserved a legacy for their daughters and for those who shaped history in the women's movement of the 1960s, 1970s, and beyond. They lived out teamwork in camaraderie and shared work to achieve life-changing goals. This strategy was clearly adopted by feminist women's groups in the 1970s. Anne Saucier emphasized the importance of the lessons her generation learned and hoped to pass on: "What we envisioned was an ongoing struggle to achieve full equality and equal rights for women. . . . Many younger women

do not realize how precarious their hard won rights are."[33] When black and white women worked together in the 1960s to gain a voice in the civil rights campaigns and Vietnam protests, they recognized the significance of the democratic process, which women of the 1940s had worked so hard to preserve. The following words of Jackie Forslund could speak for the many contributions of these and other postwar women: "[In the 1980s,] a young student who was working in the yard with me all day, planting and weeding, made the comment, 'Well, we certainly left our foot print here today.' Looking back now, I've left a lot of foot prints."[34]

Notes
Selected Bibliography
Suggested Reading
Index

Notes

Introduction: The Jane Addams Legacy

1. Introduction folder, World War II Project Collection (WPC).
2. Horowitz, *Betty Friedan*, 50.
3. Tronto, "Care as a Political Concept," 142.
4. Nelson, *Rockford College*, 36.
5. Clarke, *Sex in Education*, 56, 9.
6. Nelson, *Rockford College*, 50.
7. *Rockford College Alumna*, November 1942, 7, Rockford College Archives (RCA).
8. Ibid.
9. Linn, *Jane Addams*, 263.
10. Addams, *Twenty Years at Hull-House*, 36. In *The Education of Jane Addams*, Victoria Bissell Brown explains that Addams actually attended the Interstate Oratorical Contest as a representative of the collegiate press and to ensure that Rockford Seminary students would be able to participate the following year. Brown points out that her research indicated neither Addams nor Bryan debated at the contest. Bryan did not debate because as a senior, he was head of the local planning committee. Brown speculates that Addams's version of the story was intended to represent herself as part of the larger struggle for women's rights (66–67).
11. Jane Addams Collection, RCA.
12. Shields, "Democracy and the Social Feminist Ethics of Jane Addams," 419.
13. Addams, *Democracy and Social Ethics*, 7.
14. Elshtain, *Jane Addams*, 164–68.
15. Elshtain, *Women and War*, 237.
16. Ibid.
17. Jane Addams Collection, RCA.
18. "Civilian Defense Program," *Purple Parrot*, October 13, 1942, 1, RCA.
19. Mary Ashby Cheek's Acceptance of Jane Addams Medal (transcript), May 1987, Chapter 2 folder, WPC.
20. Wells, *Miss Marks*, 215.
21. "Dr. Mary E. Woolley, President Emeritus of Mt. Holyoke, Speaks at Charter Day," *Rockford College Alumna*, March 1938, 1, 19, RCA.
22. McAfee, who headed the WAVES, also served as president of Wellesley College from 1936 until 1949, which included a leave of absence while serving during the war. Speech transcript in Introduction folder, WPC.

23. Introduction folder, WPC.
24. Ibid.
25. "Rockford College and the War," *Rockford College Alumna*, November 1942, 6, RCA; Franklin D. Roosevelt, State of the Union speech to Congress, January 6, 1941, *American Rhetoric*, http://www.americanrhetoric.com/speeches/fdrthefourfreedoms.htm (accessed February 9, 2010).

1. War Looms

1. "Campaigns against Draft," *Rockford Register Republic*, August 3, 1940, in Rockford College Annual Scrapbook (1940–41), vol. 1, parts 1 and 2, RCA.
2. Ibid.
3. Dorothy Delman, Alumnae Interviews folder, WPC.
4. "Campaigns against Draft."
5. Elane Summers Hellmuth, Alumnae Interviews folder, WPC.
6. Woloch, *Women and the American Experience*, 331.
7. Ibid.
8. "Letters from War Torn Europe Reveal Ravages and Results of Air Raids," *Purple Parrot*, October 25, 1940, 3, RCA.
9. Ibid.
10. Ibid., 3–4.
11. "Friedrich to Speak Here at RC," *Purple Parrot*, October 25, 1940, 1, RCA. Several words in this letter follow British spelling.
12. "Letters from War Torn Europe," 3.
13. Ibid.
14. Ibid. Willkie was the Republican presidential candidate who lost to Franklin Roosevelt in the 1940 election. During the campaign, he accused Roosevelt's administration of a lack of war preparedness.
15. Ibid.
16. Ibid.
17. "Florence Sherriff Writes of War-Time Shanghai Adventure," *Rockford College Alumna*, June 1938, 18, RCA.
18. Ibid.
19. Woosung was a port city less than twenty miles down the Huangpu River from Shanghai.
20. The Bund is the historic site of foreign settlement and financial center of international commerce along the Huangpu River since the mid-nineteenth century. "Florence Sherriff Writes," 18.
21. Ibid., 18–19.
22. This was one of the public parks in the international section of Shanghai.
23. "Florence Sherriff Writes," 19.
24. The Brussels Council was an eighteen-nation conference, including the United States, held in Brussels, Belgium, which was called under provisions of the 1922 Nine-Power Treaty to discuss the threat raised by Japanese aggression in China.
25. "Florence Sherriff Writes," 19.
26. Woloch, *Women and the American Experience*, 318.
27. "American College Girl Covers European War," *Purple Parrot*, March 21, 1940, 2, RCA.

28. A fingerwave was a popular hairstyle of the day.
29. In this 1940 incident, the British navy secured the release of almost three hundred British merchant seamen captured by German naval operations. "American College Girl," 2.
30. Ibid.
31. The Schutzstaffel ("protective squadron") was created in 1925; the men of the unit served as Hitler's personal bodyguards. The SS expanded to military operations in 1932, to internal control of Germany in 1934, and to commanders of concentration camps in 1940.
32. "American College Girl," 2.
33. *Vassar Miscellany News*, April 24, 1937, in *American Students Organize*, edited by Eugene G. Schwartz, 34.
34. The Spanish civil war (1936–39) ended in the rise of Francisco Franco's fascist regime and signaled a growing struggle between fascism and democracy throughout the world.
35. Frieda Harris Engel, Alumnae Interviews folder, WPC.
36. Ibid.
37. Ibid.
38. "R-C Students Hail F.D.R. Bid for Peace," *Rockford Register Republic*, September 28, 1939, in Rockford College Annual Scrapbook (1938–39), vol. 1, part 1, RCA.
39. *Vassar Miscellany News*, 47.
40. Ibid.
41. Ibid.
42. Daniel Levine, *Jane Addams*, 201.
43. "Youth Congress Calls on World Youth for Peace," *Purple Parrot*, February 22, 1940, 4, RCA.
44. "Peace Day Held Throughout Country," *Purple Parrot*, April 25, 1940, 2, RCA.
45. "Mary Barron Pleads for PEACE," *Purple Parrot*, February 29, 1940, 4, RCA.
46. "Peace Day Celebrated: Wartime Conditions Duplicated in Classes and Chapel," *Purple Parrot*, April 25, 1940, 1, RCA.
47. "Peace Day Held Throughout Country."
48. "Peace Day Celebrated."
49. Mary Ann Cassiday, "History of Result of War on Colleges is Reviewed," *Purple Parrot*, May 16, 1940, 1, 3, RCA.
50. "Shall 1940 Become 1917?" *Purple Parrot*, April 25, 1940, 4, RCA.
51. "Eternal Vigilance Is the Price of Peace," *Purple Parrot*, May 9, 1940, 4, RCA.
52. Ibid.
53. The America First Committee's most notable member was aviator Charles Lindbergh and is believed by some to have been the staunchest of the isolationist groups in the prewar era.
54. Isabel Abbott and Elizabeth Brush were both history professors.
55. Engel, Alumnae Interviews folder, WPC.
56. The Spanish Loyalists sought external help just as their opponent Francisco Franco was receiving from Germany and Italy.
57. Engel, Alumnae Interviews folder, WPC.
58. Hellmuth said in an interview that her brother was killed during the war. Alumnae Interviews folder, WPC.

59. Engel, Alumnae Interviews folder, WPC.
60. Charlotte Bode, Alumnae Interviews folder, WPC.
61. Mary Ann Cassiday, "Compulsory Conscription Comments," *Purple Parrot*, October 25, 1940, 1, RCA.
62. Barber-Colman, a local Rockford industry, was an industry leader in production of monitoring, measuring, and controlling products.
63. Cassiday, "Compulsory Conscription Comments," 1.
64. Ibid.
65. Ibid.
66. Golden Grad Discussion, Homecoming 1995, with Christine Bruun, Chapter 1 folder, WPC.
67. Lois Pritchard Fisher, Alumnae Interviews folder, WPC.
68. Ibid.
69. "Urge Appeals to Hitler to End Warfare: Aid-Allies Group Sends Cable to Nazi Chief," *Joliet Herald News*, May 28, 1941, from Rockford College Annual Scrapbook (1940–41), vol. 2, parts 1 and 2, RCA.
70. Class of 1945 Alumni Reunion, tape recording, May 31, 1980, Chapter 1 folder, WPC.
71. Jane Smejkal Tucker, "Views on Honolulu," *Rockford College Alumna*, November 1943, 4, 19, RCA.
72. Ibid., 4.
73. Ibid., 4, 19.
74. Ibid., 19.
75. Ruth Ann Bates, Alumnae Interviews folder, WPC.
76. Aimee Isgrig Horton, Alumnae Interviews folder, WPC.
77. Engel, Alumnae Interviews folder, WPC.
78. Rankin served in Congress from 1917 to 1919, then again from 1941 to 1943.
79. The statement was part of Roosevelt's first inaugural address in March 1933 when he famously said, "The only thing we have to fear is fear itself."
80. Marsha Fisher, "A Plea for Intelligence and Sense in This Crisis," *Purple Parrot*, December 16, 1941, 4, RCA.
81. Ibid.
82. Tronto, "Care as a Political Concept," 146.
83. Engel, Alumnae Interviews folder, WPC.
84. Joyce Marsh Roos, "Patterns," *Rockford Review* 35 (1946): 35, Chapter 1 folder, WPC.

2. A Crisis of Opportunity

1. Rockford *News Letter*, August 7, 1940, RCA.
2. Ibid.
3. Lasch, *Social Thought of Jane Addams*, 187.
4. Address to ISS Conference, May 17, 1941, Chapter 2 folder, WPC.
5. Qtd. in McCandless, *Past in the Present*, 196.
6. Ibid., 197.
7. Mary Ashby Cheek's Acceptance of Jane Addams Medal (transcript), May 1987, Chapter 2 folder, WPC.
8. Frieda Harris Engel, Alumnae Interviews folder, WPC.
9. Winkler, *Home Front U.S.A.*, 33.

10. Ibid., 47.
11. Mead, "Women in the War," 278.
12. This information is collected in "Sarah Lawrence College Archives."
13. Hartmann, *Home Front and Beyond*, 116.
14. Solomon, *In the Company of Educated Women*, 188.
15. Ibid.
16. Qtd. in Bruun, "Cheek Legacy," 12.
17. Chapter 2 folder, WPC.
18. "Rockford Sees Itself through Eyes of Debaters from Lawrence College," *Purple Parrot*, February 16, 1939, 3, RCA.
19. "Civilian Defense Program," *Purple Parrot*, October 23, 1942, 1, RCA.
20. *Cupola*, Rockford College Yearbook, 1942–43, 6, RCA.
21. "Rockford College and the War," *Rockford College Alumna*, November 1942, 6, RCA.
22. "Sarah Lawrence College Archives."
23. Garraty and Carnes, *American National Biography*, 851.
24. "College Marks Charter Day by Laying Cornerstone of New Sherratt Library," *Rockford College Alumna*, March 1940, 3, 8, RCA.
25. Ibid.
26. These verses from "To Miss Cheek" were printed in the program for Sophomore Day at the college, December 12, 1939, RCA.
27. MAC, RCA.
28. MAC, RCA.
29. See chapter 1 for more details concerning Sherriff's time spent in China.
30. Betty McCarren, "Dr. Sherriff Tells What It's Like to Be One of 28 Living in One Room," *Rockford Register Republic*, January 5, 1944, Rockford College Annual Scrapbook (1943–44; 1944–45, part 2), RCA.
31. This was the "Chapei Civilian Assembly Center," as it was euphemistically known, which operated from February 1943 to August 1945, also imprisoning Belgian civilian prisoners of war.
32. McCarren, "Dr. Sherriff Tells What It's Like."
33. Ibid.
34. Mary Ashby Cheek, "Reorganized Residence Halls," *Journal of Higher Education* 7, no. 7 (October 1936): 371.
35. MAC, RCA.
36. Hartmann, *Home Front and Beyond*, 108.
37. "Sarah Lawrence College Archives."
38. McCandless, *Past in the Present*, 197.
39. "Sarah Lawrence College Archives."
40. *Rockford College Annual Catalog* (1943), 8, RCA.
41. Ibid.
42. Ibid., 11–12.
43. Chapter 2 folder, WPC.
44. National Nursing Council for War Service and the Association of Collegiate Schools of Nursing, *Guide for the Organization of Collegiate Schools of Nursing*, 5.
45. *Rockford College Bulletin* (1944), 14, RCA.
46. Ibid., 15.

47. As more and more young women chose to enroll in coeducational colleges and universities, enrollment at women's colleges across the country saw a steady decline in enrollment numbers.

48. *Rockford College Bulletin* (1944), 14–16, RCA. Information about the "practice of citizenship" was also printed in the bulletin, a catalog of courses and program information.

49. "Mrs. Nevin, Witness of Germany Occupation of Paris, Speaks to Students," *Purple Parrot*, October 23, 1942, 3, RCA.

50. Ibid.

51. Patricia Talbot Davis, Alumnae Interviews folder, WPC.

52. Although the Rockford program was one of the first during the war, the federal government supported work-study programs that grew out of the National Youth Administration during the Great Depression.

53. Kate Massee, "Women in War Work," *Chicago Tribune*, November 7, 1942, Chapter 2 folder, WPC.

54. Young women of the time were often were referred to and referred to themselves as "girls." Ibid.

55. Ibid.

56. Marie Gilbert, "Work-Study Is Worth It!" *Vanguard*, October 22, 1943, 2, RCA.

57. Ibid.

58. Ibid.

59. "Defense Work Enables Girls to Obtain Higher Education," *Indianapolis Star*, January 3, 1943, Rockford College Annual Scrapbook (1943–44), RCA.

60. "College Girls Get Defense Training," *Los Angeles Examiner*, January 10, 1941, Rockford College Annual Scrapbook (1940–41) vol. 1, parts 1 and 2, RCA.

61. "International Students Day Will Be Observed November 17: By Those Who Live for What Other Students Gave Their Lives," *Vanguard*, November 17, 1939, 1, RCA.

62. Ibid.

63. "Nazis Hate Books, MacLeish Asserts," *Washington Post*, October 21, 1940, Rockford College Annual Scrapbook (1940–41), vol. 1, parts 1 and 2, RCA.

64. Chapter 2 folder, WPC.

65. Program for Conference on the Mobilization of College Woman Power at Monticello College, Chapter 2 folder, WPC.

66. Neikind married novelist Thomas Sterling and published under her married name, Claire Sterling.

67. Claire Neikind letter, Chapter 2 folder, WPC.

68. Ibid.

69. Ibid.

70. Reka Potgieter, "Happy Thanksgiving: This Is a Holiday for Contemplation," *Purple Parrot*, November 25, 1942, 1, RCA.

71. Hartmann, *Home Front and Beyond*, 108.

72. Ibid.

3. Rescue Stories

1. Addams, *Twenty Years at Hull-House*, 156.

2. Elshtain, *Jane Addams*, 88.

3. Coser explained the settlement patterns of refugee scholars in *Refugee Scholars in America.*

4. U.S. Congress, House, An Act Providing for the Extension of Nonquota Status to Frederick Beck.

5. "Austrian Refugee New Assistant to College Librarian," *Rockford Morning Star,* September 25, 1942, Chapter 3 folder, WPC.

6. The editors of the *Vanguard* reprinted this story from an April 21, 1943, article published in the *Athens (OH) Messenger.* Rockford College Annual Scrapbook (1942–43), part 2, RCA.

7. "Young Sculptor from Vienna Is Welcomed Here," *Rockford Morning Star,* February 4, 1941, Rockford College Annual Scrapbook (1940–41), vol. 2, parts 1 and 2, RCA.

8. Austin, *From Concentration Camp to Campus,* 79–80, 85.

9. McAlister, "Saving Private Lynch."

10. Fleming and Bailyn, *Intellectual Migration,* 428.

11. Lamberti, "Reception of Refugee Scholars from Nazi Germany," 158.

12. Fleming and Bailyn, *Intellectual Migration,* 4.

13. See Krabel, *Chosen.*

14. Coser, *Refugee Scholars in America,* 8.

15. Austin, *From Concentration Camp to Campus,* 12, 96.

16. Ibid., 3.

17. Signed into law August 1, 1946, Public Law 79-584, 79th Cong., 2d sess., *United States Statutes at Large* 61 (1946): 754–55.

18. No proof remains—even among Eisenhower's papers at his presidential library— to substantiate Bettelheim's claim. Pollak, *Creation of Dr. B.,* 125.

19. Bettelheim, "Individual and Mass Behavior," 49–50.

20. Ibid., 62.

21. Ibid., 58.

22. Ibid., 53.

23. Ibid., 54.

24. Ibid., 52.

25. Ibid., 63.

26. Ibid., 51.

27. Bettelheim, "Ultimate Limit," 14–15.

28. Pollack, *Creation of Dr. B.,* 15.

29. Ibid., 30.

30. Qtd. in ibid., 109.

31. MAC, RCA.

32. Qtd. in Pollak, *Creation of Dr. B.,* 112.

33. Qtd. in ibid., 113.

34. Aimee Isgrig Horton, Alumnae Interviews folder, WPC.

35. Aimee Isgrig, "Refugee without Refuge," *Rockford Review,* May 1944, 21.

36. Coser, *Refugee Scholars in America,* 63, 68.

37. Bettelheim, "Individual and Mass Behavior," 61.

38. Ibid., 82.

39. Marianne Ettlinger essay, Chapter 3 folder, WPC.

40. Ibid.

41. The Bund Deutscher Mädel was the German girls' association of the Hitler Youth for girls ages fourteen to eighteen.

42. Ettlinger essay, Chapter 3 folder, WPC.

43. Ibid.

44. Shirer, *Rise and Fall of the Third Reich*, 252.

45. Qtd. in ibid., 249.

46. The Hitlerjugend (HJ) was the boys' association of the Hitler Youth. The HJ included boys over the age of fourteen; a junior branch, the Deutsches Jungvolk, included boys aged ten to fourteen.

47. Shirer, *Rise and Fall of the Third Reich*, 256.

48. Ettlinger essay, Chapter 3 folder, WPC.

49. Ibid.

50. *Vanguard* article about Sonni Holtedahl, Chapter 3 folder, WPC. Individual members of the Women's Army Corps were referred to as WACs. They were also sometimes called WAACs, based on the original name of the organization (Women's Army Auxiliary Corps).

51. Ibid.

52. Ibid.

53. Statistics from Austin, *From Concentration Camp to Campus*, 4.

54. "Concentration Camps?"

55. Morris, *American Heritage Dictionary of the English Language*, 275.

56. Marajean Pedlow, "Have You Met—Hisa and Teru Nakata?" *Purple Parrot*, October 23, 1942, 4, RCA.

57. Ibid.

58. Teru Nakata Kiyohara, Alumnae Interviews folder, WPC.

59. Ibid.

60. Ibid.

61. Pedlow, "Have You Met—Hisa and Teru Nakata," 4.

62. Kiyohara, Alumnae Interviews folder, WPC.

63. The Regimental Combat Team was made up of Nisei volunteers from Hawaii and the mainland. The 100/442nd Regimental Combat Team was the most decorated unit in U.S. military history for its size and length of service. "Research on 100th/442nd Regimental Combat Team."

64. Austin, *From Concentration Camp to Campus*, 77.

4. Home-Front Activism

1. Susan M. Hartmann reprinted the first page of the comic and discussed its impact in the popular media in *The Home Front and Beyond*, 188.

2. "Girls at Rockford College Combine War Work with Study," Rockford College Annual Scrapbook (1942–43), part 2, RCA; "Youth on Campus," *Chicago Tribune*, June 20, 1943, 14.

3. "College Girls Get Defense Training," *Los Angeles Examiner*, January 10, 1941, from Rockford College Annual Scrapbook (1940–41), vol. 1, RCA.

4. Originally built in 1917 for World War I needs, Camp Grant on the south side of Rockford trained up to 100,000 medical corpsmen and mustered out troops after World War II.

5. Aimee Isgrig, "Spring Fashions: Slacks, Not Slackers," *Purple Parrot*, March 5, 1943, 2, RCA.
6. "Leaders Present Survey of Defense," *Purple Parrot*, October 9, 1942, 1, RCA.
7. Ibid.
8. Ibid.
9. Hartmann, *Home Front and Beyond*, 199.
10. Heide and Gilman, *Homefront America*, 62–63.
11. "Youth on Campus," 14.
12. Heide and Gilman, *Homefront America*, 55.
13. "Conservation at R.C.," *Purple Parrot*, February 13, 1942, 2, RCA.
14. Judith Moyer Lundin, Alumnae Interviews folder, WPC.
15. Ibid.
16. "Uncle Sam Redesigns College Wardrobe," *Purple Parrot*, October 16, 1942, 2, RCA.
17. Marie Gilbert, "Fashion Focus," *Vanguard*, October 29, 1943, 3, RCA.
18. Ayling, *Calling All Women*, 196.
19. Heide and Gilman, *Homefront America*, 92.
20. Local History, World War II Folder, Vertical Files, Rockford Public Library.
21. "How to Use Plays in War Bond Promotions," 1, Chapter 4 folder, WPC.
22. Ibid.
23. "Welcome, Pre-Frosh!" war bond ad, *Purple Parrot*, April 30, 1943, 3, RCA; "These Women!" war bond ad, *Vanguard*, December 3, 1943, 2, RCA; "Don't Let This Happen Here!" war bond ad, *Purple Parrot*, January 15, 1943, 5, RCA; Chapter 4 folder, WPC.
24. "'Report to the College' Re: Sgt. Lovenstein," *Purple Parrot*, October 9, 1942, 4, RCA.
25. The Second Front was a military strategy to enclose the Germans by landing Allied troops in France and pushing the Germans back toward Berlin from the west, just as the Soviets were pushing from the east. Chapter 4 folder, WPC.
26. Evelyn Turner, Alumnae Interviews folder, WPC.
27. Chapter 4 folder, WPC.
28. "A Prisoner of War Writes Home," *Vanguard*, May 12, 1944, 4, RCA.
29. Florene Cochran, "Not the Bobbsey Twins," *Purple Parrot*, January 15, 1943, 2, RCA.
30. Ibid.
31. "RC Sponsors Drive for Victory Books," *Purple Parrot*, January 15, 1943, 1, RCA.
32. Annual reports on the successes of the Victory Book Campaign are housed in Local History, World War II Folder, Vertical Files, Rockford Public Library.
33. "WSSF Helps Students Everywhere," *Vanguard*, April 21, 1944, 1, 3, RCA.
34. Ibid.
35. Jacquelyn Silcroft Forslund, Alumnae Interviews folder, WPC.
36. These Red Cross materials are housed in Local History, World War II Folder, Vertical Files, Rockford Public Library.
37. Forslund, Alumnae Interviews folder, WPC.
38. *Memories: Walnut Street U.S.O.*, 22, Chapter 4 folder, WPC.
39. Esther Ostlund, "The USO in Action," *Rockford College Alumna*, February 1943, 6, 8, RCA.

NOTES TO PAGES 111–22

40. Ibid.
41. Overseas kits typically contained items such as toiletries, cigarettes, and food items that would travel well overseas, such as candy.
42. Ostlund, "The USO in Action."
43. Ibid.
44. Hartmann, *Home Front and Beyond*, 164.
45. Agnes Andrews Jackson, "Civilian Defense," *Rockford College Alumna*, February 1943, 7, 12, RCA.
46. A war chest is a fund of money set aside for a specific purpose. The war chest refers to any specific fund being raised for the World War II effort.
47. Jackson, "Civilian Defense," 7.
48. Ibid.
49. Ibid., 7, 12.
50. Ibid.
51. See chapter 2 for more details concerning Cheek's use of the word.
52. Jackson, "Civilian Defense," 7.
53. Chapter 4 folder, WPC.
54. Ibid.
55. Betty McDonald, "Robert Frost's Daughter Mends Planes—And Runs 'School for Open Minds,'" *Middlesboro (KY) News*, August 2, 1943, Rockford College Annual Scrapbook (1942–43), part 2, RCA.
56. Ibid.
57. Ibid.
58. Mead, "Women in the War," 289.
59. Frieda Harris Engel, Alumnae Interviews folder, WPC.

5. Women Wanted

1. Patricia Talbot Davis, Alumnae Interviews folder, WPC.
2. Elshtain, *Women and War*, 212, 213, 225.
3. "Army and Navy and Civilian Defense," *Time*, June 8, 1942, 71.
4. Weatherford, *American Women*, 36.
5. First introduced on May 28, 1941, as HR 4906, the bill was finally approved by the 77th Cong., 2d sess., and signed into law on July 30, 1942, Public Law 77–554.
6. Yellin, *Our Mothers' War*, 120–21.
7. Captain Dorothy Stratton, director of SPAR, is credited with coining the term "SPAR." Stratton was on leave from her position as dean of women at Purdue University.
8. Women pilots created a niche for themselves. The WAFS, established in 1942, delivered planes from factories to the air bases that needed them. Soon after, the WASP was formed as a training organization for women pilots. Both of these groups met intense opposition by those against women serving as pilots. The organizations merged in 1943 as the WASP and remained civilian in nature rather than as a recognized part of the military.
9. Chapter 5 folder, WPC.
10. Saucier, *I Took Rockford with Me* Scrapbook, WPC.
11. Ibid.
12. Rockford College Charter Day Program, February 25, 1945, WPC. Charter Day

is celebrated at Rockford College every year to commemorate the granting of the school's original charter by the Illinois State Legislature.

13. Maurice Harrington, *The Social Philosophy of Jane Addams* (Champaign: University of Illinois Press, 2009), 11.

14. Merrill, *Mount Holyoke*, 13.

15. Elizabeth Hoesli, "A SPAR Speaks . . . ," *Rockford College Alumna*, 1944, 4, RCA.

16. Ibid.

17. Christine Bruun's notes, WPC.

18. Camp Patrick Henry was near Newport News, Virginia, and was a point of embarkation for the European war.

19. Evelyn Turner folder (hereafter referred to as ET), WPC.

20. Dorion Cairns was a former professor of philosophy, and Meno Lovenstein was a former professor of economics.

21. ET, WPC.

22. Henry Street Settlement House was founded in 1895 by Lillian Wald. Wald, who had founded the Visiting Nurses Service, used the care of the sick in the Settlement House, modeled after Hull-House, as a way to organize a tenement community.

23. ET, WPC.

24. Ibid.

25. Ibid.

26. Ibid.

27. Elizabeth Hoesli, "A SPAR Speaks. . . . ," *Rockford College Alumna*, 1944, 4, RCA.

28. Ibid.

29. Qtd. in Gruhzit-Hoyt, *They Also Served*, 145–46.

30. "Stepsister Corps," *Time*, May 10, 1943, 55–56.

31. Evelyn Turner, "So Does a WAC. . . . ," *Rockford College Alumna*, 1944, 5, RCA.

32. Eleanor Roosevelt, "Women in War."

33. These acronyms were commonly used in the military: OWI (Office of War Information), OPM (Office of Personnel Management), WPB (War Production Board), CO (Commanding Officer), MP (Military Police), KP (Kitchen Police), CQ (Charge of Quarters), and OD (Officer of the Day). "So Does a WAC. . . . ," *Rockford College Alumna*, 1944, 5, RCA.

34. Ibid. The U.S. Air Force, as an autonomous branch of the military, was not established until September 18, 1947, as part of the newly created Defense Department by passage of the National Security Act. The Army Air Force was its immediate predecessor.

35. ET, WPC.

36. Rita Gilbert, "Live the Navy Way," *Rockford College Alumna*, November 1942, 3, RCA.

37. Ash cans were depth charges deployed against enemy submarines. They looked similar to fifty-five-gallon drums commonly used to dispose of ashes and trash in civilian life. K guns were armaments of various sizes on naval ships, "tin fish" was a universal allied term for torpedoes, and AVTs were Aviation Medicine Technicians. While hash marks were the designations on uniform sleeves to show rank for all but officers, "scrambled eggs" was the yellow or gold embroidery on caps that designated upper ranking officers. "Scuttlebutts" was the term for rumors and information among the military that may or may not have been accurate.

38. Gilbert, "Live the Navy Way," 3.
39. Ibid., 4.
40. JWR, WPC.
41. Carstens referred to the Strait of Gibraltar.
42. Letter from Dorothy Carstens, *Rockford College Alumna*, 1944, 9, RCA.
43. Ibid.
44. Ibid.
45. Ibid.
46. Atabrine was a synthetic substitute for quinine that was used for treating malaria. It was important and necessary after the Japanese captured the world's supply of quinine.
47. The Judge Advocate General's Corps was founded by George Washington in 1775 to ensure fair treatment and establish rule of law in the army.
48. Saucier, *I Took Rockford with Me* Scrapbook, WPC.
49. Ibid.
50. Ibid. There were strict regulations against fraternization between enlisted personnel and officers. Enlisted men were to date enlisted women, and officers were supposed to date only officers.
51. Ibid.
52. "C" rations were canned rations.
53. "Communiques from Overseas," *Rockford College Alumna*, February 1944, 8, RCA.
54. "The Red Cross in Africa," *Purple Parrot*, April 16, 1943, 4, RCA.
55. Ibid. Emphasis in original.
56. Ibid.
57. "A Letter from Ostberg in Africa," *Vanguard*, November 5, 1943, 4, RCA.
58. Dorothy Moyer, "From India's Coral Strands," *Rockford College Alumna*, February 1945, 4, RCA. College alumnae routinely described a proliferation of singing at the school.
59. Ibid.
60. Ibid.
61. Ibid.
62. Yellin, *Our Mothers' War*, 238.
63. Ibid., 181.
64. JWR, WPC.
65. VE-Day was May 7, 1945, the day when leaders of all the German forces unconditionally surrendered to British, French, Soviet, and American emissaries.
66. JWR, WPC.
67. Rainbow Corners was established in Paris on September 3, 1944. By VE-Day, there were fourteen of these centers in Paris.
68. The L'Église de la Madeleine is a church in Paris built to celebrate Napoleon's army.
69. JWR, WPC.
70. Charles de Gaulle was president of France from 1945 to 1946. During the war years, he led the Free French movement and organized the resistance from London. He was elected president of France again in 1958 and in 1965.
71. JWR, WPC.

72. Christine Bruun's notes, WPC.
73. Nuremberg was chosen as the site of the war crimes trial of Nazi officers after the war because it had been the site of these early Hitler rallies. In these trials (1945–49), the Allied powers—the United States, Great Britain, France, and Russia—brought twenty-three high-ranking Nazi officers to an international tribunal to answer for various crimes arising out of war activities.
74. "Knobby" was Dorothy Knoblock, another WAC.
75. JWR, WPC.
76. Ibid.
77. Ibid.
78. Ibid. This is a reference to the location of the November 1923 Beer Hall Putsch where Hitler and the Nazi Party failed in their first attempt to take over the government of Germany.
79. Christine Bruun's notes, WPC.
80. Weatherford, *American Women*, 109.
81. Far Eastern University, a non-sectarian, private institution in Manila, was founded in 1928.
82. Saucier, *I Took Rockford with Me* Scrapbook, WPC.
83. Weatherford, *American Women*, 6.
84. Saucier, *I Took Rockford with Me* Scrapbook, WPC.
85. Ernie Pyle was a famous war correspondent who wrote his Pulitzer Prize–winning daily column from the perspective of ordinary soldiers. He was greatly loved and admired by the troops especially but also by the American people for whom he embodied their loved ones fighting away from home. He was killed during action in the Ryukyu Islands near Japan on April 18, 1945.
86. The USASOS was responsible for movement of support supplies after landings of Allied troops in various theaters of war.
87. Saucier, *I Took Rockford with Me* Scrapbook, WPC.
88. Ibid.
89. Ibid.
90. Ibid.
91. Ibid.
92. Ibid.
93. Ibid.
94. Ibid.
95. Julia White Rogers, Alumnae Interviews folder, WPC.
96. Yellin, *Our Mothers' War*, 381.
97. Elshtain, *Women and War*, 224.

6. Romances of War

1. This material is included in a notebook memoir "manuscript" prepared by Catherine Glossbrenner Rasmussen and shared with the authors. In it is material written by her in the 1940s, photographs of Robert Smith, copies of materials he sent her, notice of his missing-in-action status, as well as later reminiscences from 1996 when she completed the memoir, bringing it up to date with items obtained later. Catherine Glossbrenner Rasmussen Scrapbook (CGR), WPC, 23.
2. Ibid., 45.

3. Ibid., 54.
4. Ibid., 74.
5. Ibid., 51.
6. Elshtain, *Women and War*, 7. Elshtain based her assumptions in large part upon D'Ann Campbell's research in *Women at War with America* (Cambridge: Harvard University Press, 1985).
7. Excerpts from Gee and Gee, "Dear Ones Away," WPC.
8. "Dates Divulge Opinions on RC Gals," *Purple Parrot*, March 6, 1942, RCA.
9. Chapter 6 folder, WPC.
10. *Vanguard*, March 26, 1943, 3, RCA.
11. CGR, WPC, 76.
12. *Vanguard*, October 29, 1943, 3, RCA.
13. Ibid.
14. *Purple Parrot*, March 27, 1942, 3, RCA.
15. *Vanguard*, February 12, 1943, 1, RCA.
16. "From Behind Barbed Wire," *Vanguard*, December 3, 1943, 4, RCA.
17. Keely and Keely, Letters (1940–46), WPC.
18. Lois Pritchard Fisher, Class of 1940 Alumni Reunion, tape recording, May 31, 1980, RCA.
19. Excerpts from Gee and Gee, "Dear Ones Away," WPC.
20. Joyce Marsh Roos letter, Chapter 6 folder, WPC.
21. Lois Pritchard Fisher letter, Chapter 6 folder, WPC.
22. Ibid.
23. Ibid. This refers to the China-Burma-India theater of the war against Japan, which included, among other things, the massive air shipment of supplies to China over "the hump" of the Himalayan Mountains and engagement with thousands of Japanese forces, keeping them from fighting elsewhere in the Pacific.
24. "Nostalgic Theme Pin-up Favorite," *Vanguard*, January 12, 1945, 2, RCA.
25. Littoff and Smith, *Since You Went Away*, 11.
26. "Victory Mail."
27. Chapter 6 folder, WPC.
28. "Brief History of World War Two Advertising Campaigns: V-Mail."
29. "Victory Mail."
30. Keely and Keely, Letters (1940–46), WPC.
31. Ibid. Keely referred to a 1946 effort to protest low prices for milk producers in Detroit. Labor unrest characterized the immediate postwar years (with over five thousand strikes in 1946 alone) as workers wanted a larger piece of the booming American economy. Once the war was over, strikes broke out across the nation beginning in 1946. Almost five million workers struck for improvements in wages and conditions in a wide range of industries including coal, railroad, steel, newspaper, logging, sugar, and others.
32. Ibid.
33. Ibid.
34. Guernsey.
35. Ibid.
36. Ibid.
37. Fisher letter, Chapter 6 folder, WPC.

38. Roos letter, Chapter 6 folder, WPC.
39. Qtd. in June Sochen, *Movers and Shakers*, 174.

7. Twentieth-Century Feminism and New Roles for Women

1. "Transcript: The Democratic Debate," 35.
2. Christine Bruun's notes, WPC.
3. Meno Lovenstein letter, Chapter 7 folder, WPC.
4. *Purple Parrot*, May 1945, RCA.
5. The Declaration of the United Nations was signed by twenty-six nations on January 1, 1942, and was based on the statement of war aims of the Atlantic Charter of 1941 between the United States and Great Britain, which echoed the ideals of Woodrow Wilson's Fourteen Points: national self-determination, free seas, and more open trade and collective security. From April to June 1945, 282 international delegates met in San Francisco to outline and launch the new United Nations organization.
6. "Letter from Czechoslovakia," *Rockford College Alumna*, November 1945, 8, RCA.
7. Douglas Steere was founder of the Oxford Movement, a Christian peace organization.
8. Aimee Isgrig Horton, Alumnae Interviews folder, WPC.
9. Ibid.
10. Ibid.
11. Ibid.
12. Harold L. Ickes, "Watch Out for the Women," *Saturday Evening Post*, February 20, 1943, 19–79; A. G. Mezerick, "Getting Rid of the Women," *Atlantic Monthly*, June 1945, 79–83.
13. Julia White Rogers, Alumnae Interviews folder, WPC.
14. Ibid.
15. "Fortune Survey," 8.
16. Jacquelyn Silcroft Forslund, Alumnae Interviews folder, WPC.
17. Oakes, "Servicemen's Readjustment Act," 26.
18. Forslund, Alumnae Interviews folder, WPC.
19. Rogers, Alumnae Interviews folder, WPC.
20. Ibid.
21. "'My Wife Works and I Like It,'" *Life*, December 24, 1956, 140–41.
22. Rogers, Alumnae Interviews folder, WPC.
23. Christine Bruun's notes, WPC.
24. Henriette Simon, Alumnae Interviews folder, WPC.
25. The ERA, originally drafted in 1923, stated, "Equality of rights under the law shall not be denied or abridged by the United States or by any state on account of sex," and gave Congress the power to enforce its provision by legislation (http://www.law.umkc.edu/faculty/projects/ftrials/conlaw/era.htm). It was introduced every year until it was finally passed by Congress in 1972. However, it fell three states short of ratification and was not added to the Constitution. Supporters continue in their efforts to get it passed again by Congress.
26. Mary Anne Saucier, Alumnae Interviews folder, WPC.
27. Ibid.
28. Yellin, *Our Mothers' War*, x–xi.

29. Ibid., x, xiv.
30. The United Nations Development Fund for Women is a private fund but also an adjunct to the United Nations. The fund subsidizes local projects for women in developing countries.
31. Jean Lyons Keely, Alumnae Interviews folder, WPC.
32. Addams, *Democracy and Social Ethics*, 6.
33. Saucier, Alumnae Interviews folder, WPC.
34. Forslund, Alumnae Interviews folder, WPC.

Selected Bibliography

Primary Sources
Archival Materials

Local History. WWII Folder. Vertical Files. Rockford Public Library. Rockford, Ill.
"Sarah Lawrence College Archives: War Board Scrapbook." At Sarah Lawrence College Web site. http://pages.slc.edu/~archives/wwii/background.htm (accessed February 9, 2010).

Rockford College Archives, Rockford, Ill.

Addams, Jane. Collection.
Cheek, Mary Ashby. Collection.
Cupola. Rockford College Yearbook.
Purple Parrot (1938–October 1943).
Rockford College Alumna (1938–45).
Rockford College Annual Catalog.
Rockford College Annual Scrapbooks (1938–46).
Rockford College Bulletin (1943–45).
Rockford College Historian's Book (1940–42).
Rockford *News Letter* (1940).
Rockford Review (1940–46).
Sill, Anna Peck. Collection.
Vanguard (October 1943–45).
World War II Project Collection
 Alumnae Interviews—Written and Oral
 Bates, Ruth Ann.
 Bode, Charlotte.
 Davis, Patricia Talbot.
 Delman, Dorothy.
 Engel, Frieda Harris.
 Fisher, Lois Pritchard.
 Forslund, Jacquelyn Silcroft.
 Hellmuth, Elane Summers.
 Horton, Aimee Isgrig.
 Keely, Jean Lyons.

Kiyohara, Teru Nakata.

Lundin, Judith Moyer.

Rasmussen, Catey Glossbrenner.

Rogers, Julia White.

Roos, Joyce Marsh.

Saucier, Mary Anne.

Simon, Henriette.

Tunison, Miriam.

Turner, Evelyn.

Chapter Folders, Introduction–Chapter 7.

Cohen, Marianne Ettlinger. Essays/memoirs.

Gee, Jean McCullagh. Scrapbooks.

Gee, Kenneth, and Jean McCullagh Gee. "Dear Ones Away" (unpublished).

Keely, Bill, and Jean Lyons Keely. Letters (1940–46).

Rasmussen, Catherine Glossbrenner. Scrapbook/memoir.

Rogers, Julia White. "Letters Home: Wartime Correspondence from a Daughter to a Mother" (unpublished).

Saucier, Mary Anne. *I Took Rockford with Me* Scrapbook.

Magazines, Government Documents, and Miscellaneous Materials

Atlantic Monthly.

"Brief History of World War Two Advertising Campaigns: V-Mail." Ad*Access On-Line Project, Ad #W0056. John W. Hartman Center for Sales, Advertising, and Marketing History, Duke University Rare Book, Manuscript, and Special Collections Library. http://library.duke.edu/digitalcollections/adaccess.w0056/pg.1/ (accessed February 9, 2010).

"The Fortune Survey: Women in America, Part 1." *Fortune*, August 1946, 8.

Guernsey, Otis L. Review of *The Clock. New York Herald Tribune.* Quoted in "Judy Garland Database." http://jgdb.com/clock.htm (accessed May 9, 2010).

Life.

Rockford Morning Star.

Rockford Register Republic.

Roosevelt, Eleanor. "Women in War," October 15, 1943. *The American Experience. PBS. org.* http://www.pbs.org/wgbh/amex/eleanor/sfeature/md_wi_04.html (accessed February 9, 2010).

Saturday Evening Post.

Time.

"Transcript: The Democratic Debate." *ABC News.* August 19, 2007. http://abcnews. go.com/print?id=3498294 (accessed February 9, 2010).

U.S. Congress. House. An Act Providing for the Extension of Nonquota Status to Frederick Beck. *United States Statutes at Large*, vol. 54, 1314 (1940).

———. An Act to Establish the Women's Army Auxiliary Corps. *United States Statutes at Large*, vol. 56, 278 (1942).

U. S. Congress. Senate. The Fulbright Law. *United States Statutes at Large*, vol. 61, 754 (1946).

"Victory Mail." Smithsonian National Postal Museum, Online Exhibits. http://www. postalmuseum.si.edu/VictoryMail/index.html (accessed February 9, 2010).

Books, Journals, and Pamphlets

Addams, Jane. *Democracy and Social Ethics*. New York: Macmillan, 1902.

———. *Twenty Years at Hull-House*. 1910. Reprint, New York: Penguin, 1999.

Ayling, Keith. *Calling All Women*. New York: Harper, 1942.

Bettelheim, Bruno. "Individual and Mass Behavior in Extreme Situations" and "The Ultimate Limit." *Surviving and Other Essays*. New York: Knopf, 1979.

Clarke, Edward H. *Sex in Education; or, A Fair Chance for the Girls*. 1873. Reprint, New York: Arno Press, 1972.

"How to Use Plays in War Bond Promotions." *War Bond Plays*. Women's Section, War Finance Division, Treasury Department.

Mead, Margaret. "The Women in the War." In *While You Were Gone: A Report on Wartime Life in the United States*, edited by Jack Goodman, 274–89. New York: Simon and Schuster, 1946.

Memories: Walnut Street U.S.O., Rockford, IL. YMCA, YWCA, and Jewish Welfare Board.

National Nursing Council for War Service and the Association of Collegiate Schools of Nursing. *A Guide for the Organization of Collegiate Schools of Nursing*. New York: National Nursing Council for War Service, 1942.

Secondary Sources

Austin, Allan W. *From Concentration Camp to Campus: Japanese American Students and World War II*. Urbana: University of Illinois Press, 2004.

Brown, Victoria Bissell. *The Education of Jane Addams*. Philadelphia: University of Pennsylvania Press, 2004.

Bruun, Christine. "The Cheek Legacy: The Realistic Idealism of Mary Ashby Cheek." *Decus* 7, no. 3 (Winter 1999): 10–15.

Cheek, Mary Ashby. "Reorganized Residence Halls." *Journal of Higher Education* 7, no. 7 (October 1936): 371–76.

"Concentration Camps?" *Modern American Poetry: Online Journal and Companion to Anthology of Modern American Poetry*. Ed. Cary Nelson. 2000. http://www.english.illinois.edu/MAPS/poets/g_l/haiku/camps.htm (accessed February 9, 2010).

Coser, Lewis A. *Refugee Scholars in America: Their Impact and Their Experience*. New Haven: Yale University Press, 1984.

Elshtain, Jean Bethke. *Jane Addams and the Dream of American Democracy*. New York: Basic, 2002.

———. *Women and War*. New York: Basic, 1987.

Fleming, Donald, and Bernard Bailyn, ed. *Intellectual Migration: Europe and America, 1930–1960*. Cambridge: Belknap Press of Harvard University Press, 1969.

Garraty, John A., and Mark C. Carnes, eds. *American National Biography*. Vol. 23. New York: Oxford University Press, 1999.

Gruhzit-Hoyt, Olga. *They Also Served: American Women in World War II*. Secaucus, N.J.: Carol Publishing, 1995.

Harrington, Maurice. *The Social Philosophy of Jane Addams*. Champaign: University of Illinois Press, 2009.

Hartmann, Susan M. *The Home Front and Beyond: American Women in the 1940s*. Boston: Twayne, 1982.

Heide, Robert, and John Gilman. *Home Front America: Popular Culture of the World War II Era*. San Francisco: Chronicle Books, 1995.

Horowitz, Daniel. *Betty Friedan and the Making of* The Feminine Mystique*: The American Left, the Cold War, and Modern Feminism*. Amherst: University of Massachusetts Press, 1998.

Krabel, Jerome. *The Chosen: The Hidden History of Admission and Exclusion at Harvard, Yale, and Princeton*. New York: Houghton Mifflin, 2005.

Lamberti, Marjorie. "The Reception of Refugee Scholars from Nazi Germany in America: Philanthropy and Social Change in Higher Education." *Jewish Social Studies* 12, no. 3 (2006): 157–92.

Lasch, Christopher. *The Social Thought of Jane Addams*. Indianapolis: Bobbs-Merrill, 1965.

Levine, Daniel. *Jane Addams and the Liberal Tradition*. Madison: State Historical Society of Wisconsin, 1971.

Linn, James Weber. *Jane Addams: A Biography*. 1935. Reprint, Champaign: University of Illinois Press, 2000.

Littoff, Judy B., and David C. Smith. *Since You Went Away: World War II Letters from American Women on the Home Front*. New York: Oxford University Press, 1991.

McAlister, Melanie. "Saving Private Lynch." *New York Times*, April 6, 2003. http://nytimes.com/2003/04/06/opinion/saving-private-lynch.html (accessed February 9, 2010).

McCandless, Amy Thompson. *The Past in the Present: Women's Higher Education in the Twentieth-Century South*. Tuscaloosa: University of Alabama Press, 1999.

Merrill, Phyllis. *Mount Holyoke—Everybody's College*. South Hadley, Mass.: Mount Holyoke College, 1948.

Morris, William, ed. *The American Heritage Dictionary of the English Language*. Boston: Houghton Mifflin, 1976.

Nelson, C. Hal, ed. *Rockford College: A Retrospective Look*. Rockford, Ill.: Rockford College, 1980.

Oakes, John Warren. "How the Servicemen's Readjustment Act of 1944 (GI Bill) Impacted Women Artists' Career Opportunities." *Visual Culture and Gender* 1 (2006): 23–31. http://128.118.229.237/vcg/1vol/oakes.pdf (accessed February 9, 2010).

Pollak, Richard. *The Creation of Dr. B.: A Biography of Bruno Bettelheim*. New York: Simon and Schuster, 1997.

"Research on 100th/442nd Regimental Combat Team." *National Japanese American Historical Society*. http://www.nikkeiheritage.org/research/442.html (accessed February 9, 2010).

Schwartz, Eugene G., ed. *American Students Organize: Founding the National Student Association after WWII, An Anthology and Sourcebook*. Westport, Conn.: Praeger, 2006.

Shields, Patricia. "Democracy and the Social Feminist Ethics of Jane Addams: A Vision for Public Administration." *Administrative Theory and Praxis* 28, no. 3 (2006): 418–43.

Shirer, William L. *The Rise and Fall of the Third Reich: A History of Nazi Germany*. New York: Simon and Schuster, 1960.

Sochen, June. *Movers and Shakers: American Women Thinkers and Activists, 1900–1970*. New York: Quadrangle Books, 1973.

Solomon, Barbara Miller. *In the Company of Educated Women: A History of Women and Higher Education in America.* New Haven: Yale University Press, 1985.

Tronto, Joan C. "Care as a Political Concept." In *Revisioning the Political: Feminist Reconstructions of Traditional Concepts in Western Political Theory,* edited by Nancy J. Hirschmann and Christine Di Stefano, 139–56. Boulder, Colo.: Westview Press, 1996.

Weatherford, Doris. *American Women and World War II.* New York: Facts on File, 1990.

Wells, Anna Mary. *Miss Marks and Miss Woolley.* Boston: Houghton, Mifflin, 1978.

Winkler, Allan M. *Home Front U.S.A.: America during World War II.* Arlington Heights, Ill.: Harlan Davidson, 1986.

Woloch, Nancy. *Women and the American Experience: A Concise History.* Boston: McGraw Hill, 2001.

Yellin, Emily. *Our Mothers' War: American Women at Home and at the Front during World War II.* New York: Free Press, 2004.

Suggested Reading

The primary sources used in this manuscript mainly came from archival documents at Rockford College from the period 1938–46. The college newspapers, the *Purple Parrot* and the *Vanguard*, were especially helpful. Additional archival materials included the collection of speeches by President Mary Ashby Cheek and campus guest lecturers as well as personal letters of students, alumnae, faculty, and administrators from the college. Each class year, a student was designated to compile a scrapbook that contained news articles and other documentary evidence of school activities. These proved to be a rich but problematic source due to sparse source notations. More recently, retrospective interviews, essays, and letters (electronic, typed, and handwritten) provided relevant and clarifying information. Materials collected for preparation of this book were assembled and are housed in the Rockford College Archives as the World War II Project Collection.

The *Chicago Tribune* provided regional midwestern coverage of the college. Archival scrapbooks housed at the college are filled with articles clipped from the Rockford local newspapers, the *Morning Star* and the *Register Star*. National newspapers such as the *New York Times* and the *Los Angeles Examiner* were descriptive sources of war news pertaining to women. Similarly, news about women was collected from 1940s magazines such as *Life*, *Ladies Home Journal*, and *Time*. Doris Weatherford provided a useful overview of the differing emphases of newsmagazines and newspapers in *American Women and World War II* (New York: Facts on File, 1990).

Letters have also been a rich source of wartime information about women. Judy B. Litoff and David C. Smith edited a large number of letters, covering topics such as courtship, war brides, war wives, and war jobs. Four of their books are *Since You Went Away: World War II Letters from American Women on the Home Front* (New York: Oxford University Press, 1991), *Dear Boys: World War II Letters from a Woman Back Home* (Jackson: University of Mississippi

Press, 1991), *American Women in a World at War: Contemporary Accounts from World War II* (Wilmington, Del.: SR Books, 1997), and *What Kind of World Do We Want? American Women Plan for Peace* (Wilmington, Del.: Scholarly Resources, 2000). These texts use letters as their raw material to give a unique insight into a whole generation driven by war.

Oral histories are effective sources of personal emotions and perspectives of war experiences. Tom Brokaw, moved by his historical coverage of the D-Day anniversary, shares the stories of men and women who grew up in the Depression and served in World War II in *The Greatest Generation* (New York: Random House, 1998). Other oral histories include Archie Satterfield's *The Home Front: An Oral History of the War Years in America, 1941–1945* (New York: Playboy Press, 1981), Roy Hoopes's *Americans Remember the Home Front—An Oral Narrative* (New York: Hawthorn Books, 1977), and Studs Terkel's *The Good War: An Oral History of World War II* (New York: New Press, 1997). William Guarnere and Edward Heffron, best friend paratroopers in Easy Company, part of the renowned and heroic Airborne Division, tell the story of their side-by-side combat in some of the most hard-fought arenas of the war in *Brothers in Battle: Best of Friends* (New York: Berkley Caliber, 2007). Oral histories telling about the lives of women as they experienced the war are included in George L. McDermott's *Women Recall the War Years: Memories of WWII* (Chapel Hill, N.C.: Professional Press, 1998) and Kathryn S. Dobie and Eleanor Lang's *Her War: American Women in WWII* (New York: IUniverse, 2003). Another source of women's experiences is *Out of the Kitchen: Women in the Armed Services and on the Homefront: The Oral Histories of Pennsylvania Veterans of World War II* by Frances Murphy Zauhar, Richard David Wissolik, and Jennifer Campion (Latrobe, Penn.: Saint Vincent College Center for North Appalachian Studies, 1994).

Women's writings about World War II have also been addressed in studies and anthologies, such as Sayre P. Sheldon's *Her War Story: Twentieth-Century Women Write about War* (Carbondale: Southern Illinois University Press, 1999) and Jean Gallaher's *The World Wars through the Female Gaze* (Carbondale: Southern Illinois University Press, 1999). The work of women journalists during World War II is specifically the focus of Lilya Wagner's *Women War Correspondents of World War II* (Westport, Conn.: Greenwood Press, 1989).

Other important primary sources are the many books written at the time of the war to inform both men and women of opportunities and social changes. For example, Keith Ayling's *Calling All Women* (New York: Harper and Bros., 1942) informed women of the many ways they could serve the war effort through civilian and military roles, and Ethel Gorham's *So Your Husband's Gone to War* (New York: Doubleday, Doran and Co., 1942) addressed the ques-

tions facing wives without their husbands. Jack Goodman's *While You Were Gone: A Report on Wartime Life in the United States* (New York: Simon and Schuster, 1946) was written at the end of the war with the purpose of smoothing the transition that men faced as they came home from war. Several other memoirs of the era conveyed the woman's experience of war very directly to their audiences: Susan B. Anthony III's *Out of the Kitchen—Into the War* (New York: S. Daye, 1943), Constance Bowman's *Slacks and Callouses* (New York: Longmans, Green and Co., 1944), Augusta M. Clawson's *Shipyard Diary of a Woman Welder* (New York: Penguin, 1944), Barbara Klaw's *Camp Follower: The Story of a Soldier's Wife* (New York: Random House, 1943), and Jean Stanbury's *Bars on Her Shoulders: A Story of a WAAC* (New York: Dodd, Mead and Co., 1943).

In addition to primary sources, the rich supply of secondary texts on the topic of women in World War II has been a fertile source of information. The efforts of women on the home front stretched from defense industries to the farm and office. A number of sources, such as Nan Heacock's *Battle Stations! The Homefront in World War II* (Ames: Iowa State University Press, 1992) and Stephanie Ann Carpenter's "Regular Farm Girl: The Woman's Land Army in World War II," published in *Agricultural History* 71 (Spring 1997): 163–85, are just two sources that begin to cover this far-ranging topic. Emily Yellin's *Our Mothers' War: American Women at Home and at the Front during World War II* (New York: Free Press, 2004) uses interviews, diaries, and letters to capture the stories of women involved in many sectors of life, such as parenting, politics, industrial work, and entertainment. Doris Weatherford also discusses women's roles in industry and in the home in *American Women and World War II*. Women in the workplace is another subject covered in numerous sources, including Alan Clive's "Women Workers in World War II: Michigan as a Test Case," published in *Labor History* 20 (Winter 1979): 44–72, and Deborah Scott Hirshfield's "Women Shipyard Workers in the Second World War: A Note," published in *International History Review* 11 (May 1989): 278–85. A broader look at international women in their diverse wartime activities, including many pictures, can be found in Brenda R. Lewis's *Women at War: The Women of World War II—At Home, at Work, on the Front Line* (Pleasantville, N.Y.: Reader's Digest Association, 2002).

Student political organizations in the United States during wartime took on an international focus. Eugene Schwartz describes student involvement during the war in his edited book *American Students Organize: Founding the National Student Association after World War II, An Anthology and Sourcebook* (Westport, Conn.: Praeger Publishers, 2006). In the same volume, Marguerite Kehr tells the history of the National Student Federation in the United States,

and Rockford College alumnae Janice Dowd and Mildred Wurf recount the history of the National Student Association's early years. (Dowd was active in international student work while a student at Rockford College.)

A number of sources feature the social climate on the home front affecting Americans in the 1940s. Allan M. Winkler, in *Home Front U.S.A.: America during World War II* (Arlington Heights, Ill.: Harlan Davidson, 1986), shows the opportunities that the war ushered into the workplace for both women and men, while Ruth Milkman focuses on the difficulties women faced in the workplace in her *Gender at Work: The Dynamics of Job Segregation by Sex during World War II* (Urbana: University of Illinois Press, 1987). Robert Heide and John Gilman describe cultural influences in *Home Front America: Popular Culture of the World War II Era* (San Francisco: Chronicle Books, 1995). Paul Casdorph's *Let the Good Times Roll: Life at Home in America during World War II* (New York: Paragon House Publishers, 1989) describes Americans' attitudes toward such diverse topics as rationing and sports. Other sources on the home front include John Morton Blum's *V Was for Victory: Politics and American Culture during World War II* (New York: Harcourt Brace Jovanovich, 1976), Richard Lingeman's *Don't You Know There's a War On? The American Home Front, 1941–1945* (New York: G. P. Putnam's Sons, 1970), Elfrieda B. Shukert and Barbara S. Scibetta's *War Brides of World War Two* (New York: Penguin, 1989), and Geoffrey Perrett's *Days of Sadness, Years of Triumph: The American People, 1939–1945* (New York: Coward, McCann, Geoghegan, 1973).

Wartime influences at both Mount Holyoke College and Rockford College can be explored further in several sources. In *A Memory Book: Mount Holyoke College, 1837–1987,* Anne Carey Edmonds provides information on refugees and women's contributions during World War II at Mount Holyoke (South Hadley, Mass.: Mount Holyoke College, 1988). In *Mount Holyoke—Everybody's College* (South Hadley, Mass.: Mount Holyoke College, 1948), Phyllis Merrill discusses the college's culture of internationalism and civic engagement because of the influence of Mary Woolley. *Rockford College: A Retrospective Look,* edited by C. Hal Nelson (Rockford, Ill.: Rockford College, 1980), presents the history of the college, including discussions about Jane Addams and Mary Ashby Cheek.

A rich compendium of sources highlights the life, philosophy, and work of Jane Addams, as well as the activities of Hull-House and the women who were active participants there. Addams herself described her grassroots philosophy of participatory democracy and her concept of social feminism in *Democracy and Social Ethics* (New York: Macmillan, 1902). She told the early story of Hull-House in *Twenty Years at Hull-House* (New York: Macmillan, 1910) and continued the story in *The Second Twenty Years at Hull-House* (New York: Macmillan, 1930).

In "Jane Addams and the Social Claim" (*Public Interest* [Fall 2001]: n.p.), Jean Bethke Elshtain responds to Addams's critics by explaining the relevancy of her ideas about social change and describing her social feminism. Elshtain also discusses Addams's concept of civic housekeeping and her pacifism in *Jane Addams and the Dream of American Democracy: A Life* (New York: Basic Books, 2002). Patricia Shields provides a convincing argument that Addams's theory of democracy applies to modern trends in public administration in "Democracy and the Social Feminist Ethics of Jane Addams: A Vision for Public Administration" (*Administration Theory and Praxis* 28, no. 3 [2006]: 418–43). Information on Addams's formative years at Rockford Female Seminary, including her role in the Illinois Oratorical Association, can be found in volume 1 of *The Selected Papers of Jane Addams: Preparing to Lead, 1860–1861*, edited by Barbara Bair, Maree de Angury, and Mary Lynn McCree Bryan (Chicago: University of Illinois Press, 2002). James Weber Linn, nephew of Jane Addams, shows how Rockford College shaped his aunt's belief in women's suffrage in *Jane Addams: A Biography* (New York: Appleton-Century, 1935).

Numerous books and articles examine the social and political influence of Addams's work. Estelle Freedman discusses Addams's experience at Rockford Female Seminary as an example of women's colleges' impact and the settlement house model's connection to women's suffrage in "Separatism as a Strategy: Female Institution Building and American Feminism, 1870–1930," an article published in *U.S. Women in Struggle: A Feminist Studies Anthology*, edited by Claire Goldberg Moses and Heidi Hartmann (Urbana: University of Illinois Press, 1995, pgs. 71–88). Daniel Levine describes Addams's feminism in terms of suffrage activities and pacifism in *Jane Addams and the Liberal Tradition* (Madison: State Historical Society of Wisconsin, 1971). Andra Makler presents Addams's methods of social education in "Courage, Conviction, and Social Education," an essay included in *Bending the Future to Their Will: Civic Women, Social Education, and Democracy*, which was edited by Margaret Smith Crocco and O. L. Davis Jr. (New York: Rowman and Littlefield, 1999, pgs. 253–75). In *The Rising of Women: Feminist Solidarity and Class Conflict, 1880–1917* (New York: Monthly Review Press, 1980), Meredith Tax writes about Addams's work with Mary Kenney and Florence Kelley organizing labor for women and about her leadership in forming the Women's Trade Union League.

The complex influence of eras before, during, and after the war on women's education has been discussed in a variety of sources. Linda Eisenmann's *Higher Education for Women in Postwar America, 1945–1965* (Baltimore: Johns Hopkins University Press, 2006) explores postwar differences in gendered education as well as racial and class differences in colleges and universities. Irene Harwarth, Mindi Maline, and Elizabeth DeBra provide a comprehensive look

at the history of U.S. colleges from the late nineteenth through the twentieth centuries in *Women's Colleges in the United States: History, Issues, and Challenges* (Washington, D.C.: U.S. Government Printing Office, 1997). Barbara Miller Solomon's *In the Company of Educated Women: A History of Women and Higher Education in America* (New Haven: Yale University Press, 1985) captures the complexity of the many variables (for example, politics, domestic pressures, wartime influences) that have affected the educational history of women in America within colleges, graduate schools, and professional schools. Susan M. Hartmann includes a thorough chapter on women's education in *The Home Front and Beyond: American Women in the 1940s* (Boston: Twayne, 1982). Her book sheds light on what a wartime college education and specific curricular choices meant for both black and white women. Insightful chapters edited by Joanne Meyerowitz in *Not June Cleaver: Women and Gender in Postwar America, 1945–1960* (Philadelphia: Temple University Press, 1994) explore the complex interactions of women's groups and government agencies as well as the political influence of the Cold War in the sectors of home, work, and education.

A regional look at the history of women in education can be found in Amy Thompson McCandless's *The Past in the Present: Women's Higher Education in the Twentieth-Century South* (Tuscaloosa: University of Alabama Press, 1999). McCandless traces the history of southern women's education from the nineteenth century to the present and includes a discussion of wartime education and curricula available for women.

Important influences on wartime education were made by scholars who were refugees from Nazism. The effects that these intellectuals had on education in U.S. colleges and universities are discussed in Lewis A. Coser's *Refugee Scholars in America: Their Impact and Their Experiences* (New Haven: Yale University Press, 1984) and in Donald Fleming and Bernard Bailyn's *Intellectual Migration: Europe and America, 1930–1960* (Cambridge: Belknap Press of Harvard University Press, 1969). One of the most celebrated refugee scholars was Bruno Bettelheim. A revisionist biography of Bettelheim can be found in Richard Pollak's *The Creation of Dr. B.: A Biography of Bruno Bettelheim* (New York: Simon and Schuster, 1997). One of Bettelheim's most well known works was *The Uses of Enchantment: The Meaning and Importance of Fairy Tales* (New York: Knopf, 1976). Other writings that are relevant to Bettelheim's refugee experiences can be found in *Freud's Vienna and Other Essays* (New York: Knopf, 1990) and *Surviving and Other Essays* (New York: Knopf, 1979).

The experiences of refugee students were complex. William L. Shirer's *The Rise and Fall of the Third Reich: A History of Nazi Germany* (New York: Simon and Schuster, 1960) provides background for a clearer understanding of the refugee students who had experienced Hitler's indoctrinating influence. John

Skrentny, in *The Ironies of Affirmative Action: Politics, Culture, and Justice in America* (Chicago: University of Chicago Press, 1996), discusses the easing of discrimination policies in U.S. institutions that paved the way for more Jewish students to enroll in American universities. Allan Austin explores the experiences, attitudes, and emotions of Japanese American students in *From Concentration Camp to Campus: Japanese-American Students and World War II* (Urbana: University of Illinois Press, 2004).

A number of studies have provided a broader understanding of the Japanese American experience during World War II. Lawson Fusao Inada's *Only What We Could Carry: The Japanese American Internment Experience* (Berkeley: Heyday Books, 2000) and Daniel S. Davis's *Behind Barbed Wire: The Imprisonment of Japanese Americans during World War II* (New York: Dutton Books, 1982) focus on the American concentration camps. Other studies have dealt more specifically with Japanese women, including Valerie Matsumoto's "Japanese American Women during World War II," published in *Frontiers* 8, no. 1 (1984): 6-14, and Brenda L. Moore's *Serving Our Country: Japanese American Women in the Military during World War II* (New Brunswick, N.J.: Rutgers University Press, 2003).

While this book is focused on the wartime experiences of primarily white middle- and upper-class women who attended college, some aspects of their lives as women were universal. For example, any woman serving in the WAC, SPAR, or Red Cross or working at a USO club anywhere in the country would have had similar experiences to those recounted here. Not all women, however, had access to higher education, work-study programs, or even newspapers. Almost all women struggled with rationing, shortages, and the absence and loss of loved ones, no matter what their race or social class. There is no doubt, however, that many women experienced much different aspects of the war due to poverty, racism, and exclusion. Their stories, especially those of black women, have been explored by a number of authors, including Karen Tucker Anderson, "Last Hired, First Fired: Black Women during World War II," *Journal of American History* 69 (June 1982): 82–97; Grace Mary Gouvela, "'We Also Serve': American Indian Women's Role in World War II," *Michigan Historical Review* 20 (Fall 1994): 153–84; Maureen Honey, *Bitter Fruit: African American Women in World War II* (Columbia: University of Missouri Press, 1999) and *Creating Rosie the Riveter: Class, Gender, and Propaganda during World War II* (Amherst: University of Massachusetts Press, 1984); Debra L. Newman, "The Propaganda and the Truth: Black Women and World War II," *Minerva: Quarterly Report on Women and the Military* 4 (Winter 1986): 72–92; and Paul R. Spickard, "Work and Hope: African American Women in Southern California during World War II," *Journal of the West* 33 (July 1993): 70–79.

The chronological and stark details of the war have been described in numerous historical accounts. For example, *American Heritage New History of World War II*, updated by Stephen Ambrose (New York: Viking, 1997); *World War II* (New York: Prentice-Hall Time-Life Books, 1989); and *The Rand McNally Encyclopedia of World War II* (Chicago: Rand McNally, 1977) provide accessible background and descriptions of key events and individuals during the war.

Numerous sources provide information on the roles of women in the Red Cross and the military. Olga Gruhzit-Hoyt, in *They Also Served: American Women in World War II* (Secaucus, N.J.: Carol Publishing, 1995), tells the personal stories of individual women in all branches of the military and also relates useful details about the internal operations of these separate divisions. Doris Weatherford, in *American Women and World War II*, supplies historical background to the roles women were given as well as detailed accounts of everyday military life both in the United States and abroad. Emily Yellin, in *Our Mothers' War: American Women at Home and at the Front during World War II*, relates the personal stories of women's military experiences through interviews, diaries, and letters. Anne Noggle's *For God, Country, and the Thrill of It: Women Air Force Service Pilots in World War II* (College Station: Texas A&M University Press, 1990) and Molly Merryan's *Clipped Wings: The Rise and Fall of the Women Airforce Service Pilots (WASPs) of World War II* (New York: New York University Press, 2001) focus specifically on women's role in the U.S. Air Force during the war. Emily Van Sickle's *The Iron Gates of Santo Tomas* (Chicago: Academy Chicago Publishers, 1992) tells the grim account of American women—civilians and army nurses—who were interned by the Japanese in a concentration camp in the Philippines.

The increasing involvement of women in social and political spheres evolved through obstacles and social change, preceding and following World War II. Early constraints to women's education are seen in Edward Clarke's *Sex in Education: Or a Fair Chance for the Girls* (Boston: J. R. Osgood, 1873), in which Clarke argues that education would be detrimental to the physical well-being and feminine nature of women. In *American Educational History: School, Society, and the Common Good* (London: Sage Publications, 2007), William Jeynes links the forces against racism in World War II with the civil rights movement. In *Born for Liberty: A History of Women in America* (New York: Free Press, 1989), Sara M. Evans discusses the subtleties of pressures facing women during and after the war. Included is a clear description of the role that unions played on behalf of women in the labor force. Evans also describes the delicate balance managed by postwar women in their home lives, educations, and careers. Susan M. Hartmann's *The Home Front and Beyond: American*

Women in the 1940s illustrates the contradictions of women's place in society during the war compared to what they would face in the decades to come.

Numerous sources provide insightful commentary on postwar feminism. June Sochen contends in *Movers and Shakers* (New York: Quadrangle/The New York Times Book Company, 1973) that the women's movement lost ground during the postwar years of the 1950s because of pulls toward traditional roles for women. Similarly, Elaine Tyler May, in *Homeward Bound: American Families in the Cold War Era* (New York: Basic Books, 1988), discusses the problems that educated women felt as they took on the life of homemaking and child care after the war. Joan C. Tronto reconciles the competing demands on women between their private and public lives in her innovative discussion of care as a political concept of benevolent social change in her essay "Care as a Political Concept," included in *Revisioning the Political: Feminist Reconstructions of Traditional Concepts in Western Political Theory*, edited by Nancy J. Hirschmann and Christine Di Stefano (Boulder, Colo.: Westview Press, 1996, pgs. 139–56). Betty Friedan's classic, *The Feminine Mystique* (New York: Norton, 1963), addressed the growing need of women in the 1960s to shape their own role directions, free of prescribed constraints. Daniel Horowitz's book *Betty Friedan and the Making of* The Feminine Mystique: *The American Left, the Cold War, and Modern Feminism* (Amherst: University of Massachusetts Press, 1998) discusses Friedan's work in connection with organized labor for women and the civil rights movement.

Postwar changes in jobs, careers, and professions in the push for equality for women are discussed in Fiona Macdonald's *Women in a Changing World: 1945–2000* (New York: Peter Bedrick Books, 2001). This source provides a highly accessible overview of the shifting roles of women from World War II through the 1990s and briefly highlights key events in the political, social, economic, and cultural arenas. Although a generalized account, the book presents a broad picture of the progression of the women's movement from the war to the turn of the twenty-first century. In *Inventing the American Woman: A Perspective on Women's History* (Arlington Heights, Ill.: Harlan Davidson, 1987), Glenda Riley examines the changed image of women in a number of eras, including wartime, an image that represented women seeking a greater voice in public policy decisions.

Seeking that greater voice, however, brought with it complications. On the one hand, young American women of the World War II era were as influenced by media and government propaganda as other Americans across the country. Studies such as Maureen Honey's *Creating Rosie the Riveter: Class, Gender, and Propaganda during World War II*, Leila J. Rupp's *Mobilizing Women for War:*

German and American Propaganda, 1939–1945 (Princeton, N.J.: Princeton University Press, 1978), and Allan M. Winkler's *The Politics of Propaganda: The Office of War Information, 1942–1945* (New Haven: Yale University Press, 1978) examine these influences. Claiming a voice of their own, however, meant writing themselves into the story of war. While Richard J. Gerrig's *Experiencing Narrative Worlds: On the Psychological Activities of Reading* (New Haven: Yale University Press, 1993) examines the implications of becoming part of a narrative in more general terms, Jean Bethke Elshtain's *Women and War* (New York: Basic Books, 1987) focuses specifically on the ways in which war itself "thrust women into a world of care, responsibility, and obligation" (237). Perhaps war was the greatest influence on their "story," but women of World War II also assumed a stronger voice in the world because of their willingness to take action.

Publishing on World War II and women's roles in it, both at home and abroad, continues to grow. As more attics are cleaned out, an increasing number of primary sources either become available or disappear. As more women of the "greatest generation" die, their stories are either revealed or lost. Those who recognize the value of the important place of women in the nation's fighting of the war will continue to share the stories.

Index

This index refers to World War II as WWII and to Rockford College as RC. Page numbers in italics denote illustrations.

Mary Weaks-Baxter is the Hazel Koch Professor of English at Rockford College, where she teaches courses in rhetoric and literature. She has coedited three books, including *Talking with Robert Penn Warren*, *Southern Women's Literature*, and *The History of Southern Women's Literature*, and written a monograph, *Reclaiming the American Farmer*.

Christine Bruun is Professor of Psychology Emerita and former chair of the psychology department at Rockford College. She is also a clinical psychologist. Bruun's current research interest concerns the intergenerational aspects of empathy. With a collateral interest in history and the classics, she has also published a psychological analysis of the *Aeneid*.

Catherine Forslund is professor of history and chair of the history department at Rockford College, where she teaches U.S., Latin American, and Asian history. Her publications include *Anna Chennault: Informal Diplomacy and Asian Relations* and the forthcoming *Edith Kermit Roosevelt: Victorian Modern First Lady*, for which she received a White House Historical Association grant.

For more information, visit the online archive at weareacollegeatwar.org.